A CELEBRATION OF LIMERICK'S SILVER

Edited by John R. Bowen & Conor O'Brien

The Collins Press

THE HUNT MUSEUM

Published in 2007 by
THE COLLINS PRESS, West Link Park, Doughcloyne, Wilton, Cork,
in association with
THE HUNT MUSEUM, The Custom House, Limerick.

Published to coincide with the exhibition 'A Celebration of Limerick's Silver'
at The Hunt Museum, Limerick, 14 September 2007 - 13 January 2008

© John R. Bowen and Conor O'Brien 2007
John Bowen and Conor O'Brien have asserted their moral rights to be identified as the authors of this work.

The material in this publication is protected by copyright law.
Except as may be permitted by law, no part of the material may be reproduced (including by storage in a retrieval system) or transmitted in any form or by any means adapted, rented or lent without the written permission of the copyright owners. Applications for permissions should be addressed to the publisher.

British Library Cataloguing in Publication Data
Bowen, John R.
 A celebration of Limerick's silver
 1. Silverwork - Ireland - Limerick - History 2. Goldwork - Ireland - Limerick - History
 I. Title II. O'Brien, Conor, 1933-
739.2'3'0941945

ISBN 978-1-905172-55-9

Designed and produced by DOWLING & DOWLING DESIGN CONSULTANTS LIMITED

Printed by NICHOLSON & BASS

Table of Contents

Acknowledgements ...4

Foreword ...6

Sponsor's Preface ...7

Silver and Gold: An Introduction ..8

The Goldsmiths' Craft in Limerick: An Overview12

Goldsmiths and Limerick City, 1640-1840
Jennifer Moore ..18

CATALOGUE OF THE EXHIBITION

 Notes to the Catalogue ...40

 Section One – **Ecclesiastical**
 Clodagh Lynch and Michael Lynch..42

 Section Two – **Civic, Ceremonial and Commemorative**
 Conor O'Brien ...76

 Section Three – **Sports**
 Eamonn Noonan and Jim Noonan ..98

 Section Four – **Modern**
 John McCormack ..116

 Section Five – **Flatware**
 John R. Bowen ..126

 Section Six – **Treasury**
 John R. Bowen ..140

 Section Seven – **Miscellany**
 John R. Bowen ..156

 Section Eight – **Food and Drink**
 John R. Bowen ..170

A Directory of the Goldsmiths of Limerick
John McCormack and Conor O'Brien ..190

Glossary of Terms ...212

A Select Bibliography..214

Index ...216

Acknowledgements

The Organising Committee of this exhibition and the editors of the catalogue wish to acknowledge with appreciation and gratitude the following individuals and organisations who have helped so magnificently and so tangibly to give effect to this unique and very special project.

The Chairman of The Hunt Museum, George Stacpoole, has been an unstinting champion of the project from the time it was first mooted. The Director of The Hunt Museum, Virginia Teehan and her colleagues, particularly Fiona Davern and Naomi O'Nolan, have been capable and committed helpers throughout.

The most sincere appreciation has to be expressed to all of those individuals and institutions who have made items available on loan to this exhibition, and in so doing have given effect to what is probably the greatest collection of Limerick silver assembled to date. Many of the lenders are individuals who did not wish to be identified. Without the willingness of the lenders to make their items available, there would be no exhibition. It is a credit to the generosity of our lenders that no request to borrow an item for the exhibition was declined.

Special thanks for assistance in many ways, moral and material, are due to Douglas Bennett and Ida Delamer of the Company of Goldsmiths of Dublin; to The Knight of Glin; to The Earl of Rosse; to Alison Fitzgerald and Malgorzata Krasnodebska-D'Aughton of University College Dublin; to Dr. Pat Wallace, Director, National Museum of Ireland, and his colleagues Michael Kenny and Sandra McElroy; to Rebecca Hayes, Archivist, Freemasons' Hall, Dublin; to Ellen Murphy of Limerick Archives; Denis Leonard of Limerick Civic Trust; Allan Kilpatrick of Weir & Sons Dublin Ltd.; and to Lola Armstrong, Curator, Clandeboye Estate, Co. Antrim.

The following individuals helped to secure the important loans of the Franciscan plate. They are also the organizers of the Louvain 400 celebrations with which we are proud to be associated. In addition, they have made a financial contribution towards the costs of this exhibition. Professor John McCafferty, Director, The Mícheál Ó Cléirigh Institute, University College Dublin; Dr. Joseph Mac Mahon, OFM, Office of the Provincial, The Irish Franciscans; Dr. Edel Bhreathnach, Postdoctoral Fellow, The Mícheál Ó Cléirigh Institute, University College Dublin.

Trevor Stacey, Head of Property and Trusts, Representative Church Body, and his colleagues Dr Raymond Refaussé, Librarian and Archivist, and Dr. Susan Hood, Archivist, at the Representative Church Body Library, were extraordinarily helpful in securing the loans from Church of Ireland sources. In this context too the support for the project from The Right Reverend Michael Mayes, Bishop of Limerick, Ardfert, Aghadoe, Killaloe, Kilfenora, Clonfert, Kilmaduagh and Emly, cannot be overstated and is acknowledged with appreciation.

Unstinting support and assistance throughout the project was gratefully received from the two Roman Catholic bishops of the region, Most Reverend Donal Murray, DD, Bishop of Limerick, and Most Reverend William Walsh, DD, Bishop of Killaloe. Special thanks too to Abbot Christopher Dillon and Dr. Colmán Ó Clabaigh, Glenstal Abbey, Murroe; to Fr. Dermot Brennan, Prior, St. Saviour's, Dominican Priory, Limerick; and to Fr. Denis Mullane, Administrator, Diocesan Office, Limerick.

Jimmy and Martin Weldon of J W Weldon, Dublin, have been enthusiastic supporters of this project from its inception. Jimmy Weldon was particularly generous with his time in helping to locate many of the exhibits and in encouraging their owners to make them available for the exhibition, and also in numerous other ways.

The design of the exhibition was carried out by Billy Wilson and his colleagues at Wilson Architecture to whom a special word of appreciation is due and, in particular, to Tillman Leistner.

Tony McGennis, Fine Art Transport, provided discreet and effective logistical support in the task of getting the many items to The Hunt Museum.

The promotion and marketing of the exhibition has been capably handled by Margaret O'Brien, PR Consultant, and by Mary Fennelly, Marketing Consultant, with the financial support of Fáilte Ireland.

This profusely illustrated catalogue was the collaborative effort of many and special thanks are due to all of the contributors of articles and written material and, in particular, to Jennifer Moore whose specially commissioned essay enhances this catalogue immeasurably by setting much of the goldsmiths' work in its historic context.

Janice O'Connell of F22 Photography, who took almost all of the photographs, has added immensely to the catalogue as an enduring record of the exhibition. Ber Murphy and Gail Dowling of Dowling & Dowling Design Ltd. were patient and professional in transforming a mass of words and photographs, capably and competently into the current production as well as devising the overall master identity for the exhibition. Margaret Lantry provided vital project management, giving us the necessary steady hand at the tiller at the critical pre-production phase of the catalogue as well as undertaking the copy-editing and indexing.

The Collins Press agreed to act as joint publisher of the catalogue, with The Hunt Museum, thereby giving it the access to international distribution it deserves, and Nicholson & Bass in Belfast produced the volume in absolutely record time.

To the many others who have assisted with this project in a myriad of ways over the past two years we say a heartfelt and humble Thank You!

ORGANISING COMMITTEE
 John R. Bowen, *Chairman*
 Fiona Davern
 Brian Hodkinson
 Clodagh Lynch
 Michael Lynch
 John McCormack
 Eamonn Noonan
 Jim Noonan
 Conor O'Brien
 Thomas Sinsteden
 Virginia Teehan
 Larry Walsh

Foreword

Eavan Boland opens *Against Love Poetry* (2001) with a poem entitled, *"In Which Hester Bateman, 18th Century English Silversmith, Takes an Irish Commission"* – a poem that introduces several concerns including Irish tradition and the arts. Hester Bateman, we learn, "made a marriage spoon/And then subjected it to violence". After Bateman cools "the sweet colonial metal," a figure of a couple appears on the spoon's handle.

Boland writes:

Here in miniature a man and woman

Emerge beside each other from the earth,

From the deep mine, from the seams of rock

Which made inevitable her craft of hurt.

The spoon, made from silver, has been crafted from mined seams of rock. It has been shaped by the chasing, hammering, scarring and marking that the creation of such a small, yet perfect, thing entails. As this poem depicts the craft binding the silversmith to her spoon, so this exhibition celebrates the craft of Limerick's silversmiths as it evolved over six centuries.

Curating this exhibition has been a joy for The Hunt Museum. In so doing, we have depended upon not only dedicated and insightful staff, scholars, and enthusiastic lenders, but also a wider internationally based community of supportive individuals and friends who demonstrated faith in and support for our work. The belief of those individuals and companies in the importance of supporting and underwriting our activities is impressive and much appreciated.

Virginia Teehan
Director

Sponsor's Preface

My colleagues and I at the Bowen Group are proud and delighted to be associated with the sponsorship of this unique exhibition *"A Celebration of Limerick's Silver"* of which this catalogue will be an enduring legacy. Limerick has a fine tradition of silver and gold and it is indeed very satisfying to display and interpret the work of generations of talented craftspeople, and to bring to modern audiences an appreciation of their abilities and artistry.

Silver is an exciting lens through which to look at history. Limerick is an historic place and its silversmiths and allied trades have lived through that history, turning out their wares in bad times and in good, right down to today. Limerick's goldsmiths and silversmiths fashioned marvellous items for the medieval church. They were witnesses to the great sieges of 1690 and 1691. They catered for increasingly affluent tastes in Georgian times and they witnessed the near decimation of their trade following the Act of Union. Indeed, these craftspeople reflect the history of their times in a way that endures and inspires!

This exhibition is not just about silver and gold objects actually made in Limerick, it is also about items in silver and gold connected with Limerick. Thus we appreciate the sporting achievements of generations of Limerick's sons and daughters, and the trophies they brought home subsequent to their conquering exploits in contests far and near.

It has been an immense personal pleasure for me to work on this project.

John R. Bowen
Chairman & Chief Executive
The Bowen Group

Silver and Gold: An Introduction

Silver has many properties which have made it attractive to man since the earliest days of metallurgy. It is the most reflective metal known, and consequently became a favoured material for ornamental objects. With the exception of gold, it is the most malleable and ductile metal, a property that enabled utilitarian objects to be wrought from it, and vessels made in silver (and gold) are known to have been made in Asia Minor as early as the middle of the third millennium BC.

In its pure state, silver is too soft to use in objects subject to everyday wear and tear. This drawback is overcome by fusing it with a certain proportion of another metal, usually copper, thereby obtaining an alloy of the desired hardness and working qualities. Until recently in Ireland and Britain it was obligatory for the alloy to contain not less than 92.5% pure silver; this being known as the 'sterling standard', a name derived from the eleventh-century English penny.

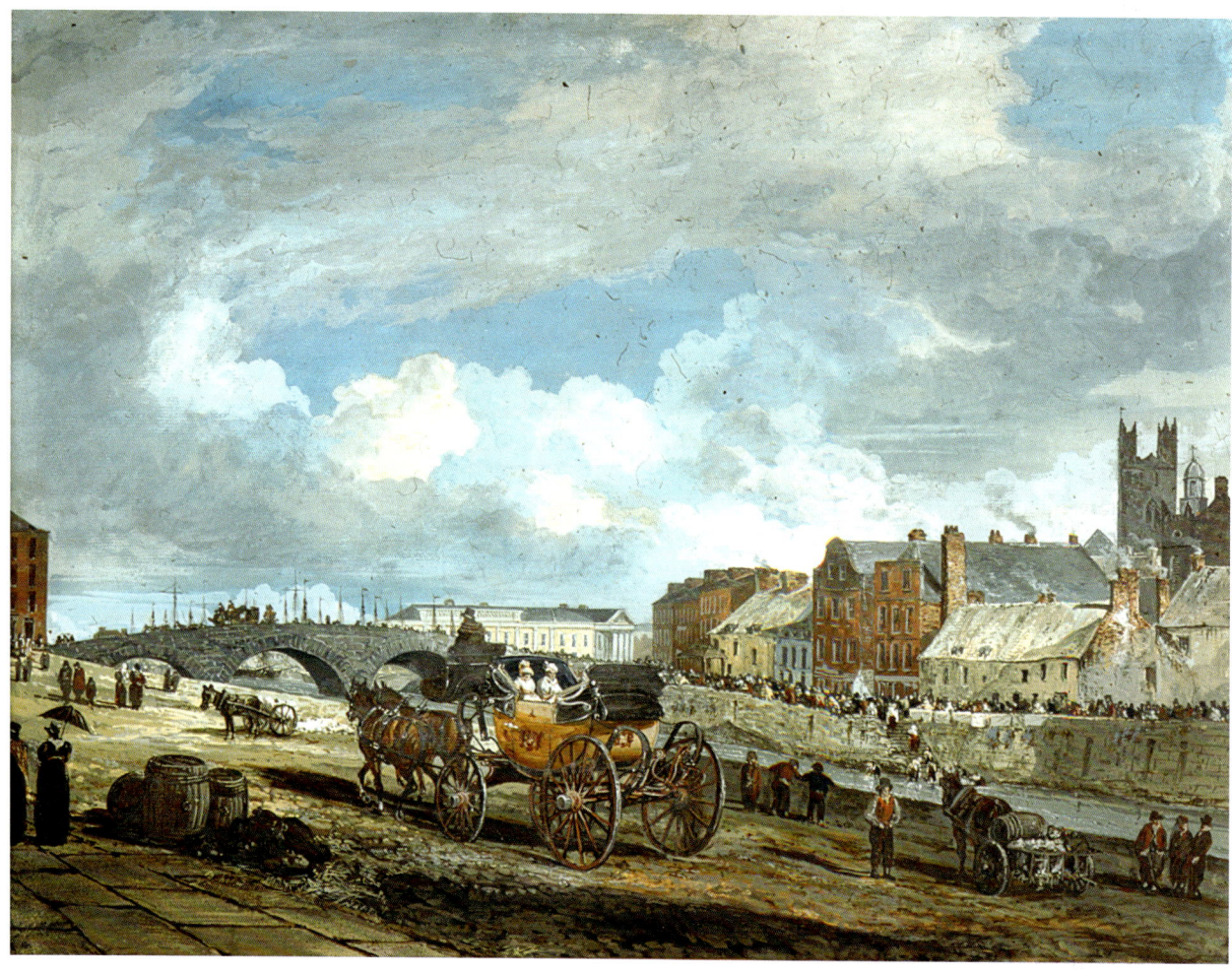

Plate 1 *William Turner de Lond, fl. c. 1820. A View of Limerick, c. 1837.* Collection of the Knight of Glin

Until modern times there had been an intimate relationship between silver and gold, termed the precious metals, and the currencies of most European countries. The value of a given coin depended on its intrinsic precious metal content. In the days before banks became commonplace, a person's store of plate (i.e., objects made from gold or silver) represented in many cases a substantial portion of his or her liquid assets. This was so because plate was interchangeable with coin, the value being determined by the weight of the objects, with little or no consideration given to the workmanship. The ready convertibility of plate to coinage led to minimum standards of purity of the alloys used in goldsmiths' wares being established by law. Thus began the earliest system of consumer protection – hallmarking.

HALLMARKING

In order to protect customers from unscrupulous craftsmen using excessive quantities of cheaper base metals in gold and silver wares, a statute was passed in England in 1300 forbidding goldsmiths to make objects of gold or silver "except it be of the true alloy, that is to say gold of a certain touch, and silver of the sterling alloy … and that no vessel of silver depart out of the hands of the workers, until further, that it be marked with the leopard's head; and that they work no worse gold than the touch of Paris."

Even up to the present day, the application of certain prescribed marks on approved items of plate is performed in the goldsmiths' guildhall, and thus the term 'hallmark', denoting quality, entered the language. Translated to modern terminology, the 'touch of Paris' represents gold of 80% purity (19.2 carats), a standard lowered to 75% (18 carats) in 1478, and raised in 1576 to 91.67% (22 carats), at which level it remained until 1798. Since then certain permissible lower standards of fineness for gold have been authorised from time to time, the lowest now being 9 carat, equivalent to a fineness of 375 parts gold in 1,000 parts of alloy.

In the case of articles wrought in silver, as pointed out above, the 'sterling' standard defined so many years ago is 925 parts pure silver in 1,000 parts of alloy i.e., 92.5% fineness. Since December 2001 it has become permissible in Ireland to market silver articles of as low as 80% fineness.

Whilst modified many times over the intervening centuries it is the basic principles enshrined in that particular statute of 1300 that still control the hallmarking, and ultimately the sale of precious metal wares in Ireland and Britain to the present time. It may be said to have given the language such expressions as 'good as gold', 'sterling standard', 'hallmark quality' and such like.

Plate 2
Touchstone by Thomas Burke, Limerick c. 1785
Exhibit 7.03

The early methods used to measure, or 'assay', the precious metal content, or 'fineness' of alloys, involved rubbing the article to be tested on a finely-grained hard black stone known as a 'touchstone'. By comparing the colour of the resulting streak with a range of corresponding rubbings made on the stone by rods of known composition, termed touch needles, a trained eye could estimate the fineness of the test subject with a reasonable degree of accuracy. Within the craft the word 'touch' came to be used both as noun and verb, the former denoting conformity with standard, and the latter the actual assaying operation. More sophisticated and scientifically advanced methods of assay have been adopted in the intervening centuries.

THE POSITION IN IRELAND

Hallmarking as we know it was introduced to Ireland in 1637 when, following vigorous complaints about the deceitful practices of goldsmiths there, a royal charter granted by Charles I established a body incorporated by the name of 'The Wardens and Company of Goldsmiths of our said City of Dublin' to control the craft in the whole of Ireland. The charter envisaged that the Dublin Company should have the same rights and powers as the ancient London Company of Goldsmiths. The same standards of fineness as applied in England were set and an assay office was established in Dublin where conforming wares were to be stamped with 'The King's Majesty Stamp called the Harp Crowned'. A mandatory second stamp, termed the goldsmith's 'proper' mark, was one identifying the maker of the item; this was normally the goldsmith's initials. Following the London practice, to ensure accountability of the assayer a further mark adopted by the Dublin Company was a code identifying the year of assay. This consisted of a letter of the alphabet, alterations to the design of the letter or shape of the surrounding shield differentiating one cycle of the alphabet from another. From time to time in the intervening years further hallmarks were introduced such as those indicating the payment of excise duties, or others commemorating notable anniversaries. The Dublin Assay Office commenced operations on 6 April 1638 and has continued its consumer protection role in Ireland to the present day. It is located at Dublin Castle.

Whilst the Dublin Company was empowered to seek out corrupt practices amongst goldsmiths countrywide, the charter concentrated on the craft as practised within three miles of the city of Dublin. Goldsmiths working in provincial centres were obliged to observe the same ordinances as applied in Dublin but the charter was somewhat vague as to specifics, merely stating in the convoluted legal language of the time, that one or two men from provincial goldsmithing centres should "draw near to ... Dublin, to know the science of the said mystery [i.e., the craft], and there to ask and seek for the same, their touch of gold and silver and also their punch – namely a harp crowned – to mark denote and impress their works and wares and every of them within the same, as of old it was accustomed and ordained within our city of London." There is no evidence that any goldsmiths in Limerick (or for that matter other provincial centres) ever adopted this provision of the charter.

Plate 3
An example of Dublin hallmarks for 1981

Plate 4
An example of Dublin hallmarks for 2005

The Goldsmiths' Craft in Limerick: An Overview

The numerous finds in the Shannon estuary area of objects of gold dating to prehistoric times attest to the long history of the goldsmith's craft in this part of Ireland. Of the numerous gold gorgets or collar ornaments found in the region, perhaps the best known is that discovered in 1932 near Gleninsheen, Co. Clare, dating to around 700 BC. The area has yielded many artefacts dating from the Christian era, of which the most famous is the Ardagh chalice. This is an exquisite masterpiece of the metalsmith's craft, incorporating gold, silver and bronze, and dating to around 800 AD. It was found as part of a hoard of two chalices and four brooches by two men digging potatoes in a ring-fort near Ardagh, Co. Limerick, in 1868. It was last exhibited in Limerick during a Holy Year exhibition in 1950 when the Souvenir Catalogue proudly proclaimed 'Limerick men and women will recall with pride this occasion on which the Ardagh Chalice returns for a brief space to the county of its origin'.

Whilst not proof positive, the relatively high incidence of such finds in the lower Shannon basin would suggest that many of them had actually been made locally, the products of local craftsmen. We have virtually no knowledge of who these early craftsmen were or where and how they learned their craft.

We have to move forward to the fifteenth century before we find outstanding examples of a local goldsmith's work where the creator can be identified. These are the mitre and crosier made for Conor O'Dea, Bishop of Limerick, from 1400 to 1426. They are in the possession of the bishop's successor and are held by The Hunt Museum on loan. The mitre was made in 1418 and bears the signature of its craftsman, Thomas O'Carryd. The silver gilt crosier was made in the same year for Bishop O'Dea and while it does not bear the craftsman's signature, it was most likely also made by O'Carryd.

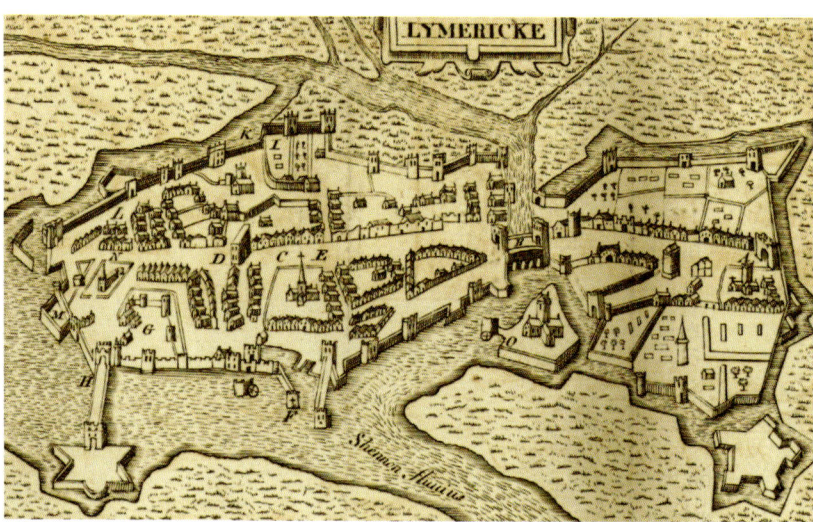

Plate 5
17th century map of Limerick.
John Speed

12

The aftermath of the Reformation and the spoliation of the monasteries which commenced in 1579 following the failure of the Second Desmond Rebellion created difficulties for the survival of the craft, since religious communities had been amongst the goldsmiths' principal patrons. In spite of this some of the traditional goldsmith families managed to survive. Before the mid-1600s it was not the custom of Irish goldsmiths to stamp their wares with an identifying mark, as was the case in Britain and the Continent. This creates difficulties in identifying plate from the Tudor period. However, some managed to record their names for posterity by inscribing them on their works. One such is Philip Lyles who in 1625 inscribed the Arthur Cross *Phi Lyles fecit.*

Plate 6
Philip Lyles' name inscribed on The Arthur Cross

This was at a time when there was little or no standardisation in the spelling of names, but we feel justified in suggesting that Philip was one of a hereditary family of goldsmiths bearing anglicised variants of the Gaelic name Laighléis, trying to eke out a living in the towns of Munster as journeymen goldsmiths. Variants of that family name, such as Lawless and Lillis, occur in the context of goldsmithing in disparate records. The Lawless or Lillis name had long been prominent in Limerick. A Philip Lawless was sheriff in 1403 and again in 1413. Others of those surname variants held office as sheriff and mayor of Limerick during the seventeenth century, and probably numbered some goldsmiths amongst their extended families.

Another local goldsmith of the period to have autographed his work in a similar fashion was Richard Fennell, inscribing some chalices he made in the 1670s *Rickardus Fennell fecit.* These craftsmen are known to history but only by their names. We know nothing at this point of how, when, or where they learned their craft. It is reasonable to assume that there were many more goldsmiths working in Limerick and other provincial centres in these earlier centuries, producing exceptionally fine examples of their craft, but sadly, even their names are lost to history.

Plate 7
Richard Fennell's name inscribed on the foot of a chalice

THE SEVENTEENTH CENTURY

We are on firmer ground when it comes to the post-Cromwellian period. We learn from the Orrery archives of the Earl of Orrery's efforts to revive trade and industry in Limerick in the 1660s. The name of John Bucknor, goldsmith, crops up in Orrery's accounts at this time and it was probably the same Orrery who encouraged Bucknor to establish himself as a goldsmith in Limerick. Judging by the small corpus of Bucknor's work that survives, he was a very fine and well-trained craftsman, about whom we hope silver historians will discover more. A surprise find in the course of

Plate 8
Maker's mark of John Bucknor

mounting this exhibition was a communion cup presented to the Parish Church of Clonallen, near Warrenpoint, Co. Down, by Viscount Dungannon in 1704 (Exhibit 1.21a). It bears John Bucknor's maker's mark, which dates it to c. 1665.

The discovery of a Limerick-made piece of plate belonging to a distant Ulster church aroused curiosity as to how it arrived there. No documentary record to explain the circumstances survives. The donor of the cup, according to the inscription it bears, was Lord Dungannon. He died in Spain in November 1706, aged 37. It could not therefore have been Dungannon himself who commissioned the piece from Bucknor. However, his father might well have done so.

Dungannon's father, Marcus Trevor, was ennobled as the first Viscount Dungannon in 1662. He held several prestigious State offices; he was appointed Governor of Ulster in 1664 and Marshal of the Irish Army in 1667. He died in 1669 at Dundalk, aged 51. We may presume that, as holder of high office, the first Dungannon would have been well acquainted with Lord Orrery, Lord President of Munster and Major-General of the Army. We can therefore speculate that it was through Orrery's patronage that Bucknor secured the Dungannon commission.

In the post-Cromwellian era the goldsmiths' craft began to develop rapidly and to prosper in Limerick. The standard of workmanship of the surviving plate is generally impressive, though with the exception of church plate, too few items have been located to enable informed judgements about the existence of specific regional characteristics or design details.

THE EIGHTEENTH CENTURY

This exhibition demonstrates that the same high standards of workmanship were maintained by Limerick goldsmiths throughout the later seventeenth century and most of the eighteenth. These standards are evidenced in particular by the work of Joseph Johns, amongst others. Other craftsmen such as Jonathan Buck; Collins Brehon; George Moore; Maurice, Garrett and William Fitzgerald, to name but a few, produced a large range of items, which consistently equalled in quality, that of Dublin work of the period. Limerick recovered well from the disaster of the two Williamite sieges and throughout the peaceful eighteenth century, it prospered and expanded. The city's prosperity provided the demand for wrought plate which sustained the goldsmith's craft.

In the later part of the eighteenth century a number of Limerick's goldsmiths appear less ambitious about the work they were prepared to undertake

personally, preferring to meet their customers' more demanding requirements with goods obtained from Dublin and England, whilst confining locally-made produce largely to flatware and similar wares that did not involve the more complex skills, such as casting and chasing.

THE NINETEENTH CENTURY

By the early nineteenth century the craft in Limerick appears to have gone into decline. The reasons for this are several, including the free trade consequences of the Act of Union, and the inability of the artisan goldsmiths to compete on price with the industrial-scale production of similar wares in England. Another reason was the relative decline in economic activity in the country following the end of the Napoleonic Wars and the associated large demand for meat and cereals to feed huge armies and navies, a demand that to all intents and purposes went back to the American War of Independence (1775-83). Nonetheless some makers such as Robert O'Shaughnessy, Matthew Walsh and Samuel Purdon, amongst others, attempted to survive, in many cases their wares exhibiting a marked decline in quality from that obtaining earlier.

There was little if any plate wrought in Limerick during the later nineteenth century, with the term goldsmith coming more and more to signify a retailer of such goods rather than an artisan practising ancient skills.

THE MODERN ERA

A revival of interest in Limerick-wrought plate occurred in the late 1950s when a group of local entrepreneurs came together and established the firm of Cosmacs Limited for the production of silver wares. However, the times were not propitious for such a venture, and the firm ceased operations some short few years later.

More encouraging developments occurred later in the century with the establishment of schools and centres in Ireland, where the craft was taught to dedicated students, many Limerick-born. To these young and gifted artist-silversmiths we look for a transformation in public attitudes to precious metal wares. We hope for the day when sports organisations will tire of reproduction two-handled cups and such like as trophies, and instead award commissions to young artist craftsmen and women to create original works using traditional methods, that honestly and capably reflect contemporary design.

THE GOLDSMITHS' CRAFT IN LIMERICK: AN OVERVIEW

THE MARKS ON LIMERICK SILVER

Distance from Dublin, and the attendant risks of sending valuable goods by roads infested with highwaymen, militated against Limerick's goldsmiths submitting their wares to the Dublin Assay Office. We know from the records in the Assay Office that some Limerick goldsmiths did so, on occasion. However, the general practice was to stamp their work locally with devices suggestive of official approval. Thus we find a castle gateway in combination with a six or eight-rayed star stamped on wares in the later seventeenth century. The castle gateway is thought to have been inspired by the arms of the city itself but the significance of the star-form device remains obscure. From about 1710 onwards these devices gave way to the mark STERLING or variations such as STER and STARLING denoting that the metal was of the legally prescribed fineness. Thus the goldsmiths put forward their own names and reputations as the equivalent of a personal warranty.

For some decades after about 1720 a number of Limerick goldsmiths used a maker's punch composed of a lion rampant between their initials. The lion rampant is a prominent feature on the city maces. Later in the century others incorporated an unsanctioned variation of the official Harp Crowned in their marks, again presumably intended to imply official endorsement. This practice had been outlawed by an order promulgated in 1731 by the Company of Goldsmiths of Dublin forbidding the use of such ornamental devices in makers' punches. Given the continuation of the practice in Limerick, it would seem the Dublin Company's attitude towards their Limerick brethren was rather benign.

Plate 9
IJ flanking a lion rampant in an irregular punch - the mark of Joseph Johns

Plate 10
The engrailed oblong punch of George Moore together with STARLING

Plate 11
A Limerick 'Town Mark' - a star on a chalice by James Robinson

Plate 9

Plate 10

Plate 11

16

CHALLENGES FOR HISTORIANS

It is our earnest hope that this exhibition will arouse an increased interest in the history of Limerick silver, and stimulate further research. Quite a few questions remain unsolved. While theories abound, we don't know the precise significance of the so-called 'town mark' of a star. Neither do we know why a number of Limerick goldsmiths incorporated a lion rampant in their maker's mark, nor why a plume of feathers as a decorative feature on flatware was so popular in Limerick, nor what is the significance of the trefoil device found stamped on the back of much Limerick flatware around 1800, nor how or why the State tolerated the manifest evasion by the Limerick goldsmiths of the duty imposed on plate in 1730.

During the preparation of, and research for this exhibition, the names of a number of Limerick goldsmiths, previously unheard of, came to light. It is hoped that future collectors and connoisseurs of Limerick silver will discover more about their origins and and succeed in identifying their makers' marks, thus allowing their works to be accurately catalogued. Admittedly, this will be difficult in the case of contemporaneous goldsmiths bearing the same initials, such as John Calbeck, John Cherry, James Collopy and John Cullum. Unravelling such puzzles makes Limerick silver a fascinating, challenging and satisfying field of study.

Plate 12
Maker's mark of Thomas Burke with STERLING incuse and the trefoil device found in Limerick flatware around 1800

Goldsmiths and Limerick City, 1640-1840

Jennifer Moore

The craft of the goldsmith is an ancient one, existing as it has done for many centuries as a core competence within a civilised society. In this regard Limerick is no different to other Irish cities and large towns. As theirs was regarded as a pre-eminent craft, many goldsmiths enjoyed prominent positions in Limerick society, and frequently held civic office. By the very nature of their work and the clientele they interacted with, they were exposed to lucrative opportunities.

They were never very numerous and in 1769, for example, there were just ten goldsmiths and their allied trades in Limerick city compared with fifty-two grocers or twenty shoemakers.[1] Limerick's goldsmiths served a market that was for practical purposes, entirely local, and their wares were not essential items for living; rather, they were at the luxury, or discretionary, end of the spectrum. As such, demand for goldsmiths' wares was to a large extent correlated with the economic circumstances of the region at any given time. Owing to the nature of a trade that worked with precious metals, and had a payment system based on extensive credit terms, some goldsmiths felt obliged to change their occupation to a less financially onerous one. Others, at times of reduced local demand, moved to another location where there was perceived to be more demand and possibly less competition. A few ultimately went bankrupt.

Within the goldsmiths' craft a hierarchy evolved, since it was desirable for some to cultivate strong links with the Corporation for commissioned work, and to attract affluent patrons with the resources to indulge in some of the more luxurious items that became status symbols in the late seventeenth and eighteenth centuries.

EARLY SILVER

Limerick's first successful settlement was established by the Danes in the ninth century. They navigated up the Shannon estuary and established a community on a well-protected island surrounded by fertile lands. As the colony expanded various trades evolved to encompass a vibrant and prosperous society. Goldsmiths, silversmiths and their allied trades have had a long history in Limerick city and its hinterland.[2] Necessities such as a mint required skilled labour and was an essential component of the city. An Anglo-Norman mint operated in Limerick as early as c. 1196-98.[3] While documentary evidence is slim, some early silver objects such as the Ardagh chalice may have been made in the Limerick or lower Shannon region.[4] A mitre made for Bishop Conor O'Dea of Limerick in 1418 was engraved *'Thomas O'Carryd, artifex faciens'* by its maker. It suggests the probability that O'Carryd was a Limerick goldsmith.[5]

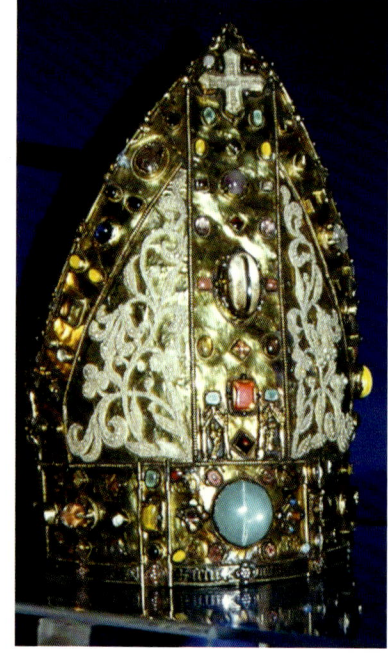

Plate 13
Mitre made for Bishop Conor O'Dea by Thomas O'Carryd, Limerick, 1418

SOURCING SILVER AND GOLD

The source of their raw materials was always an important consideration for goldsmiths. Gold and silver coin was often melted down and, likewise, damaged and unfashionable plate was recycled through the melting pot. In the case of Limerick, however, the city's proximity to Silvermines, fifteen miles to the North West, meant a steady supply of silver was available for the goldsmiths of the area. Silver was mined there from at least 3 May 1289.[6] Gold, zinc and copper were also found in the area and on the banks of the Mulcair River. It is unknown if the mines were active in the fifteenth and sixteenth centuries, but they were rediscovered by the new settlers in the 1620s. Up to five pounds of silver was found per ton of lead extracted from the mines. The activity was such that the population in the area exceeded that of Nenagh and it was on the main route to Dublin. In the first half of the seventeenth century, refined silver from the mines was sold in Dublin for 5s 2d sterling per ounce and lead was sold for £11 sterling the ton or £12 at Limerick. There was a power struggle for ownership of the mines. The output and the high profits made by the farmers of the mines became known, and they were therefore declared Royal Mine, thereby ensuring the Exchequer obtained a share of the profits. Prior to the 1641 Rebellion it was estimated that the mines profited £2,000 after the king's share of £800. The area would have seemed industrious to passers-by with many refining houses, mills and a workhouse all surrounding the mines. However, in the year following the Rebellion, between fourteen and thirty-two Protestant farmers, their wives and children were murdered. It was estimated in a petition to parliament that the present owners had lost £10,000 worth of resources from the mines. By the 1660s the mines had recovered and it was estimated that they supported five hundred Englishmen, though this figure may have been exaggerated.[7] In 1769 'fine bullion silver at 6s 3d per ounce' from Silvermines, as well as lead made up in various forms, was being advertised.[8]

Despite the proximity of the silver mines, few pieces of Limerick-made plate are extant for the medieval and early modern period. However, it has now been estimated that one hundred and sixteen goldsmiths and allied craftsmen traded in the city from earliest records up to 1900.[9] The majority of these were active in the period 1740 to 1800, when the city enjoyed economic growth and a surge in population, lower taxes and regulation of the provincial trade.[10] Eighteenth-century Ireland was, on the whole, a prosperous century for the gold and silver trade. A reflection of the growth can be seen in the amount of silver submitted for hallmarking to the Dublin Assay Office. The quantity expanded from 26,000 ounces in 1700, to 60,000 in 1720, 80,000 in 1788 and 100,000 in 1800, before it declined in the post-Union period when only 6,000 ounces were assayed in 1835.[11]

GROWTH OF CITY AND FUNCTIONING OF GUILDS

For the purpose of understanding the position that goldsmiths held in society, it is necessary to discern the economic and political climate in which they operated. From Limerick's initial charter in 1197 to 1840, fourteen subsequent charters expanded the governing body of the city and the trade within it.[12] The position of the city on the Shannon surrounded by a rich hinterland ranked Limerick the third trading city c. 1600 in Ireland behind those of Dublin and Cork.[13] In terms of population, by 1706 Limerick also ranked third with a probable population of 11,000, behind Dublin with over 60,000 and Cork with an estimated 25,000 people.[14] Charters were also granted for the formation of various guilds to cater for the different trades that evolved during the medieval period. However, the minute book of the Guild of Masons, 1746-57, is the only surviving one.[15]

Governance of cities and corporate towns was carried out by a number of organisations which were essentially the dominant groups, or 'corporations', in the various aspects of city life. The municipal Corporation governed the city, with corporations or guilds of craftsmen regulating their respective trades. Members admitted had the exclusive right to practise a craft or trade within the city limits. It was therefore essential for any craftsman or woman to become a brother or sister of a guild. As both the population and demands of city trade increased, so too did the numbers of merchants and members of the craft guilds. Each guild received a charter outlining the rules and regulations by which it was to operate. A guild was normally headed by a Master elected annually, two Wardens appointed by the Master, and had an unlimited number of brethren and sisters. These guilds met quarterly at Michaelmas, Christmas, Easter and Midsummer. They managed their own finances and although some of the wealthier guilds in the country owned their own property, there is no record of any Limerick guild holding any property for the specific purposes of meetings or socialising.[16] Instead they held meetings in inns or public houses and it was customary to admit the proprietor as a freeman of the guild, and consequently it became lucrative to be such a host.[17] Sons of freemen were admitted when they came of age. However, many were allowed to practise their trade before that. Others were required to serve seven years as an apprentice or were admitted by 'grace especial' whereby noteworthy persons were admitted on account of their achievements in society. It was also necessary to become a member of a guild if standing for parliamentary election. The larger guilds were the most prosperous since they acted as pseudo-political parties granting 'grace especial' freedom to the various candidates. The guilds became prominent in the social life of the city, putting on plays and holding pageants, and they brought great colour to the affairs of the city.

As a legal authority, each guild oversaw and could certify a tradesman's work, and could render him disenfranchised. The various guilds of Limerick were under the control of the Merchant of the Staple, the predecessor to the

Chamber of Commerce. They operated as a great trading corporation by buying collectively for the guild members by the shipload and selling at a fixed price. The exclusivity of trade meant that the guilds held a complete monopoly over the commercial economy in the city. They were frequently tempted to abuse this position by raising prices or trading in inferior merchandise. In such cases the Common Council of the municipal Corporation stepped in and imposed fines. In more serious cases the Corporation threatened to open the city's trade to non-guildsmen, which usually resolved the immediate problem of a prohibitive monopoly.

THE GUILD OF SMITHS

Unlike Dublin, there is no record of a specific charter that established a guild of goldsmiths in Limerick. Instead, like Waterford, Youghal and Kilkenny which had a guild or Company of Hammermen from 1577, 1657 and 1687 respectively, Limerick's goldsmiths were incorporated into the Guild of Smiths.[18] This was a reflection of provincial traders where the population did not initially demand a large number of tradesmen and so craftsmen with common interests amalgamated to form more powerful guilds within the corporate town or city. However, there is evidence that the goldsmiths dominated the officer positions in the Guild of Smiths. Freedom certificates were given to new members of a guild, and on one issued in 1741 the guild was referred to as the 'Guild of goldsmiths, blacksmiths etc', indicating primacy of goldsmiths within the guild.[19]

Plate 14
Taken from John Ferrar, An history of the city of Limerick *(Limerick 1767) p101*

Unfortunately for today's historian, most of the minute books of the Corporation went missing during an enquiry into its mismanagement in the early decades of the nineteenth century. More recently, other records went missing when the City Museum moved from the Carnegie Library in the 1940s. Therefore it is not known exactly when the Limerick Guild of Smiths was granted its charter. However, there are clues in some eighteenth-century publications that suggest it was one of the oldest and foremost companies in the city. Civic ceremonies, or public demonstrations of allegiance and power, were occasionally displayed through the medieval tradition of perambulating the boundaries, also known as the riding of the franchises. These originally took place in order to ensure the roads were in good condition and were later extended to maintain urban boundaries against encroaching estates.[20] As the centuries progressed, it became an elaborate pageant and one which would display civic unity and strength within the Corporation and collaboration between the various guilds. There were some notable perambulations in the 1760s and 1770s under the direction of

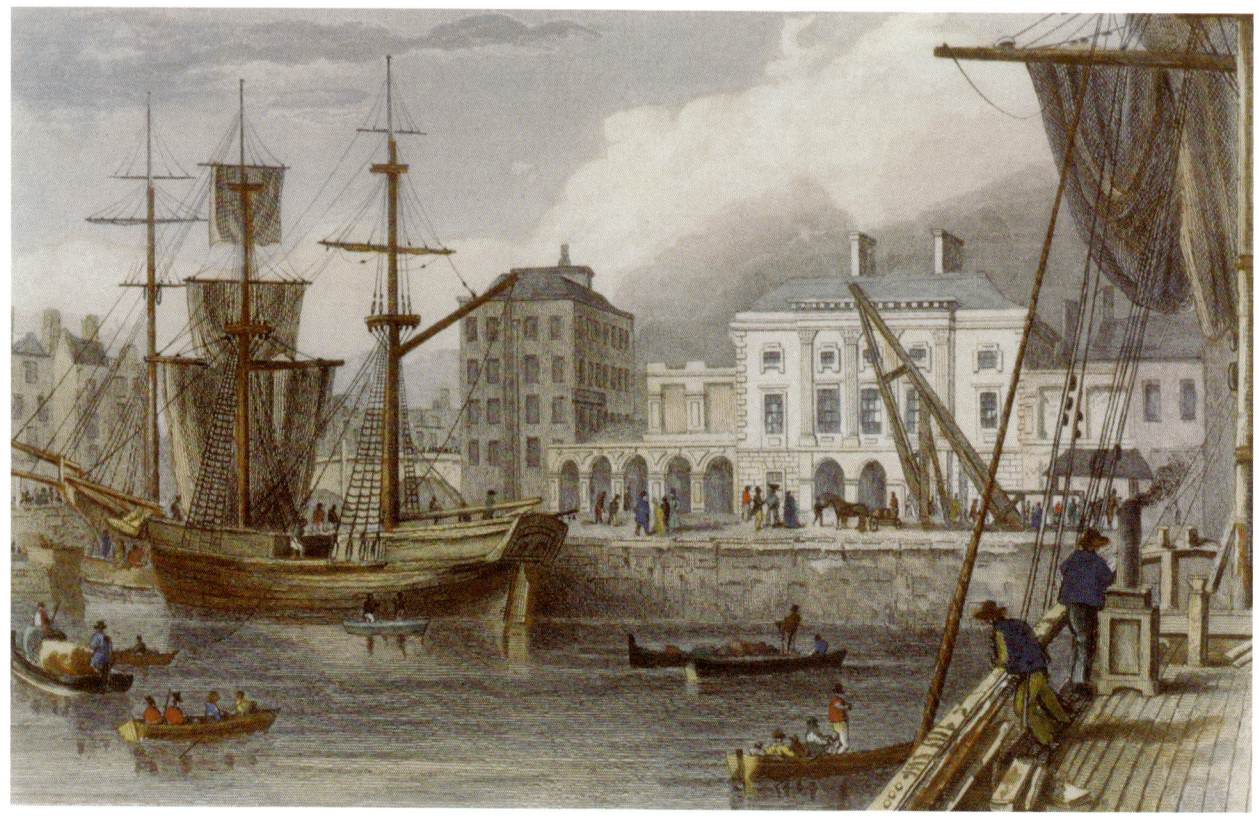

Plate 15
W. H. Bartlett; E. K. Procter,
The Custom House, Limerick
The Hunt Collection

mayor Thomas Smyth which were published by John Ferrar in *An history of the city of Limerick* and in the *Limerick Chronicle*.[21] The first procession took place in July 1765 to lay the foundation stone of the new Customs House (now The Hunt Museum) at Mardyke. The mayor was accompanied by the sheriffs and the fifteen corporations, or guilds, on horseback. They proceeded ceremonially in order of antiquity with the Smiths first, then the Carpenters, Weavers, Shoemakers, etc. The Guild of Tobacconists, granted its charter in 1676,[22] was positioned twelfth, therefore indicating that the Guild of Smiths was granted its charter before that date.

1640-1700: SIEGES AND GOLDSMITHS

As a fortified city, Limerick suffered a number of military assaults during the seventeenth century which had adverse affects not only on the political situation in Ireland, but also stifled the city's economic growth. Prior to 1650, Ireland had little native shipping and most of the trade was carried out by the Dutch. Limerick imported various goods including wine, brandy and tobacco, exporting goods like cattle and hides.[23] The goldsmiths were important components of a working city, providing coinage, domestic ware, jewellery and ceremonial items. They interacted with, and were dependent

upon other craftsmen and merchants within the city for raw materials, trade links and advertising. As such, they also tended to experience the same fortunes as the rest of the tradesmen during the various economic and political fluctuations.

The Cromwellian campaign and the Siege of 1651 had adverse effects on both the Irish merchants and the Old English who had established commercial interests and networks. The 1640s and 1650s had an immediate effect on the economy when Dutch and new English settlers supplanted the Irish and Old English trading within the city walls. This was an especially hard time for the goldsmiths of the city. The Dublin Goldsmiths' Company Assay Office was established by a charter of Charles I in 1637, and formed a national regulatory centre. By this charter, and because of the nature of the precious metals, all gold and silver wares were to be sent to the assay office in Dublin to be tested and subsequently hallmarked to affirm that correct quantities of gold or silver were present in each piece. Shortly after this charter was granted Ireland endured a currency crisis and it was ordered in Dublin that citizens surrender half of their plate to the Assay Office where, under the auspices of the Master and Wardens, it was to be melted down and made available for new coinage to be struck.[24] This is one of the principal reasons why so little domestic silverware survives from before 1640. It has been estimated that only six non-ecclesiastical pieces are extant, five of which are spoons.[25] The Williamite wars and the sieges of 1690 and 1691 also had negative effects on the city's economy. Trade was suspended in 1689 until peace was restored in 1691-2. The warfare also exposed the city to many thieves and it is thought that many items originally wrought in the city were removed from their original owners or melted down.[26]

Contrary to the Dublin Assay Office regulations, many provincial goldsmiths did not send their silver to be assayed in Dublin due to the cost and danger of their goods being stolen. Instead they developed their own distinctive town marks in conjunction with their personal marks, which by the 1660s was either a castle, or a star.[27] The castle either represented the arms of Limerick, King John's castle, or one of the gates leading into the city. There was another coinage shortage in the 1670s and so tokens were struck by merchants of the city to encourage trading. The arms of Limerick were also used on the tokens and were possibly the work of some resident goldsmiths.[28] It has been suggested that the star represented the family arms of the notable citizen Sir Geoffrey Galwey, mayor in 1652, which depicted Baal's Bridge and two stars.[29] The earliest example of these marks occurs on a chalice and paten at Askeaton, dated 1663.[30]

The more common surviving pieces made during the seventeenth century are religious or ceremonial in nature. Some notable chalices and flagons survive from one of the most prominent goldsmith families in seventeenth-century Limerick, the Smiths. The Ennis Chalice, inscribed, 'For Ennis Church 1685',

GOLDSMITHS AND LIMERICK CITY 1640-1840

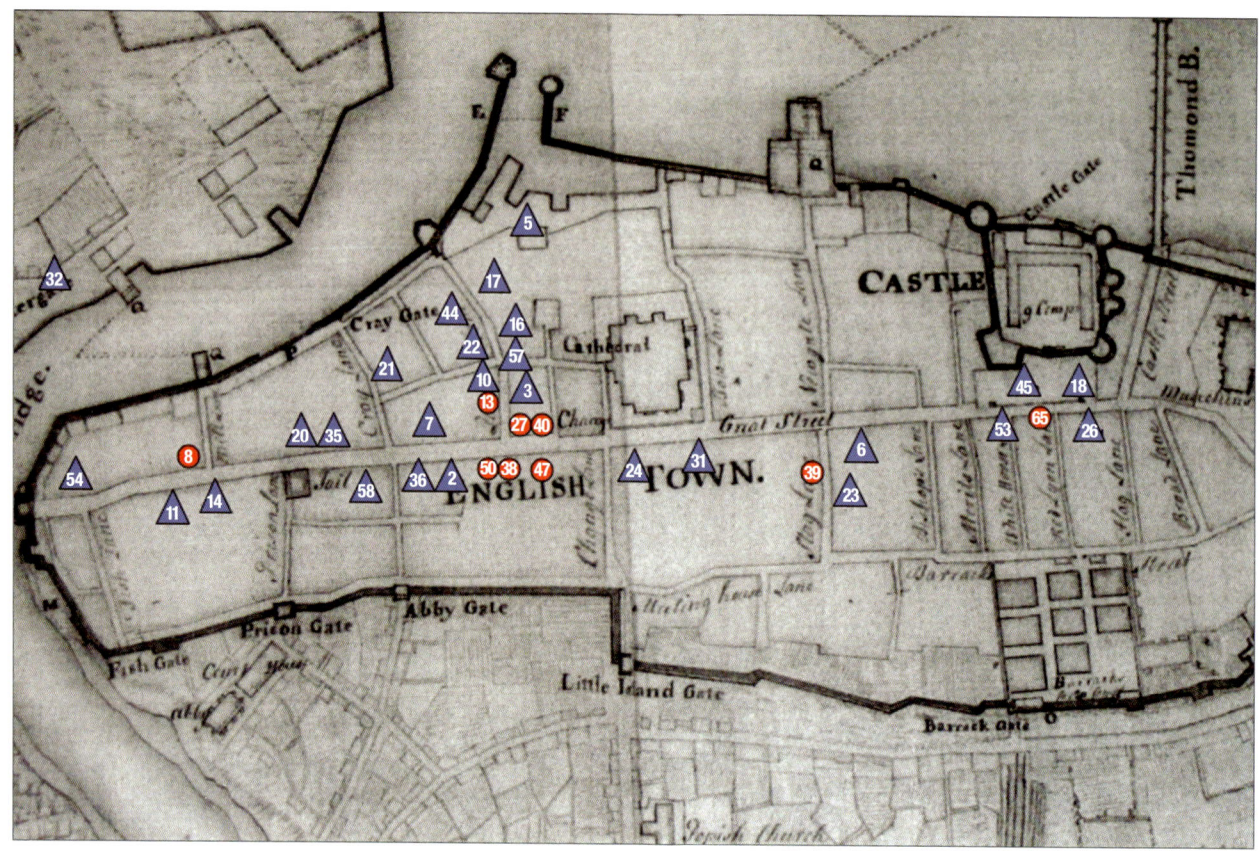

Plates 16 & 17
Location of goldsmiths and allied trades c. 1640-1840,

(top) Englishtown
A colored plan of Limerick... drawn by William Eyre, in 1752
British Library Maps K.Top.54.21

(right) Irishtown and Newtown Pery From John Ferrar's History of Limerick (1787)
University of Limerick Library, Special Collections

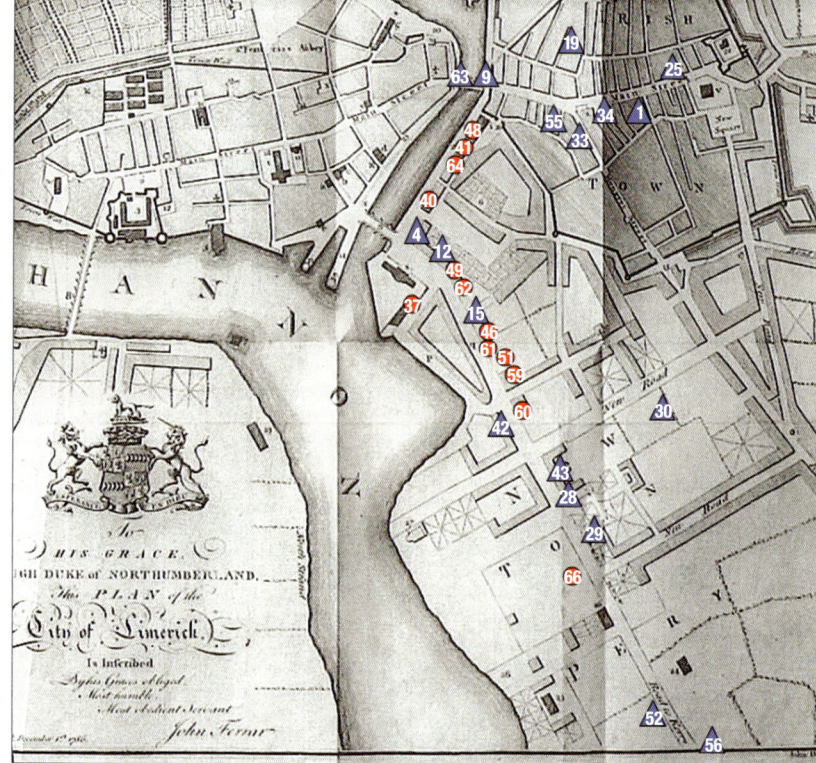

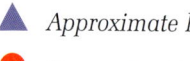
▲ *Approximate location*
● *Known location*

LOCATION OF GOLDSMITHS KEY

In alphabetical order by surname. References are to numbers on the maps.
Note that individual goldsmiths changed location over time and some also took over premises of their colleagues.

1	Bradford, Robert 1770	8	Johns, Samuel 1770 and John Herbert Croan	51	Smith, Henry W. (1) 1830
2	Brush, George 1750			52	Smith, Henry W. (2) 1846
3	Burke, Thomas 1784	28	Knight, Nicholas (1) 1830	51	Smith, Richard W. 1827
6	Calbeck, Samuel 1726	29	Knight, Nicholas (2) 1840	53	Smith, William c. 1660s
4	Carroll, William 1791	30	Laing, John 1846	54	Strit, John 1771
5	Cherry, John 1840	31	Latch, Robert the elder (1) 1768	55	Stritch, Matthew 1788
7	Connell, Patrick 1783	32	Latch, Robert the elder (2) 1771	56	Wallace, Richard 1830
8	Croan, John Herbert 1770 and Samuel Johns	32	Latch, Robert the younger (1) 1768	57	Walsh, Matthew 1784
		31	Latch, Robert the younger (2) 1771	58	Walsh, Philip 1781
9	Cullum, John 1751	33	Lynch, Arthur 1784	41	Walsh, Thomas (1) 1790
10	Downes, Henry 1786	34	Lynch, Robert 1784	59	Walsh, Thomas (2) 1809
11	Fitzgerald, Maurice 1760 (1)	35	Lysaght, Daniel 1780	60	Walsh, Thomas (3) 1812
12	Fitzgerald, Maurice 1815 (2)	36	Martin, George 1788 (1)	61	Walsh, Thomas (4) 1824
13	Fitzgerald, Maurice 1798 (3)	37	Martin, George 1846 (2)	62	Walsh, Thomas (5) 1846
14	Fitzgerald, William (1) 1794	39	Moore, George (1) 1748	63	Ward, William (1) 1798
15	Fitzgerald, William (2) 1800	13	Moore, George (2) 1768	64	Ward, William (2) 1824
16	Gloster, John 1755	40	O'Shaughnessy, Robert (1) 1804	65	Watson, James 1774
17	Goggin, James 1789	41	O'Shaughnessy, Robert (2) 1804	66	Wood, Cornelius 1846
18	Guppy, Alexander 1748	42	O'Shaughnessy, Robert (3) 1805		
38	Halloran (O'Halloran), George 1766	43	O'Shaughnessy, Robert (4) 1842		
19	Harrison, Charles (1) 1741	44	Parker, Philip 1788		
20	Harrison, Charles (2) 1768	45	Parker, William c. 1710		
21	Harrison, Charles (3) 1770	46	Purcell, Charles 1813		
22	Harrison, Charles (4) 1772	46	Purcell, Elizabeth 1821		
23	Harrison, Charles (5) 1782	47	Purcell, John 1787		
24	Harrison, Charles (6) 1786	47	Purcell, John 1820		
25	Hawley, John 1784	48	Purdon, Samuel (1) 1800		
26	Hicks, Randal 1688-c. 1679	49	Purdon, Samuel (2) 1824		
27	Johns, Joseph 1731	50	Ryan, Malachy 1766		

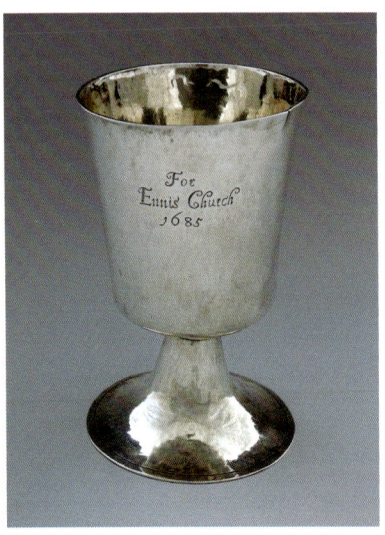

Plate 18
Communion Cup by Robert Smith, Limerick c. 1685
Exhibit 1.04

with the maker's initials 'RS' suggests that Robert Smith was the likely goldsmith.[31] Smith was prominent in civic society and served as sheriff in 1674, a member of the Common Council and mayor in 1685. He was also commissioned to make three silver freedom boxes which were presented to the Earl of Strafford, Thomas Ratcliffe and George Matthews in 1678.[32] He was a much esteemed mayor and was noted to have given the Nail to the Exchange where public business could take place on the pillar. He also

' ... *flagged the city court house, made the jury room ... rebuilt the King's Island Gate, and with his own hand cut on a stone which is over the gate, the following inscription "REAEDIFCATA AN I IACOBI 2di. REGIS ANNO DNI 1685 ROBERTO SMITH PRAETORE."*'[33]

A paten located in Ballintemple, Co. Tipperary, also has marks which suggest it was made in Limerick. They consist of a castle gateway and an eight-pointed star, along with the stamp 'IR' in monogram, albeit much worn, pointing to James Robinson, another prominent goldsmith from the city.[34] Robinson crafted the flagon given by Sir Joseph Williamson to St. Mary's Cathedral, possibly around 1680. Williamson had married the widow of Lord Henry O'Brien in 1679 and received the freedom of Limerick, in a silver box, in 1680. Such donations of ecclesiastical silverware testified to the wealth of local benefactors.[35] Robinson served in the high civic offices of sheriff in 1686 and 1691 and was mayor in 1698. There were seven subsequent Robinson goldsmiths working in Limerick until 1775. Although not all were descendants of James Robinson, it is likely that at least five were related and they too enjoyed the civic franchise and positions in the Corporation.[36]

There were at least ten goldsmiths active in Limerick in the period 1650 to 1700 though only three have known locations. John Bucknor, William Smith and Randal Hicks leased premises from the Earl of Orrery in the High Street of Englishtown.[37] As mentioned above, the city had strong trade links with Holland. The driving force behind the Dutch economy in Limerick was the Earl of Orrery. He was Lord President of Munster and was hostile to Catholics and the Irish. Dutch and Flemish artisans, mostly Protestant, were installed in the hope of reviving a depressed economy. Both he and the municipal government of the city remarked that they stimulated trade, especially in the woollen industry. Upwards of forty industrious families were settled in the city. A reflection of this strength was conveyed in the Dutch-influenced architecture which dominated the streets.[38] John Bucknor was on the account books of Orrery and supplied him with a fruit dish, twenty-two trencher plates and two communion cups among other items. He has also been identified as the goldsmith who made a paten for St. Mary's Cathedral c. 1665.[39] However, trade was hampered during the Anglo-Dutch wars in 1652 and 1674 and industry did not develop as it had before.[40] The New Rules which were issued under Royal Charter by Charles II on 13 February 1671 facilitated and encouraged more Protestant merchants and traders to settle in the city.

'all foreigners, strangers and aliens … who are or shall be merchants, traders, artificers, seamen or otherwise skilled and exercised in any mystery … then residing and inhabiting within the city of Limerick, or who should at any time thereafter come into the city with intent and resolution there to inhabit, reside and dwell, should upon his or their reasonable suit or request made, and upon payment down or tender of £20 by way of fine unto the chief magistrate or magistrates and common council … be admitted a freeman thereof … '[41]

Huguenots also settled in Limerick from about 1685 when the toleration of French Protestants enshrined in the Edict of Nantes was revoked and many fled France as émigrés. They brought with them many skills and styles that influenced many trades at this time including silversmithing. The 'Glorious Revolution' in 1688 and the ensuing Williamite campaign in Ireland into the 1690s also had a crippling effect on Limerick's economy.

Another prominent goldsmith family, the Bucks, who may have had Dutch origins, were trading in Limerick towards the end of the century. Adam Buck was granted the freedom of the Dublin Goldsmiths Company in 1690 but had settled in Limerick by 1694. It is possible that he was the son of George Buck, a burgess in Limerick Corporation in 1672-80,[42] and who was suggested by Sir Charles Jackson to have been a goldsmith in Limerick then.[43] It is likely that Adam was apprenticed in Dublin and was one of the few Limerick goldsmiths to submit items to the Assay Office in Dublin. His son Jonathan continued in the tradition, and as a family, traded in Limerick until at least 1743 and permanently relocated to Cork sometime between then and 1755, Jonathan dying in Cork in 1762.

LIMERICK POLITICS 1700-1740

The success of many goldsmiths, and indeed most trades, depended on the networks they formed. Those aligned with the city Corporation tended to succeed in the trade, receiving commissions and elevating their own social status in the process. Political stances often played a role in the rise or fall of a goldsmith. The eighteenth century saw a marked change in the constitution of municipal government. The turbulent decades of the seventeenth century had two main outcomes that affected the economy in Ireland. First, many Orange, or Williamite oligarchies were placed in the influential positions on municipal corporations, thus displacing the patriciate families. Secondly, the introduction of the Penal Laws prohibited Catholics and Dissenters from becoming full members of guilds, consequently excluding them from contributing to, and benefiting from, the local economy. Given the high proportion of the population which was Catholic, and the penal stipulations of payment into any trade as a quarter brother, trade suffered.[44] The Orange Roche family headed the Corporation coterie that controlled the city in the first half of the eighteenth century.[45] In order to understand the conditions under which goldsmiths worked and some of the items that were wrought, it is necessary to understand the political climate in the city at the time.

The Roches were placed in power as an oligarchy in order to preserve and create a new loyal Protestant society. The family was headed by Toxeth, or Tock, Roche and his oligarchy was exceptionally anti-Catholic. He turned the Catholics out of the city for three weeks during the Whig and Tory faction fighting with the succession of the Hanoverian monarchy. Ructions in the 1720s temporarily removed power to General Thomas Pearce who was outspoken against their control. The body of freemen, or court d'oyer hundred, were not represented in the municipal Corporation and were unhappy with increased tolls and taxes.[46] Goldsmiths took different sides in the dispute. Some were unhappy with taxes and the others wanted to be aligned to the new Corporation in order to secure commissions.

1700-1740: GROWTH OF TRADE

There were approximately fourteen goldsmiths (and allied trades) engaged in business in Limerick from 1700 to 1740. Only four have a known location, three of whom resided in Englishtown and one, William Cherry, in the liberties of the city at Caherdavin. There was a general economic turndown in the 1720s due to a series of crop failures that affected all aspects of society. It is difficult to ascertain how vibrant Limerick's trade was as only a few sent their work to Dublin to be assayed. The town mark used by Limerick goldsmiths seemed to be a sufficient stamp of quality for the local consumers and many seemed proud to purchase indigenous goods. Both Limerick and Cork goldsmiths often used the stamp 'STERLING' to guarantee their pieces at this time also.

This habit of trade was evident in Limerick from the 1730s when a number of prominent merchants combined to form an *'engagement of traders'*. It was a united front of merchants, shopkeepers and retailers against the rising smuggling trade being carried out in Limerick and the environs. They published their objectives and how they were to police clandestine traders in the *Dublin Evening Post* in 1732 and it was promoted that other traders throughout Ireland should follow their example.[47] The goldsmith, Jonathan Buck (d.1762), son of Adam Buck, was involved in such clandestine activities in 1730 which had him reprimanded by the Revenue Commissioners in the following year. It was alleged that he had purchased silver stolen from the Danish vessel, *The Golden Lyon*. The ship had been stranded off the coast of Kerry with £20,000 worth of silver coin and bullion on board.[48] It was precisely such actions that the 'engagement of traders' set out to halt as it hampered trade within city walls. As the consumer society was expanding, this patriotic turn served as an ample marketing pitch that allowed traders to take full economic advantage of shifting fashions and the rising wealth in society. The patriot movement grew throughout the eighteenth century with organisations such as the Dublin Society, founded to encourage Irish manufacture, and awarding grants as incentives to industrious traders.

FAMILY BUSINESSES AND THEIR PATRONS

The importance of strategic alliance was prominent during the first half of the eighteenth century. The Buck family, for instance, made strategic alliances in terms of trade. Some of the earliest surviving Limerick pieces of the eighteenth century include a communion flagon and a paten c. 1710. In the mid-1720s Jonathan Buck was also commissioned by the prominent county Limerick gentleman, Thady Quin, to make a monstrance for St. John's Church.[49] Jonathan rose in the civil ranks of Limerick society and was made churchwarden from 1727-8. Like his father, he was one of the few goldsmiths to send items to Dublin to be assayed. A cup made by 'Buck of Lymrick' was brought to the Goldsmiths' Hall by Thomas Walker but was deemed to be substandard.[50] He sent another small amount in 1730, but as records are missing for a period after 1730, it is not known if other quantities were sent to Dublin to be touched.[51] Tax of sixpence per ounce was introduced on all silver wrought in Ireland from 30 April 1730. The figure of Hibernia was stamped on all pieces to denote the duty had been paid. This discouraged provincial goldsmiths from submitting their work to the Assay Office. Despite the negative attention Jonathan Buck received from the Revenue Commissioners regarding the stolen silver in 1730, he received a municipal commission from Robert Oliver Jr. between 1733 and 1738 to make the seal for the Corporation of Kilmallock.[52]

The Parker family featured in a number of areas. Both William and Edward Parker were goldsmiths in the 1710s and 1720s and were sons of John Parker, a gunsmith of the city. Another brother, David, was an inn holder in the city where the Guild of Masons held their meetings. Edward was later described as an ale seller and innkeeper. Located in High Street Englishtown, William, the eldest brother, was elected sheriff in 1723 and burgess in 1725. It has been suggested that he was commissioned by the influential Monsell family of Tiervoe, Co. Limerick, to produce, among other items, a sugar bowl made c. 1716-19 engraved with the Monsell armorials.[53] As a respected member of society William was a petty juror in the trial of Thomas Powell of Caherelly for murder.[54] William may also have been a member of the Guild of Masons in 1747.[55] Members of the Parker family continue in the goldsmith and innkeeper occupations and also hold prominent positions in the Corporation throughout the eighteenth century. Many were granted the freedom of the city and some became burgesses of the city; others displayed their allegiance to the city and crown by joining the militia. John Parker was a militia officer as an ensign in 1756. Another Edward Parker was a member of the City of Limerick Volunteers in 1779.[56]

POLITICAL TENDENCIES OF GOLDSMITHS

Aside from the reaction to clandestine trading, the 1731 election was not without incident. It was contested by Charles Smyth, who represented the

old Corporation, and Philip Rawson who joined General Pearce in the upheaval of 1726, subsequently becoming mayor in 1731. A number of votes cast for Rawson were deemed illegal due to claims of papists and non-full freemen voting. Nine goldsmiths cast their vote in a total electorate of 315 freeholders and freemen. Four voted for Rawson, including James Robinson who served as deputy mayor that year, Edward and William Parker and Samuel Hill. The other five who voted for Charles Smyth were Samuel Calbeck and Caleb Colbeck,[57] William Cherry, Jonathan Buck and Joseph Johns. Smyth represented the city in parliament for forty-five years and his family became the dominant members of the Corporation from the 1760s. Joseph Johns, Limerick's most prolific eighteenth-century goldsmith, also became a prominent member of civic society, serving as mayor in 1774.

Those who stood for parliamentary election had to be a member of at least one guild of the city. It became prestigious for guilds to have a member elected to parliament and therefore they would offer freedom to standing candidates. In the by-election of 1741 a freedom certificate granted suggests that the Guild of Smiths was being dominated by the goldsmiths of the city, its name being changed to the *'Guild of goldsmiths, blacksmiths etc.'* Joseph Johns was noted as the master, Joseph Kinsela and George Robinson were wardens and Simon Cowell was clerk. Guilds also played prominent roles in election campaigns for candidates. Several gentlemen contested the by-election including Edmund Sexten Pery. He was admitted to the Guild of Smiths;

'To all Christian people to whom these presents shall come greeting, know ye all that for the great regard and esteem we have for Edmund Sexten Pery Esq. have admitted him free brother of the society of Goldsmiths, blacksmiths, etc., of the city of Limerick, to have and to hold all the franchises and liberties thereunto belonging in full and ample manner ... etc.'[58]

GROWTH OF A CONSUMER SOCIETY

The growth of a consumer society had positive implications for the goldsmiths. Previously it was either a wealthy patron from amongst the gentry, or the Corporation, which offered the most lucrative trade and at whom the goldsmiths aimed their goods. However, during the eighteenth century the middling gentry entered the silver market. The Limerick farmer and agent, Nicholas Peacock, bought both pewter and silver ware. He was given a silver cup by his employer, Mrs Hartstonge, in 1745.[59] It was quite an extravagant gift, but it had become a recognised method of thanking an employee or acquaintance, and thus extended the market for goldsmiths. Tea drinking also warranted the skills of goldsmiths. One's social status was often depicted by the spoons that were used, and the better the quality of the spoons, the higher one ranked in society. Many aspired to this mode and by the 1780s the teaspoon was one of the most common utensils made by

goldsmiths, indicated by the fact that 28,000 were assayed in the Dublin Assay Office in 1788.[60] Such purchases were also seen as investments, both in family heritage if an engraving was made, or as collateral. Silver and gold retained their worth in any form, and could be readily converted to currency if needed.[61] This is this reason why so many goldsmiths acted as bailsmen in the Tholsel court.[62] The diary of Nicholas Peacock also hints at the competition that goldsmiths faced from merchants. He bought six teaspoons from a general merchant and not a silversmith whom he paid in two instalments at the Nail in the Exchange in 1748.[63] Other items such as coffee pots, punch bowls, salt cellars, candlesticks, buckles, butter boats, bread baskets, dish rings, wine labels, snuff boxes, toothpick cases and even pet collars were desired in silver by an increasing number of consumers, which inevitably increased the demands on the trade.

1740-60: REACTION TO CORPORATION CONTROL

The 1740s and 1750s were an unstable time in Limerick city. Frustration was expressed by merchants at the lack of economic growth, lack of investment, and prohibitive tolls and taxes. It had reached the stage that some had stopped tilling in the area.[64] There were a number of complaints against the Corporation. When Arthur Roche was mayor in 1743 he appointed John Vincent to the annual post of town clerk, which he managed to retain for twenty-one years. Together they conducted much of the Corporation business themselves without reference even to the Common Council.

Throughout the decade Roche sustained control of the Common Council and, among other abuses, excluded at least three freemen from the city franchise who had been sheriffs and leased Corporation lands to themselves.[65]

These acts of the Corporation were the final straw for those excluded from the circle. Reverend Charles Massy, Dean of St. Mary's Cathedral, took on the Corporation and called for their accountability to the state of the city and the neglect of the charities in their care. Massy approached Andrew Welsh, the prolific eighteenth-century printer who published his attacks on the Corporation in the *Munster Journal* over the summer months of 1749 and collated them in a pamphlet called 'A collection of resolutions and queries'. Massy rallied wide support, including the influential Edmund Sexten Pery, later Speaker of the Irish House of Commons. A powerful group called the Independent Free Citizens was formed and this proved to be a formidable force in uniting the anti-Corporation faction and removing the Roches from power, promoting trade and expanding the city.[66]

Plates 19 & 20
A selection of Limerick goldsmiths' trade advertisements from the eighteenth century.

Plate 21
Limerick City Mace by John Robinson
Limerick c. 1739
Exhibit 2.04

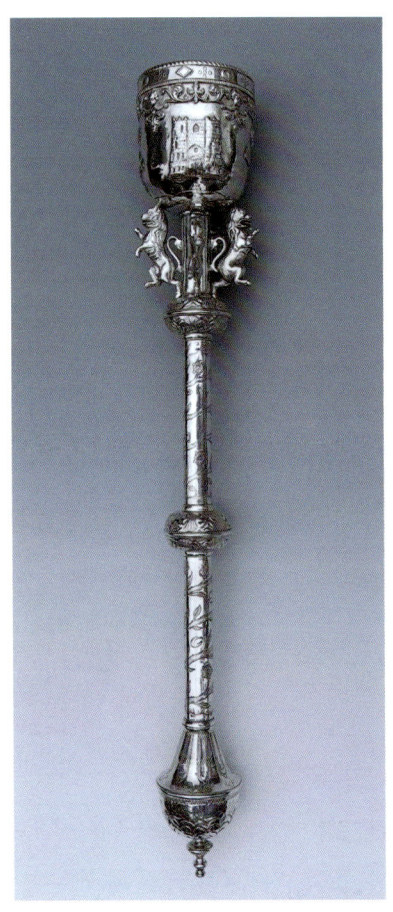

1760-1800: NEW POLITICS, NEW CITY

More important, however, for the development and expansion of the city, was the influence of Edmund Sexten Pery. His family had inherited a substantial amount of land adjacent to the city after the dissolution of the monasteries by Henry VIII. As a member of parliament Pery also introduced a number of bills for improvements to the city during the 1750s. The Perys modernised the city's infrastructure by canalising the Abbey River, building a new quay, a new bridge and a new customs house. The plan was to build a new city in the modern grid system as had been carried out by the Gardiner family in Dublin. These improvements facilitated the city's large extension. In 1761 a parliamentary committee examined the grievances of the Independent Free Citizens and deemed that the Roche family should be removed from the mayoralty.[67] It was a significant point of departure for the city as it symbolised a move into a modern city with a modern economy. Many eligible freemen who had been prevented from receiving the freedom of the city under the Roches were granted the privilege. The walls of the city were taken down and trade was encouraged. The population of the city also grew rapidly from approximately 40,000 in town and suburbs in 1752 to about 85,000 inhabitants in 1817.[68]

Almost three hundred freedoms were granted between March 1746 and October 1771, with seventy-seven being to guild members, four of whom were allied to the goldsmiths in the late 1750s and early 1760s. In the general election of 1761, contested by Edmund Sexten Pery, Charles Smyth and Hugh Dillon Massy, the number of freemen and freeholders had doubled. Of the 770 freeholders and freemen who voted in the election, eighteen were goldsmiths. Because of Pery's commanding position as the local landlord and his successes in parliament, all but twelve freeholders and freemen gave him one of their two votes. The battle for the second city seat was a much tighter contest. Smyth represented the Corporation interests while Massy represented the Independent Free Citizens vote. The goldsmiths were split, with eight voting for Massy and ten for Smyth.[69] Although Massy received more votes overall, the final outcome was overturned by Smyth on appeal. With the Roches no longer in municipal control, the Smyths superseded them for the following sixty years holding the high civic offices. The prominent goldsmith, Joseph Johns, exerted his civic influence and was one of Smyth's supporters. As mentioned previously, he was master of the 'Guild of goldsmiths, blacksmiths etc.' in 1741 and served in various civic offices including church warden of St. Mary's, sheriff, burgess, chamberlain, and mayor. He was commissioned by the Corporation to make a number of freedom boxes including one for the Right Hon. John Earl of Loudon in 1751, Nicholas Bonfoy Esq. in 1755 and in 1769, a gold freedom box presented to the Right Hon. Earl Percy, son of the Duke of Northumberland.[70] He was also treasurer of Masonic Lodge no. 9 in 1769. He had other important connections within the city. His daughter Mary married John Ferrar, author, publisher and printer. Through his newspaper, the *Limerick Chronicle*, Ferrar took a pro-Corporation stance,

A CELEBRATION OF LIMERICK'S SILVER

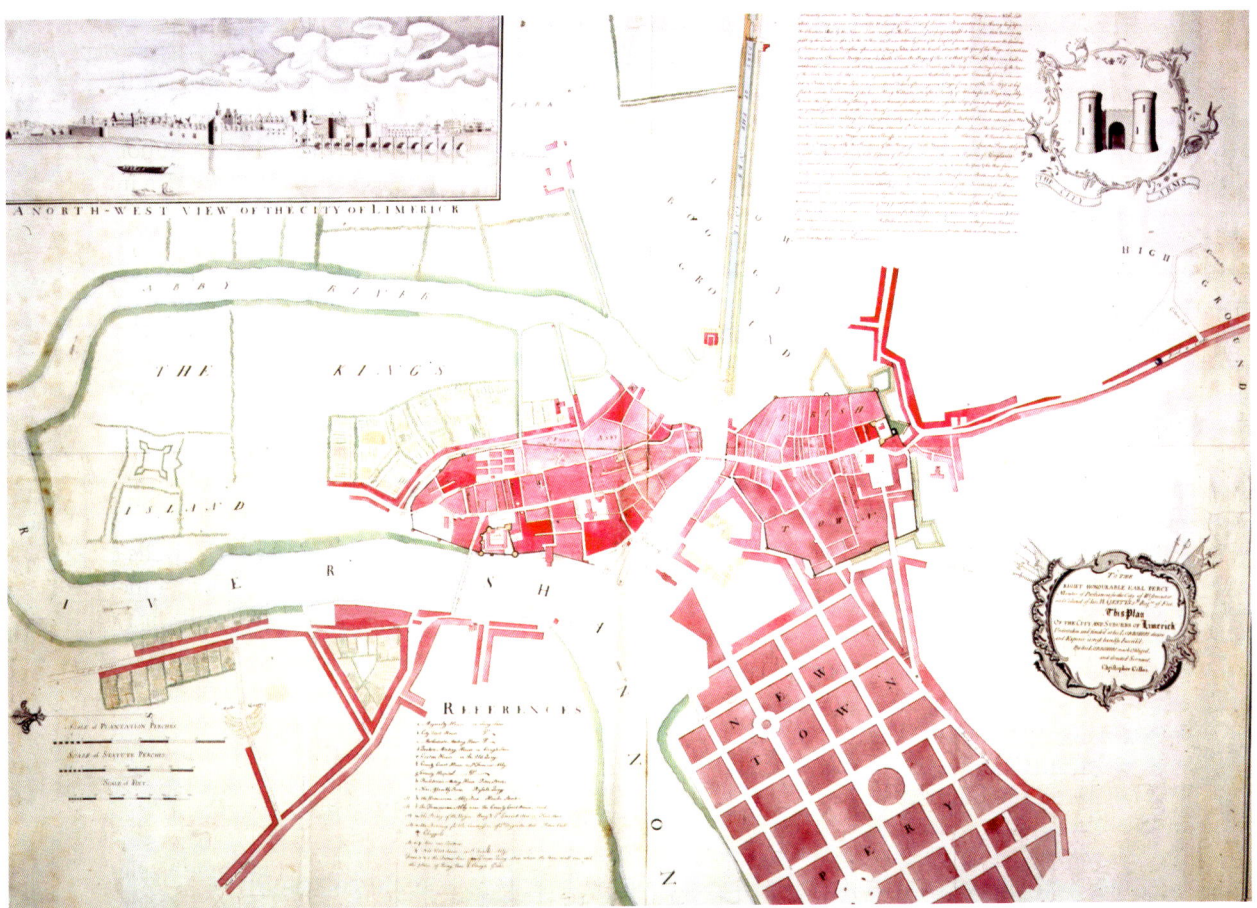

Plate 22
Plan of Limerick, 1769
British Library Add. Ms. 273911E

promoting its ideals and the advance of the city. One of Johns's maker's marks consisted of his initials 'I I' bracketing a lion rampant. In later years there was a fashion for using a plume of ostrich feathers, known as the Prince of Wales feathers, as decoration on spoons and other flatware. It has been suggested that this could identify those who were either in the municipal Corporation, or who had links with it. The Corporation maces, made by John Robinson c. 1739, incorporate lions rampant and fleurs-de-lis as ornamental features. Those who used these symbols were making a public statement showing either their patrons, or whom they supported.

THE RISING CITY – NEWTOWN PERY

The contrast between the early years of the century, when the economy stagnated, and its closing decades of substantial growth can be attributed to two main factors. The early control of the Corporation by the Roches meant that trading conditions were unfavourable to most, and merchants could not practise freely. However, it united those, of many backgrounds, who were not included in the spoils of Corporation booty. Pery offered his land to

merchants who wished to move out of the Corporation jurisdiction. His plan for the city was drawn up by Davis Duckart and Christopher Colles in 1769 and more importantly, was *'free from tythes etc. the situation advantageous, the prospect delightful and the title indisputable'*.[71] The plan was ambiguous and essentially created a new town adjacent to the medieval one.

This area, which later became Newtown Pery, offered the perfect refuge for those who had been subject to inflated tolls and taxes and was governed, not by the Corporation, but by the Parish of St Michael's Vestry. Questions have been raised as to Pery's motives, whether the expansion was for self-promotion or city promotion. Either way, the city was the ultimate benefactor. In the earlier part of the century Limerick lagged behind Dublin, Cork and Waterford, but with the advent of Newtown Pery, Limerick reclaimed her status as an important and desirable commercial centre in Munster. From 1769 to 1800 Limerick's trade increased 157% ahead of Dublin which had increased 100%.[72]

This period marked the most successful time for Limerick goldsmiths. Seventy-four conducted business in one form or other, forty-seven with known addresses. Despite the transferral of many merchants from Englishtown to the tax-free area of Newtown Pery, most goldsmiths remained within the jurisdiction of the Corporation. The most desirable area to trade in was around the Exchange, on Main Street or Quay Lane, as this was where the focus of the city's business was located. The prosperous O'Halloran family survived the implications of the penal legislation and emerged as a successful Catholic family. George O'Halloran (or Halloran), the younger brother of the noted Dr. Sylvester O'Halloran, was a jeweller and goldsmith and resided at the *'Sign of the Golden, Pearl and Ring'* which was next door to the Masons' Coffee house, near the Exchange. Notices appeared regularly in the *Limerick Chronicle* advertising his trips to London and the variety of *'plate, jewels, watches, and rich toys, and he continues to manufacture every article in his way as usual, and has now ready for orders, diamonds of all sorts ...'*[73]

Such a strategic position was desired by many merchants and craftsmen, and there was a tendency for premises to be passed from one member of a trade to another. They would often purchase the tools and equipment already present in the building. This is one of the reasons why goldsmiths were slow to move into Newtown Pery. Samuel Johns was another goldsmith who had Catholic sympathies. He was located at *'Golden Cup'* on the corner of Mill Lane and the Main Street.[74] Despite the name, he does not seem to have been closely related to Joseph Johns. He was warden of the Guilds of Smiths in 1769 and was also a member of the Common Council.[75] He was in business with John Herbert Croan and made watches and clocks in the 1770s before changing businesses due to economic necessity in the 1790s.[76] Samuel advertised regularly in the *Limerick Chronicle* and gave details of the various goods he stocked. John Herbert Croan was apprenticed to another well-known watch and clock makers, Robert Latch, the elder and the

Plate 23
Samuel Johns' trade advertisement.

younger, before going into business with Samuel Johns.

Aside from business generated for domestic ware, there was also a lucrative market for ceremonial wares. The Corporation had a significant outlay for such goods, especially for presentation freedom boxes and Corporation regalia. In the riding of the franchises in 1765, mentioned above, the Silver Oar was carried by Alderman Cripps when the mayor set off on his boat to Scattery Island. These were small silver replicas of oars, given to water bailiffs to denote their office.[77] It was at this island where the mayor, Thomas Smyth, threw a silver dart into the water to declare the jurisdiction of the Corporation. The dart was especially commissioned for this occasion, although it is not known which goldsmith made it. There was a description of it in the *Limerick Chronicle*:[78]

'It had four sides, on one was engraved '*Thomas Smyth Esq., Vice Admiral of the Shannon Sept 12, 1765*', on the next side, '*Long Live the King*', on the next, the arms of Limerick, with '*Success to the city of Limerick and the trade thereof*', and on the last side '*LIBERTY AND PROPERTY.*'

Ceremonial silverware was also required by the Freemasons for their rituals and festivities. At least seven goldsmiths were members of one or other of the six freemasonry lodges that met in the city. Joseph Johns was treasurer of Lodge no. 9 in 1769. This was known as the Corporation lodge and had its own chaplain. They met at the King's Head Tavern.[79] Jonas Bull was also a member of this lodge. John Cherry was a member of Lodge no. 13 in 1757; Croker Barrington was warden of Lodge no. 236 in 1759, and finally John Calbeck and John Gloster were members of Lodge no. 271 in 1781.[80] Being a member of the Freemasons inevitably opened business connections and opportunities for commissioned pieces for the lodge and also for the members who had the means to indulge.

Outside the brethren of the Freemasons, Limerick's economy also performed very well during this period. With the increased population came increased wealth and consumption. Limerick's speed of expansion was second only to Belfast's at this time, due mostly to the development of Newtown Pery. The Volunteer movement was in full swing in Ireland and there were campaigns for the people of Ireland to purchase Irish manufacture. Membership of the city's Volunteer Militia also warranted the services of goldsmiths. An advertisement by Thomas Bennis in 1780 offered Volunteer buttons, also stating that he had an engraver who could inscribe whatever was desired on each button.[81] As the movement gathered momentum there was a select demand for commemorative pieces.

An interesting theory regarding the Limerick mark of a small fleur-de-lis, or trefoil, was suggested when the flatware was catalogued for this exhibition. The mark, which seems to have been struck by the same punch, is found on numerous items of the 1780-1810 period. However, many of the flatware pieces bearing this mark were made by different Limerick goldsmiths,

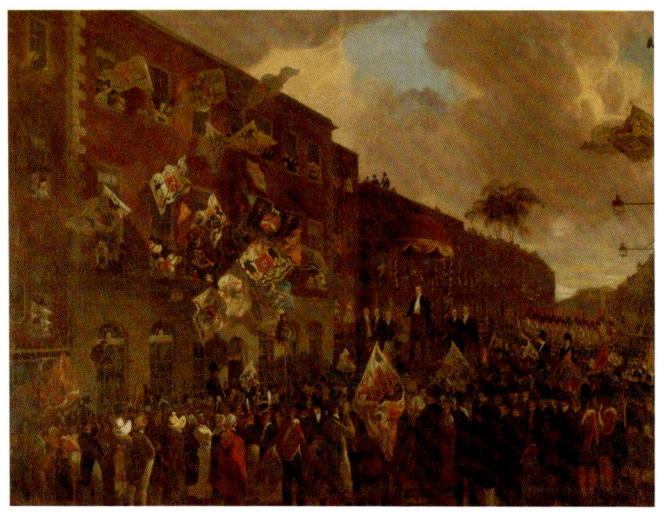

Plate 24
William Turner de Lond, fl. c. 1820.

The Chairing of Thomas Spring Rice in Limerick in 1820, c. 1837.

Courtesy of the Limerick Chamber of Commerce.

suggesting that these items were stamped by a municipal officer to indicate conformity with a local ordinance of some nature, such as payment of a tax. However, no documentary evidence has yet been found to explain the mark. Significantly perhaps, while the Dublin Assay Office received much plate at this period from other provincial centres for hallmarking, none appears to have been submitted by Limerick goldsmiths.

1800-1850: DECLINE OF GOLDSMITHS AND GUILDS

The Act of Union opened up free trade between Britain and Ireland but had detrimental effects on the Irish economy. Limerick goldsmiths could not compete with the lower cost plate on offer from the mass producing British industry. The number of goldsmiths and watchmakers declined in this period to twenty-eight. Some of the older goldsmith families had retired from the business or had died and of the twenty-five known addresses, sixteen were in Newtown Pery, with eight in Englishtown and Irishtown. From 1810 to 1850 the number reduced to fourteen with only two holding premises in the old towns. Newtown Pery was the recognised fashionable and economic centre, especially with the establishment of the Chamber of Commerce in 1815. The majority of the goldsmiths moved to the new thoroughfares of Patrick Street, George's Street and Francis Street. Guilds on the whole went into decline becoming politically orientated and neglecting the functions to which they were bound.

In the 1810s there were a number of challenges to the Corporation, at this time under the oligarchic control of the Prendergast-Smyth and Vereker families. These culminated in the victory of Thomas Spring Rice in 1818. A number of enquiries took place investigating affairs in Limerick. However, the Corporation still gave business to goldsmiths. £25 18s 10d was spent on boxes for complimentary freedom from 1811 to 1821, and between 1824 and 1833 £207 0s 10d was spent collectively on freedom boxes and the ceremonial gold chains for the mayor and sheriffs.[82] It is not known which goldsmith received these commissions, or if they were made in Limerick. However, by 1833 no guild was associated directly with the Corporation and in Newtown Pery, the Merchant of the Staple was replaced by the Chamber of Commerce which represented all trades within the city.

As the political climate changed in Ireland, and with the move towards capitalism and free trade, there was a reversal in the need for guilds. Initially, membership of the guilds was seen as a step towards civic government, but the powers of the guilds began to slowly diminish from the

beginning of the nineteenth century. Standards had dropped within the guilds and there were increasing calls for deregulation. After the 1835 Commission into the Municipal Corporations of Ireland, guilds were no longer regarded as occupying an integral part of Limerick's commercial life, and only two of the existing twenty-one guilds were able to produce their original charter.[83] They had, essentially, degenerated into political clubs by the time of the 1835 Commission and were no longer seen as a stepping-stone to civic government.

CONCLUSION

Over a period of two hundred years, Limerick city had a prosperous goldsmith community comparable to other provincial towns in Ireland and Britain. Essential to the prosperity of the industry was the development of a consumer society. The networks formed were imperative to the success of each goldsmith. It was clear that an association with the Corporation facilitated the most desirable alliances which allowed those goldsmiths to move up the social and civic ranks of the city. Many were granted the freedom of the city and became burgesses or held high office within the Corporation. It is evident from the freedom certificate issued in 1741, mentioned earlier, that goldsmiths had become the dominant trade in the Guild of Smiths, indicating the vibrancy of their trade and their municipal influence.

Despite the lack of an assay office in Limerick, consumers were content to purchase plate and goods from the goldsmiths without the Dublin assay mark, or indeed the duty mark imposed in 1730. This was a reflection of the focus on Irish manufacture from the mid-eighteenth century and purchasers were satisfied with the castle, star or 'sterling' punch. Goldsmiths also took advantage of the need for various ceremonial wares that required their expertise. While Joseph Johns held the monopoly on the majority of Corporation commissions, other organisations such as the Freemasons and the Volunteers offered similar opportunities for trade. Again, the importance of a sustainable network was vital for prosperity. Many goldsmiths had to be flexible in their craft, often switching trades when their income waned.

However, the Act of Union was a turning point for many Irish industries. The ongoing development of capitalism altered the mode by which the guilds operated and ultimately ended their necessity. There was a desire for power, and with this came vested interests, corruption, favouritism and oligarchies. The passing of the Act of Union saw the start of centralisation in Ireland and less of a need for the guilds. The establishment of non-denominational Chambers of Commerce in the early nineteenth century and the Municipal Reform Act of 1840 spelled the end for the ancient craft guilds. While goldsmiths survived, they no longer had the same degree of influence in Limerick as previously.

ENDNOTES

* For the purpose of this essay the term goldsmith will also include silversmith.

1. J. Ferrar, *The Limerick Directory* (Limerick, 1769). Included in allied trades were watch and clockmakers, and an engraver. While the directory is extensive, it is possible that not all traders and merchants were included in it.

2. Allied trades include engravers, watch and clock makers and whitesmiths.

3. M. Dolley, 'The mediaeval coin-hoards of Thomond' *North Munster Antiquarian Journal* [hereafter *NMAJ*], vol. XII (1969), p30.

4. M.S.D. Westropp, 'The goldsmiths of Limerick' *NMAJ*, vol. I, no. 4 (1939), p159.

5. Westropp, as note 4, p159; R. Wyse Jackson, 'Some Irish provincial silver' *NMAJ*, vol. VIII, no. 2 (1959), p61.

6. D. Gleeson, 'The Silvermines of Ormond' *Journal of the Royal Society of Antiquaries of Ireland* [hereafter *JRSAI*] vol. 67 (1937), p103.

7. Gleeson, as note 6, p108.

8. *Faulkner's Dublin Journal*, 21 October 1729. The price was presumably in Irish currency.

9. G. Boate, *A natural history of Ireland in three parts* (Dublin, 1755, reprint), p79.

10. These figures are based largely on the Directory herein compiled by McCormack and O'Brien; L. Walsh, 'A directory of Limerick gold and silversmiths' in D. Lee and D. Jacobs (eds), *Made in Limerick* (Limerick, 2006), pp233-244; C.J. Jackson, *English goldsmiths and their marks*, 2nd ed. (London, 1921; Dover reprint, 1964), pp641-711; the *Limerick Chronicle* and the various directories of the city 1769-1900.

11. L. Walsh, as note 10, p223.

12. *Reports from commissioners: sixteen volumes. Corporations, Ireland: First report and supplement and appendix* H.C. 1835 xxvii 7 [hereafter, *Municipal corporations report*], p344.

13. P.J. O'Connor, *Exploring Limerick's past, an historical geography of urban development in county and city*, (Limerick, 1987), p36.

14. E. MacLysaght, *Irish life in the seventeenth century* (Dublin, 1939), p190.

15. Minute book of the Guild of Masons 1746-57, Jim Kemmy Municipal Museum.

16. J.J. Webb, *The guilds of Dublin* (Dublin, 1929), pp18, 103.

17. R. Herbert, 'The trade guilds of Limerick' *NMAJ*, vol. II, no. 3 (1941), p128. For example, the Parker family were both innkeepers and goldsmiths and held meetings of the Guild of Masons on their premises.

18. I. Delamer and C. O'Brien, *500 years of Irish silver* (Bray, 2005), p18; C. O'Brien, 'The goldsmiths of Waterford' *JRSAI*, vol. 133 (2003), pp111-129. Waterford's guild pre-dates 1577 as in that year the Guild of Hammermen were split into two guilds, a new Guild of Timbermen and a reconstituted Guild of Hammermen. Increased trade and confrontation between the different crafts necessitated the split.

19. Limerick Papers, NLI, Packing Case 875, 13/1. The author acknowledges the help of David Fleming for this reference.

20. J. Hill, 'Corporatist ideology and practice in Ireland, 1660-1800' in S.J. Connolly, *Political ideas in eighteenth-century Ireland* (Dublin, 2000), p68.

21. *Limerick Chronicle*, 17 October 1768.

22. R. Herbert, as note 17, p26.

23. R. Hayes, 'Some old Limerick wills' *NMAJ*, vol. I, no. 4 (1939), p165.

24. Delamer and O'Brien, *500 Years of Irish Silver*, p14.

25. Walsh, as note 10, p221.

26. C.J. Jackson, as note 10, p707.

27. R. Wyse Jackson, 'An introduction to Irish silver' *NMAJ*, vol. IX, nos. 1&2 (1962 & 63), p17.

28. J. Ferrar, *An history of the city of Limerick* (Limerick, 1767), pp121-2.

29. J.N.A. Wallace, 'Notes on silver marks' *NMAJ*, vol. II, no. 3, (1941), p35.

30. Walsh, as note 10, p229.

31. Wallace, as note 29, p136.

32. See McCormack and O'Brien, 'Directory of Limerick Goldsmiths' herein.

33. Ferrar, as note 28, p39.

34. Wallace, as note 29.

35. T. Barnard, *Making the grand figure; lives and possessions in Ireland, 1641-1770* (London, 2004), p138.

36. They were James (c. 1687-d.1736), John (c. 1717-52), George (fl. 1740s), his two sons Edward (c. 1742-59) and George (c. 1759-75).

37. Limerick street names frequently changed through the centuries and during this time Nicholas Street was known as High Street. It was later referred to as Main Street.

38. Hayes, as note 23, p165.

39. C. O'Brien, 'Some misidentified Munster goldsmiths' *Silver Society Journal*, Autumn, (2001), p35.

40. D. Fleming, 'Limerick's eighteenth-century economy' in *Limerick history and society* (forthcoming).

41 *Municipal corporations report*, p353.

42 McCormack and O'Brien, 'Directory of Limerick Goldsmiths' herein.

43 C.J. Jackson, as note 10, p711.

44 Craftsmen who were not members of the Church of Ireland could apply to a guild to become a quarter brother whereby a fee would be paid by them to the guild. If accepted they were allowed to carry out trade in the city but not hold office, or have a vote within the guild.

45 There were three principal Roche families in Limerick at this time. Two were Catholic branches who were successful merchants and the Orange or Protestant Roches, who arrived in the city in the late seventeenth century.

46 E. O'Flaherty, 'Urban politics and municipal reform in Limerick 1723-62' *Eighteenth-Century Ireland*, vol. VI (1991), p109.

47 *Dublin Evening Post*, 27 June 1732.

48 *Faulkner's Dublin Journal*, 19-22 June 1731; McCormack and O'Brien, 'Directory of Limerick Goldsmiths' herein.

49 The Hunt Museum, *North Thomond Church Silver 1425-1820* (Limerick, 2000), p31.

50 McCormack and O'Brien, 'Directory of Limerick Goldsmiths' herein.

51 C.J. Jackson, as note 10, p673; T. Sinsteden 'A "sterling" relationship, the Cork goldsmiths and the company of goldsmiths of Dublin' in J.R. Bowen & C. O'Brien, *Cork silver and gold: four centuries of craftsmanship* (Cork, 2005), p21.

52 E.C.R. Armstrong, 'Matrix of the seal of the corporation of Kilmallock, Co. Limerick', *JRSAI*, vol. IV (1914), pp160-1.

53 These items were auctioned by Sotheby's, New York, in 2002 and Christies in London in 1934; see McCormack and O'Brien 'Directory of Limerick Goldsmiths' herein.

54 *Pue's Occurrences*, 29 July 1735.

55 Minute book of the Guild of Masons, 9 October 1749, Jim Kemmy Municipal Museum.

56 *A list of officers in the several regiments and independent troops and companies of militia* ...(Dublin, 1757), p. 71; a list of volunteers was printed entitled *Limerick volunteers, September 26, 1779*, Jim Kemmy Municipal Museum.

57 These two were possibly related as the spelling of the names varies in many records.

58 Limerick Papers, NLI, packing case 85.

59 M.-L. Legg (ed), *The diary of Nicholas Peacock. The worlds of a county Limerick farmer and agent* (Dublin, 2005), p140.

60 A. Fitzgerald and C. O'Brien, 'The production of silver in late Georgian Dublin' *Irish Architectural and Decorative Studies*, vol. IV (2001), p24; Barnard, as note 35, pp134-6 and 150.

61 Barnard, as note 35, p136.

62 For example, Samuel Johns, Philip Burbridge, John Calbeck and John Gloster, James Collopy, John Cullum and Maurice Fitzgerald. See McCormack and O'Brien, 'Directory of Limerick Goldsmiths' herein.

63 Legg, as note 59, p192.

64 M. Lenihan, *Limerick: its history and antiquities* (Cork, 1967 reprint), p340.

65 O'Flaherty, as note 46, pp110-113.

66 This group were largely influenced by similar actions carried out against the Dublin Corporation by Charles Lucas. See J. Hill, *From patriots to unionists. Dublin civic politics and Irish Protestant patriotism 1660-1840* (Oxford, 1997).

67 *Report from the committee appointed to examine into the matters contained in the petition of John O'Donnell of the city of Limerick* ...(Dublin, 1761), pp46-52.

68 R. Pococke, *Pococke's Tour in Ireland in 1752* edited by G. T. Stokes (Dublin, 1891) p114; J.B. Trotter, *Walks through Ireland in the years 1812, 1814 & 1817* (London, 1819), p336.

69 1761 city poll book, NLI Ms. 16,092.

70 *Finn's Leinster Journal*, 4 February 1769.

71 *Limerick Chronicle*, 15 August 1768.

72 D. Dickson, 'Large-scale developers and the growth of eighteenth-century cities' in P. Butel and L.M. Cullen (eds), *Cities and merchants: French and Irish perspectives on urban development 1500-1900* (Dublin, 1986), p109.

73 *Limerick Chronicle*, 8 September 1768.

74 *Limerick Chronicle*, 11 August 1774.

75 Ferrar, as note 1, p41.

76 McCormack and O'Brien, 'Directory of Limerick Goldsmiths' herein; Walsh, as note 10, pp238-9.

77 Barnard, as note 35, p137.

78 *Limerick Chronicle*, 17 October 1768. A Samuel Johns is listed as warden of lodge no. 9, but it is likely that he was the attorney and not the silversmith. See McCormack and O'Brien, 'Directory of Limerick Goldsmiths' herein.

79 Ferrar, as note 1, p43.

80 Rolls of admittance, Grand Lodge Dublin.

81 *Limerick Chronicle*, 28 September 1780.

82 *Municipal corporations report*, pp404-5.

83 The two original charters belonged to the broguemakers whose charter dated from 1688 and the plasterers and slaters dated from 1672. Other charters were copied in to old council books. *Municipal corporations report*, p348.

Catalogue Notes

The exhibition is presented in eight sections. Each section has been curated by the author(s) of the short introductory text which precedes the catalogue entries for that particular section.

Each catalogue entry observes the following conventions.

The maker is identified where known, otherwise the term "Maker unidentified" is used.

The place of manufacture and the approximate date of the item are given, e.g., "Limerick, c. 1750". Dating Limerick silver accurately is difficult without a date bearing inscription or hallmarks. Dates have been ascribed using such circumstantial evidence as the known working life of the maker, the stylistic characteristics identifiable with a particular period, and the authors' own judgement.

The exhibits are all of silver unless otherwise stated, e.g., "Silver-gilt" or "Gold".

The maximum dimensions are noted as in "H: (rim) 160 cm", H denoting height, D diameter, W width, L length.

The marks on the item are described. Unlike many of the larger centres where the goldsmiths' craft was more formally organised, there was no system of registering makers' (or more accurately, sponsors') marks in Limerick. Consequently attributions of such marks are generally based on initials corresponding to those of a known goldsmith working at the time the subject object was made. However, without supporting chronological or other documentary evidence such attributions can be erroneous, particularly in the case of contemporaneous goldsmiths sharing the same initials. It is hoped that this exhibition will be the catalyst for further research in the field of the goldsmiths of Limerick which in turn will lead to us to greater knowledge than is currently available.

Retailers' marks where applied are noted.

Heraldic crests are described and, where appropriate or possible, identified.

Armorials are not described in detail, but where possible are identified.

Inscriptions and similar are noted in italics.

The reader is referred to the Glossary for the explanation of specialised terms used in the catalogue.

Plate 25 *Sauceboat (detail) by Philip Walsh, Limerick c. 1785.* Exhibit 6.11

A CELEBRATION OF LIMERICK'S SILVER

41

Ecclesiastical

Clodagh Lynch and Michael Lynch

Any exhibition of church plate in significant numbers is a rare occurrence. It is also a wonderful opportunity to view precious artefacts that have survived through periods of conflict and turbulence. These are mainly vessels used in the celebration of Holy Communion in different Christian traditions and their form and design display to the fullest, the craft of the Limerick silversmiths.

Limerick and its environs bear testimony to a long tradition in the craft of the goldsmith. The Bronze Age gold hoard from Mooghaun and the Balline hoard from the Iron Age demonstrate that this tradition was well established from the earliest times. The Ardagh Chalice (c. AD 800) found in Co. Limerick in 1868 is probably the finest piece of early Christian metalwork in Ireland. The mitre and crosier made to the order of Conor O'Dea, Bishop of Limerick, in 1418 are extraordinary, not only for their artistic quality and for the fact that they are still in the possession of Bishop O'Dea's successor, but also because the mitre bears the name of its maker, Thomas O'Carryd. Both of these remarkable items are on permanent display at The Hunt Museum.

Plate 26
Flagon by James Robinson,
Limerick c. 1695
Exhibit 1.01

Apart from an early Franciscan chalice of 1589 (Exhibit 1.35) most of the items here are from the seventeenth and eighteenth centuries. The earliest piece definitively known to have been made by a Limerick silversmith, is the Arthur Cross of 1625 (Exhibit 1.38), which was made by Philip Lyles.

Chalices and communion cups are the most numerous class of items of church plate on display. The constituent parts of the chalice have remained more or less unchanged over time and the form of the chalice has evolved into a design which we see in the exhibition. From earliest times chalices have been made from

precious metals, and gold and silver chalices have prevailed right up to present times. Early chalices came in two forms, a ministerial chalice used for the communion of the faithful, and a sacrificial chalice used by the celebrant for the consecration. The consecration chalice was small in size while the ministerial chalice consisted of a large bowl with two handles and a foot. The Ardagh Chalice is an example of the latter. When the consecrated wine was withdrawn from the laity at the end of the twelfth century this type of chalice became redundant.

The chalice in its simplest form consists of three parts, the cup, the stem, with or without a knop, and the foot. The cup is generally deep, and in the case of Roman Catholic chalices, is invariably gilded internally. The knop allows an easy grip to facilitate handling, and the foot is splayed for stability. The stem, the knop and the foot lend themselves to ornamentation, evident on many of the chalices on display. The foot on Catholic chalices frequently bears a dedicatory inscription, of important historical record, where the name of the donor and the date of the chalice are often engraved.

The earliest shape of the foot was circular, but in the fourteenth century this was changed to hexagonal. This was to facilitate the liturgical practice of placing the chalice on its side with the bowl resting on the paten to demonstrate that no consecrated wine remained after communion. As the circular foot tended to roll on the altar the hexagonal foot gave the chalice stability. Although this liturgical practice ceased, the preference for the hexagonal foot prevailed almost invariably in the case of Irish Catholic chalices to the seventeenth century and beyond.

The Reformation in Ireland brought about profound changes in the design of the chalice in the Anglican Church. The traditional style was replaced by a plain, austere communion cup with little or no decoration, typically with a beaker-type bowl, a circular straight or tapering stem, with or without a knop, and a circular foot. The large bowl was required as consecrated wine was consumed by the laity during communion. The earliest extant examples of Limerick-made communion cups are those of the 1660s by John Bucknor. Although very plain, they resemble the pre-Reformation chalices with shallow bowls and globular knops (Exhibits 1.08 and 1.16). These appear to have a distinct local style. The plainness of early Limerick Church of Ireland communion cups contrasts with contemporary Cork examples, which have the decorated knops and hexafoil feet of the Catholic chalices. The only Limerick-made example with a hint of pre-Reformation decoration is the Robert Smith c. 1680 communion cup (Exhibit 1.05).

Plate 27
Flagon by James Robinson,
Limerick c. 1711
Exhibit 1.02

SECTION 1 ECCLESIASTICAL

Plate 28
Paten by John Bucknor, Limerick c. 1665
Exhibit 1.03

Plate 29
Communion Cup by Robert Smith, Limerick c. 1685
Exhibit 1.04

By the 1680s very plain beaker-shaped cups with trumpet feet and no knops were introduced, such as that for Ennis Church by Robert Smith (Exhibit 1.04). This type continued into the 1730s (Exhibit 1.13) but by then was replaced by larger communion cups with conical stems, flattened knops and moulded, spreading feet, such as the Tulla communion cup by Joseph Johns (Exhibit 1.09a). This style prevailed in Limerick throughout the eighteenth century and was undoubtedly influenced by examples made in London, such as that at Lough Gur (Exhibit 1.19a). In the case of these Anglican communion cups, inscriptions, if any, are usually found on the bowls.

There are a substantial number of seventeenth and eighteenth century Catholic chalices throughout the Limerick area, and it is likely that most were made locally. Unfortunately they do not bear makers' marks; therefore the identities of their makers remain unknown. In selecting examples of these chalices for the exhibition a preference was given to Franciscan plate. This was to align the exhibition with the current 'Louvain 400' celebrations of the Franciscan Order, and also because some of the more interesting examples of seventeenth and eighteenth century Catholic plate from the Limerick area are Franciscan pieces. The *'John Farrell Chalice 1619'* (Exhibit 1.28) and the *'Anastasia Rice Chalice 1626'* (Exhibit 1.29), donated to the Friars Minor in Limerick, were most probably made in Limerick and their height and abundance of decoration are thought to reflect a distinctive regional style. Three other Franciscan chalices from Ennis and Quin (Exhibits 1.30 and 1.31 and 1.36) are of particular interest in that their maker, Richard Fennell has inscribed his name on the pieces.

The paten accompanies the chalice and fulfils the function of holding the bread at the celebration of the Eucharist. Before 1600 Catholic patens were dish shaped and had circular or multifoil depressions such as the Franciscan example (Exhibit 1.35b). This circular depression continued into the 1600s but eventually gave way to a plain dished form. Many patens have been separated from their chalices, probably due to their small size and also because generally no inscriptions were engraved on them. Very often the dished patens of the eighteenth century had the sacred monogram *IHS* with other symbols engraved on the underside (Exhibit 1.40).

The early Church of Ireland patens in Limerick and elsewhere were generally small and dish-shaped with a central depression (Exhibits 1.03 and 1.11b). Later, in the eighteenth century, they took the form of a flat dish of considerable size usually with a central circular spreading foot (Exhibit 1.09b) but sometimes on three feet (Exhibit 1.15b).

After the Reformation the need to distribute the communion wine to the laity led to the introduction of the most impressive piece of Anglican Church plate, the flagon. Limerick silversmiths responded to this challenge and three fine examples are exhibited. The oldest, made by John Bucknor (Exhibit 1.17a) in the 1660s, is of exceptional quality. Because of their function these flagons tend to be large and are visually imposing. They are well executed with 'S' scroll handles and decorative thumb pieces and probably owe their design to the domestic tankards of the day.

The monstrance is a striking addition to any display of church plate. The form originally dates to medieval times when it was used for the display of relics. The present form was introduced in the sixteenth century for the purpose of the exposition of the Eucharistic host. It consists of a glass disc-shaped receptacle within a silver or silver-gilt sunburst supported by a stem and foot, often richly decorated. The *'Thady Quin 1725'* monstrance (Exhibit 1.23) is a rare example of Catholic early eighteenth-century plate with a maker's mark.

The importance of church plate in the preservation and identification of makers' marks cannot be overstated. Church plate has generally survived in good condition because of the respect with which it was treated, whereas domestic plate has fared far less well. The dedicatory inscriptions on Church plate, with the names of donors, priests and clergymen, are of great importance to historians. The combination of inscriptions, dates and makers' marks are especially important to provincial silver enthusiasts for whom Church plate often provides the only extant examples of silversmiths' marks. This is certainly the case for Limerick silver. The identification of the marks of silversmiths, such as Robert Smith, James Robinson and more recently John Bucknor has been due to the study of church plate. During research for this exhibition, what is most probably the previously unrecorded mark of Samuel Calbeck on a Roman Catholic chalice dated 1722 (Exhibit 1.39) was discovered.

SECTION 1 ECCLESIASTICAL

A CELEBRATION OF LIMERICK'S SILVER

Plate 31
Communion Cup by Robert Smith,
Limerick c. 1675
Exhibit 1.05

Plate 32
Communion Cup probably Joseph Johns, Limerick c. 1758. Exhibit 1.06a
Paten by Joseph Johns, Limerick c. 1758. Exhibit 1.06b

Plate 30
Bread Plate, Communion Cup and Paten by Maurice Fitzgerald, Limerick c. 1779
Exhibits 1.15c, 1.15a and 1.15b

SECTION 1 ECCLESIASTICAL

Plate 33
Communion Cup by John Purcell, Limerick c. 1812
Exhibit 1.07

Plate 34
Communion Cup by John Bucknor, Limerick c. 1665
Exhibit 1.08

Plate 35
Paten by Collins Brehon, Limerick c. 1760
Exhibit 1.10

Plate 36
Communion Cup and Paten,
both attributed to John Bucknor, Limerick c. 1663
Exhibits 1.11a and 1.11b

SECTION 1 **ECCLESIASTICAL**

Plate 37
Communion Cup by James Robinson, Limerick c. 1703
Exhibit 1.12

Plate 38
Communion Cup by Jonathan Buck, Limerick c. 1732
Exhibit 1.13

A CELEBRATION OF LIMERICK'S SILVER

Plate 39
Communion Cup by James Robinson, Limerick c. 1699
Exhibit 1.14

Plate 40
*Communion Cup, Paten and Bread Plate
by Maurice Fitzgerald, Limerick c. 1779*
Exhibits 1.15a, 1.15b and 1.15c

SECTION 1 **ECCLESIASTICAL**

A CELEBRATION OF LIMERICK'S SILVER

Plate 42
Paten by George Moore, Limerick c. 1757
Exhibit 1.20

Plate 43
Communion Cup by John Bucknor, Limerick c. 1665
Paten probably John Bucknor, Limerick c. 1665
Exhibits 1.21a and 1.21b

Plate 41
Flagon by John Bucknor, Limerick c. 1660. Exhibit 1.17a
Bread plate by Hercules Beere, Youghal c. 1660. Exhibit 1.17b
Communion Cup by John Bucknor, Limerick c. 1660. Exhibit 1.16

53

SECTION 1 ECCLESIASTICAL

Plate 44
Communion Cup, unidentified maker, London 1679. Exhibit 1.19a
Paten, unidentified maker, London 1679-80. Exhibit 1.19b

Plate 45
Chalice by Jonathan Buck, Limerick c. 1726. Exhibit 1.25a
Paten by Jonathan Buck, Limerick c. 1726. Exhibit 1.25b

Plate 46
Paten by Matthew Walsh, Limerick c. 1780. Exhibit 1.40

SECTION 1 ECCLESIASTICAL

Plate 47
Monstrance by Jonathan Buck, Limerick c. 1725
Exhibit 1.23

Plate 48
Chalice by James Roche, Limerick 1959. Exhibit 1.24
Bread Plate by John O'Shea, Limerick 1986. Exhibits 1.41

A CELEBRATION OF LIMERICK'S SILVER

Plate 49
Chalice by Cosmacs Ltd., Limerick 1960
Exhibit 1.26

Plate 50
Chalice, unidentified maker, probably Limerick c. 1640
Exhibit 1.27

57

SECTION 1 **ECCLESIASTICAL**

Plate 51
Chalice, unidentified maker, Limerick c. 1619
Exhibit 1.28

Plate 52
Chalice, unidentified maker, Limerick c. 1626
Exhibit 1.29

A CELEBRATION OF LIMERICK'S SILVER

Plate 53
*Chalice by Richard Fennell,
probably Ennis or Limerick c. 1671*
Exhibit 1.30

Plate 54
*Chalice by Richard Fennell,
probably Ennis or Limerick c. 1671*
Exhibit 1.31

59

SECTION 1 ECCLESIASTICAL

Plate 55
*Chalice, unidentified maker,
probably Limerick 17th century*
Exhibit 1.32

Plate 56
*Monstrance, unidentified maker,
possibly Limerick c. 1714*
Exhibit 1.33

A CELEBRATION OF LIMERICK'S SILVER

Plate 57
Chalice, unidentified maker, possibly Limerick c. 1638
Paten, unidentified maker
Exhibits 1.34a and 1.34b

Plate 58
Chalice, unidentified maker, possibly Limerick c. 1589
Paten, unidentified maker, possibly Limerick c. 1589
Exhibits 1.35a and 1.35b

SECTION 1 ECCLESIASTICAL

Plate 59
Chalice by Richard Fennell,
probably Ennis or Limerick c. 1670
Exhibit 1.36

Plate 60
Chalice, unidentified maker, Limerick c. 1627
Exhibit 1.37

Plate 61
Cross by Philip Lyles, Limerick c. 1624
Exhibit 1.38

Plate 62
Chalice by Samuel Calbeck, Limerick c. 1722
Exhibit 1.39

SECTION 1 ECCLESIASTICAL

Plate 63
Communion Cup probably Samuel Calbeck,
Limerick c. 1725
Exhibit 1.18

Plate 64
Chalice by Adam Buck, Limerick c. 1718
Paten, unidentified maker, possibly Limerick c. 1718
Exhibits 1.22a and 1.22b

Plate 65
Communion Cup and Paten by Joseph Johns, Limerick c. 1765
Exhibits 1.09a and 109b

SECTION 1 ECCLESIASTICAL

Catalogue

1.01 FLAGON
James Robinson
Limerick, *c.* 1695
H: 29.8cm;
D: (lip) 13cm x 11.3cm,
(base) 18 cm;

Marks: Castle gateway; IR in conjoined script; eight pointed star; all in irregular punches, struck once

Tapering cylindrical body on trumpet-shaped, spreading foot, with domed lid, 'S' scroll handle and a shell-thumbpiece. Engraved with the arms of Williamson impaling Lennox. Inscribed *Ex Dono Josephi Williamson Equitis Aurati Ecclesiae Cathedrali Beatae Mariae Virginis Limericencis.*

Sir Joseph Williamson held amongst other appointments that of Principal Secretary of State in England. In 1679 he married Baroness Clifton, widow of Lord Henry O'Brien.

Courtesy of the Church of Ireland Representative Church Body.

1.02 FLAGON
James Robinson
Limerick, *c.* 1711
H: 28cm; D: (rim) 10.3cm,
(base) 13.4cm;

Marks: IR in conjoined script in an irregular punch struck thrice

Tapering cylindrical body on a low moulded foot; stepped domed lid, 'S' scroll handle with beaded decoration, corkscrew thumbpiece. Inscribed *The gift of Mrs. Dorathea Smith to the Church of St. Munchins May 1st 1711*. Bears scratch weight *28:17*.

Dorathea Smith was the wife of Thomas Smith, Bishop of Limerick (1695-1725). Three months after this flagon was donated she died on 6th August 1711 and is buried in St. Munchin's Church, where there is a monument erected to her memory. St. Munchin's Church is reputed to be the oldest church in Limerick. It was founded by St. Munchin, first Bishop of Limerick, in 651 and was the Cathedral Church of Limerick until the building of St. Mary's c. 1194. It has been rebuilt on many occasions and the present structure dates to 1827.

Courtesy of the Church of Ireland Representative Church Body.

1.03 PATEN
John Bucknor
Limerick, *c.* 1665
D: 15.4cm

Marks: Castle gateway between two towers in a shield-shaped punch; IB flanking three stars, in quatrefoil punch

Plain circular dish-shaped paten with a wide rim. No inscription.

Courtesy of the Church of Ireland Representative Church Body.

1.04 COMMUNION CUP
Robert Smith
Limerick, *c.* 1685
H: 16cm; D: (rim) 9.8cm,
(foot) 10.1cm

Marks: Eight pointed star; RS; castle gateway; all in irregular punches

Deep, slighting tapering, beaker-shaped bowl with an everted rim, on a spreading trumpet foot. Inscribed *For Ennis Church 1685*.

Courtesy of the Church of Ireland Representative Church Body.

1.05 COMMUNION CUP
Robert Smith
Limerick, *c.* 1675
H: 20cm; D: (rim) 8.4cm,
(foot) 10.4cm

Marks: Castle gateway; RS with star beneath; six wavy pointed star; all in irregular punches

Deep, everted-rimmed bowl, supported on a calyx, the baluster stem with globular knop; the round spreading moulded foot on a reeded flange.

The overall design, although more restrained, is similar to Catholic chalices of the period.

Courtesy of the Church of Ireland Representative Church Body.

1.06a COMMUNION CUP
Probably Joseph Johns
Limerick, *c.* 1758
H: 19.5cm; D: (rim) 9.2cm,
(foot) 10.5cm

Marks: Unmarked

Deep bowl with everted rim; slightly conical knopped stem; spreading stepped circular foot on a narrow flange. Engraved with a coat of arms within a foliate cartouche having a crest and motto similar to those on the paten. Inscribed *The Gift of Augustine*

Fitzgerald Esq of Silvergrove to the Parish of Kilsiely 14th of May 1758.

Courtesy of the Church of Ireland Representative Church Body.

1.06b PATEN
Joseph Johns
Limerick, c. 1758
H: 4.7cm; D: 16.5cm, (foot) 7.4cm

Marks: II flanking a lion rampant, in an irregular punch; STERLING in an oblong punch

Dished paten, with applied rim on a domed foot. Bears crest, a mounted knight with the motto *Fortis et Fidelis*. Inscribed *The Gift of Augustine Fitzgerald Esq of Silvergrove to the Parish of Kilsiely 14th of May 1758.*

Courtesy of the Church of Ireland Representative Church Body.

1.07 COMMUNION CUP
John Purcell
Limerick, c. 1812
H: 20.2cm; D: (rim) 8.5cm, (foot) 1cm

Marks: IP in a rectangular punch; three trefoils and STERLING incuse

Tapering bowl with everted rim; the conical stem with globular knop; the spreading moulded foot on a wide flange. Inscribed *Quin Church 1812*. Bears scratch weight *10oz 10*.

This may well be an earlier communion cup reworked by John Purcell.

Courtesy of the Church of Ireland Representative Church Body.

1.08 COMMUNION CUP
John Bucknor
Limerick, c. 1665
H: 18.5cm; D: (rim) 8.3cm, (foot) 10.1cm

Marks: Rubbed but apparently the maker's mark of Bucknor

Wide tapering bowl on a knopped stem; the trumpet-shaped drum foot with a narrow flange.

This is known as the 'Kilmastulla Cup' and is very similar to the 1663 Askeaton communion cup.

Courtesy of the Church of Ireland Representative Church Body.

1.09a COMMUNION CUP
Joseph Johns
Limerick, c. 1765
H: 23.2cm; D: (rim) 10.8cm, (foot) 11.7cm

Marks: II in a heart-shaped punch

Deep bowl with everted rim; knopped stem with reeded decoration; spreading stepped footon a narrow flange. Inscribed *For the Parish Church of Tulla 1765.*

Courtesy of the Church of Ireland Representative Church Body.

1.09b PATEN
Joseph Johns
Limerick, c. 1765
D: 18.3cm

Marks: II flanking a lion rampant in an irregular punch struck thrice

Dished paten with a narrow raised rim supported by a central lightly moulded circular foot. Inscribed *For the Parish Church of Tulla 1765.*

Courtesy of the Church of Ireland Representative Church Body.

1.10 PATEN
Collins Brehon
Limerick, c. 1760
D: 16cm

Marks: CB flanking a lion rampant, in an oval punch

Dished paten with a wavy edge. Inscribed *O'Briens Bridge Church 1824*. Bears scratch weight *VI oz V11*.

Possibly a salver made for secular use and later presented to the church in O'Briensbridge.

Courtesy of the Church of Ireland Representative Church Body.

1.11a COMMUNION CUP
John Bucknor (attributed)
Limerick, c. 1663
H: 18.5cm; D: 9cm, (foot) 9.5cm

Marks: Castle gateway between two towers in a shaped punch; eight pointed star

Wide shallow bowl on knopped stem; trumpet-shaped stepped foot with a narrow flange. Inscribed *Ex do: Simos Eaton Armr Par: Askeaton Anno 1663.*

This Communion Cup and Paten are the earliest known dated pieces of Church of Ireland Limerick silver. Simon Eaton was was sheriff of Co.

SECTION 1 ECCLESIASTICAL

Limerick in 1661 and of Co.Kerry in 1676. He was created a baronet in February 1682. He died in 1697 and was buried at St. James's Westminster whereupon the baronetcy became extinct.

Courtesy of the Church of Ireland Representative Church Body.

1.11b PATEN
John Bucknor (attributed)
Limerick, *c.* 1663
D: 11.9cm

Marks: Same as above

Dish-shaped paten.

Courtesy of the Church of Ireland Representative Church Body.

1.12 COMMUNION CUP
James Robinson
Limerick, *c.* 1703
H: 25.2cm; D: (rim) 10.8cm, (foot) 12.7cm

Marks: JR in conjoined script, in an irregular punch struck on the bowl and foot

Deep tapering bowl with everted rim; the knopped stem on a spreading moulded circular foot. Bears a finely engraved armorial of Southwell. Inscribed *The Gift of the Lady Elizabeth Southwell to the Parish Church of Rathkeale Anno Domini 1703.*

It was the Southwell family which brought the Palatine people to County Limerick granting them land.

Courtesy of the Church of Ireland Representative Church Body.

1.13 COMMUNION CUP
Jonathan Buck
Limerick, *c.* 1732
H: 14.5cm; D: (rim) 9.1cm, (foot) 9.1cm

Marks: IB flanking a star in an oblong punch

Deep beaker-shaped, slightly tapering bowl on spreading moulded foot. Inscribed *Ecclesia de Kilmeedy 1732.*

Courtesy of the Church of Ireland Representative Church Body.

1.14 COMMUNION CUP
James Robinson
Limerick, *c.* 1699
H: 26.6cm; D: (rim) 11.4cm, (foot) 13cm

Marks: Eight pointed star; JR in conjoined script; castle gateway, all in irregular punches

Deep flat-bottomed bowl with tapering sides and everted rim; knopped conical stem above a spreading moulded foot on a wide flange. Inscribed *In Usum Ecclesiae de Crome Comunibus Parochia Impensis Anno Domino 1699.*

An almost identical communion cup was presented to Adare Church also in 1699 and no doubt was also made by James Robinson.

Courtesy of the Church of Ireland Representative Church Body.

1.15a COMMUNION CUP
Maurice Fitzgerald
Limerick, *c.* 1779
H: 29cm; D: (rim) 10.5cm, (foot) 12.8cm

Marks: MFG in an oblong punch

Deep bowl with everted rim; tapering knopped stem on a moulded foot with narrow flange. Inscribed *PARISH OF ABINGTON DIO CASHELL 1779.*

Courtesy of the Church of Ireland Representative Church Body.

1.15b PATEN
Maurice Fitzgerald
Limerick, *c.* 1779
D: 17.2cm

Marks: Same as above

Dished paten with narrow rim, on three hoof feet. Inscribed *PARISH OF ABINGTON DIO CASHELL 1779.*

Courtesy of the Church of Ireland Representative Church Body.

1.15c BREAD PLATE
Maurice Fitzgerald
Limerick, *c.* 1779
D: 24.3cm

Marks: Same as above

Dished circular plate with gadrooned rim. Inscribed *PARISH OF ABINGTON DIO CASHELL 1779*, and on its underside, *GIFT OF REVD JOHN SEYMOUR RECTOR.*

Courtesy of the Church of Ireland Representative Church Body.

1.16 COMMUNION CUP
John Bucknor
Limerick, *c.* 1660
H: 20cm; D: (rim) 9.2cm, (foot) 11.5cm

Marks: IB flanking three stars in quatrefoil punch; castle gateway in shield-shaped punch

Wide shallow bowl with everted rim on knopped stem; trumpet-shaped foot with moulded step on narrow flange. Inscribed *Ex dono viri honorabilis Johannis Percivall, Equitis Aurati, in usum Ecclesiae Parochialis de Browheny.*

Sir John Percivall was knighted by the Lord Deputy of Ireland, Henry Cromwell, on July 22 1658, and was created a Baronet by King Charles II on September 9 1661. Being designated a knight (eques auratus) in the inscriptions on Exhibits 1.16, 1.17a and 1.17b, indicates that the donation of these items took place prior to September 1661 when the donor was elevated to a baronetcy.

Courtesy of the Church of Ireland Representative Church Body.

1.17a FLAGON
John Bucknor
Limerick, *c.* 1660
H: 27.4cm; D: (rim) 11.2cm, (foot) 17.4cm

Marks: IB flanking three stars in a quatrefoil punch; castle gateway in a shield-shaped punch

Tapering flagon with flanged rim; the slightly domed moulded lid with bifurcated thumb-piece hinged to top of tapering S-scroll handle; trumpet shaped foot with reeded decoration, on narrow flange. Inscribed *Ex dono viri honorabilis Johannis Percivall, Equitis Aurati, in usum Ecclesiae Parochialis de Browheny.*

Courtesy of the Church of Ireland Representative Church Body.

1.17b BREAD PLATE
Hercules Beere
Youghal, *c.* 1660
D: 25cm

Marks: HB conjoined in a pelleted circle struck twice

Plain circular dished bread plate. Inscribed *Ex dono viri honorabilis Johannis Percivall, Equitis Aurati, in usum Ecclesiae Parochialis de Browheny.*

Courtesy of the Church of Ireland Representative Church Body.

1.18 COMMUNION CUP
Probably Samuel Calbeck
Limerick, *c.* 1725
H: 24cm; D: (rim) 12cm, (foot) 13.8cm

Marks: Rubbed but apparently S(C?) in oblong punch

Deep bowl with flat base and everted rim; knopped conical stem; flanged spreading moulded foot. Inscribed *The Gift of Edward Croker Esqr to ye Church of Chahircorny 1725.*

Courtesy of the Church of Ireland Representative Church Body.

1.19a COMMUNION CUP
Unidentified maker
London, 1679
H: 11.5cm; D: (rim) 11.3cm, (foot) 10.6cm

Marks: RC

Deep beaker-shaped bowl with everted rim; tapering stem with applied narrow ring; trumpet foot on reeded edge. Inscribed *The Gift of the Right Honorable Rachell Countess Dowager of Bath To her Chappel att Loughgur in the Kingdom of Ireland Anno Dom:1679.*

Courtesy of the Church of Ireland Representative Church Body.

1.19b PATEN
Unidentified maker
London, 1679-80
D: 20.5cm, (foot) 7.9cm

Marks: RC

Dish-shaped with reeded and moulded edge; chased in the centre with the sacred monogram IHS surmounted by a cross within a sunburst. Inscribed same as above.

John and Gertrude Hunt resided at Lough Gur for several years. John Hunt was involved in the prehistoric excavations at Lough Gur by Professor Ó Ríordáin and a copy of this communion cup and paten are now displayed in the Interpretative Centre at Lough Gur.

Courtesy of the Church of Ireland Representative Church Body.

SECTION 1 **ECCLESIASTICAL**

1.20 **PATEN**
George Moore
Limerick, *c.* 1757
D: 14.2cm

Marks: GM with pellet between in an engrailed oblong punch

Plain dished paten with narrow rim. Inscribed *ye church of Eglish 1757* and on the underside *1559*.

Courtesy of the Church of Ireland Representative Church Body.

1.21a **COMMUNION CUP**
John Bucknor
Limerick, *c.* 1665
H: 20cm; D: (rim) 9.2cm, (foot) 11.1cm

Marks: IB flanking three stars in a quatrefoil punch; castle gateway in a shield-shaped punch

Wide shallow cup with everted rim on knopped stem; spreading trumpet foot rests on a flanged reeded step. Engraved on the bowl with a coat of arms. Inscribed *The Gift of the Right Honble Marcus Lord Vicount Dungannon To ye Parish Church of Clonallen 1704*.

Courtesy of the Church of Ireland Representative Church Body.

1.21b **PATEN**
Probably John Bucknor
Probably Limerick, *c.* 1665
D: 12.2cm

Marks: Unmarked

Small dished paten with wide outer rim. Engraved with the same coat of arms and inscription as above.

Courtesy of the Church of Ireland Representative Church Body.

1.22a **CHALICE**
Adam Buck
Limerick, *c.* 1718
H: 18cm D: 8.3cm (bowl), 10.5cm (foot)

Marks: AB in an oval punch struck twice

Made in three parts; the bowl of inverted conical form with everted rim, resting on a calyx; the cylindrical stem with decorated spherical knop; the trumpet-shaped foot engraved with the Crucifixion resting on a plain flange. Bears inscription *AD. M.D. Gl Fr. FLORus B. ME FIERI FECIT, J.M. PADDEN 1718* or in its extended form "Ad Majorem Dei Gloriam Frater Florentus B. Me Fieri Fecit, J. McPadden 1718" (For the greater glory of God Brother Florence B had me made, J McPadden 1718).

On loan from the National Museum of Ireland.

1.22b **PATEN**
Unidentified maker
Possibly Limerick, *c.* 1718
D: 9.6cm

Marks: Unmarked

Of plain dished form; engraved on the concave (upper) side with the sacred monogram IHS, a cross potent and three nails.

This paten was acquired in 1909 by the National Museum of Ireland together with the Florence B. chalice and is likely that it is the paten originally made for the chalice. It is unusual in that it is engraved on its upper side rather than on its underside which is more usual.

On loan from the National Museum of Ireland.

1.23 **MONSTRANCE**
Jonathan Buck
Limerick, *c.* 1725
H: 44cm; D: (foot) 19cm

Marks: IB in an oblong punch applied five times; IB flanking a star with a buck below in a shield shaped punch applied once

Of conventional form with glazed receptacle mounted with a moulded silver frame surrounded by alternate straight and wavy pointed rays; the frame surmounted with a crucifix; knopped, baluster stem with fluted flanges. supported on a double-domed oval. Inscribed *Ex dono Thadaei Quin Armigeri de Adare ad Usum Parochiae Sti Joanis Limericensis in honorem Venerabilis Sacramenti A.D. 1725 Orate Pro Eo* (The gift of Thady

Quin Esquire of Adare to St. John's Parish, Limerick, in honour of the Blessed Sacrament, AD 1725, Pray for him). Bears scratch weight *23:14*.

Thady Quin was the grandson of James Quin of Kilmallock, brother of John Quin, a Dominican of Kilmallock Priory, who was Bishop of Limerick at the time of the Reformation. Thady's father, Donough, married an O'Riordan of Croom. The Dunraven family are their descendants.

On loan from the Diocese of Limerick.

1.24 CHALICE
James Roche
Limerick, 1959
H: 19.4cm; D: (rim) 9.7cm, (foot) 14.9cm

Marks: OSB in an oblong punch; Dublin hallmarks for 1959

Deep internally gilded bowl with splayed sides; knopped stem on trumpet foot with applied beads forming a cross. Inscribed *To the Memory of Thomas and Mary Hayes*.

The maker of this chalice, Father James Roche, was a member of the Benedictine community at Glenstal.

On loan from the Abbot and Benedictine Community, Glenstal Abbey, Co. Limerick.

1.25a CHALICE
Jonathan Buck
Limerick, *c.* 1726
H: 24cm; D: (rim) 9cm, (foot) 14cm

Marks: IB with pellet between in an oblong punch

Deep parcel gilt bowl with everted rim, resting on above a chased calyx; the baluster stem with ornamental ovoidal knop, between two beaded flanges; decorated, stepped, domed foot on a decorated narrow flange. Inscribed *ex dono Thadai Quin Armigeri de Adare in perpetuum Usum Parochiae Sancti Nicolai de Adare anno dni 1726 orate pro:eo.*

Similar in design to many French chalices of the period.

On loan from the Adare Heritage Trust, Adare, Co. Limerick.

1.25b PATEN
Jonathan Buck
Limerick, *c.* 1726
D: 4.5cm

Marks: IB in an oblong punch (rubbed)

Gilt paten with dished centre. The underside has the sacred monogram IHS surmounted by a cross and three nails below, all within a circular band chased with floral and foliate decoration. No inscription.

On loan from the Adare Heritage Trust, Adare, Co. Limerick.

1.26 CHALICE
Cosmacs Ltd.
Limerick, 1960
H: 20cm; D: (rim) 9.1cm, (foot) 15.2cm

Marks: CLtd in a dumbbell shaped punch for Cosmacs Ltd.; WMJ in oblong punch; Dublin hallmarks for 1959

Silver-gilt replica of the De Burgo O'Malley chalice. Deep bowl with slightly everted rim. The octagonal stem with a chased knop with eight pseudo-collets and rests on an incurved octagonal foot with incurved base lines. One facet of the foot has the sacred monogram IHS and the opposite facet has a cross. Inscribed *To the most Rev. H. Murphy Bishop of Limerick For the new Diocesan College April 28th 1960 Presented by Cosmac's Ltd.*

On loan from St. Munchin's Diocesan College, Limerick.

1.27 CHALICE
Unidentified maker
Silver-gilt,
Probably Limerick, *c.* 1640
H: 24.3cm; D: (rim) 8.6cm, (foot) 13.4cm

Marks: Unmarked

Deep bowl and everted rim; a horizontal raised rib around the centre of the bowl is mounted above by alternately applied crosses and fleurs-de-lis. Below the rib are four applied winged cherubs' heads. The balustral stem has a vase-shaped knop with another four cherubs' heads. The

circular stepped domed foot rests on a narrow flange and also has four applied winged cherubs' heads as on the bowl and knop. The design of the chalice was probably inspired by the 1625 Arthur chalice on display in The Hunt Museum. Inscribed *Orate Pro Anima Patritii Sarsfield et Elenorae White qui hunc Calicem fieri fercerunt 1640. Spectat AD Conventum Sti Salvatoris Lim. Ord Praed* (Pray for the souls of Patrick Sarsfield and Eleanor White who caused this chalice to be made in 1640. The property of the Dominican Priory of St Saviour's Limerick).

The chalice was given in reparation for the part played by the donor's uncle, Dominick Sarsfield, in the judicial murder of John Burke of Brittas.

Courtesy of the Dominican Community, Limerick.

1.28 CHALICE
Unidentified maker
Silver-gilt,
Probably Limerick, *c.* 1619
H: 26cm; D: (rim) 8.9cm, (foot) 14.7cm

Marks: Unmarked

Deep bowl and everted rim; calyx of six decorated sepals; knopped hexagonal stem with chased and pierced decoration; incurved stepped hexagonal foot, one facet engraved with the Crucifixion with symbols of the Passion, the other facets engraved with vines and foliate detail. Inscribed *In usum Frater Minorum Limericensium me fieri fecit Frater Johannes Ferallus Minorita 1619* (Friar John Ferrall, of the Order of Friars Minor, caused me to be made for the use of the Friars Minor of Limerick 1619).

Fr. John Farrell was a preacher and Latin poet who entered the Franciscan Order in 1610. He composed a poem on the stigmata of St Francis and so it is not surprising that the Instruments of the Passion are engraved on his chalice. (*Franciscan College Annual*, 1952, 54).

On loan from the Irish Franciscans OFM.

1.29 CHALICE
Unidentified maker
Silver-gilt,
Probably Limerick, *c.* 1626
H: 26.4cm; D: (rim) 8.9cm, (foot) 15.1cm

Marks: Unmarked

Deep bowl with everted rim and an engraved calyx of six sepals; hexagonal stem with decorated knop set with six stones; incurved hexagonal foot, one facet engraved with a complex Crucifixion scene, a second facet has a depiction of Mary as the Apocalyptic Woman. Inscribed *D Anastasia Riz Terty Ord S Francisci Me Fieri Fecit Pro Altari Conceptionis B Mariae Fratrum Minorum Lymericensium Ano Domini 1626* (Mistress Anastasia Rice of the Third Order of St. Francis caused me to be made for the altar of the Conception of the Blessed Mary of the Friars Minor of Limerick 1626).

From the late 16th century the image of the Apocalyptic Woman depicted as praying and without the Child, became the most frequent way of representing the Immaculate Conception. The Irish Franciscans' devotion to the Immaculate Conception is reflected in the donation of this chalice.

On loan from the Irish Franciscans OFM.

1.30 CHALICE
Richard Fennell
Probably Ennis or
 Limerick, *c.* 1671
H: 21.4cm; D: (rim) 8.2cm, (foot) 13.2cm

Marks: Inscribed underneath the foot *Rickardus Fennell fecit*

Parcel gilt bowl with everted rim on a knopped hexagonal stem; the incurved, stepped hexagonal foot resting on a decorated flange; one facet of the foot with a Crucifixion scene on a calvary. Inscribed *Pr fr Moriartus O Gripha me fieri fecit Anno domini 1671*.

On loan from the Irish Franciscans OFM.

1.31 CHALICE
Richard Fennell
Probably Ennis or
 Limerick, *c.* 1671
H: 23cm; D: (rim) 8.5cm, (foot) 12.5cm

Marks: Inscribed underneath the foot *Rickardus Fennell fecit*

Deep parcel gilt bowl with everted rim on a knopped baluster stem with beaded flanges; the decorated knop chased with six lobed panels; the stepped domed circular foot

with a crucifixion scene. Inscribed *Dominus Terentuis O Kerin Sacerdos me fieri fecit ad Vsum Fratrum minorum de Innish Cluon Rauda Anno domini 1671.*

On loan from the Irish Franciscans OFM.

1.32 CHALICE
Unidentified maker
Probably Limerick,
17th century
H: 20.4cm; D: (rim) 7cm, (foot) 11cm

Marks: Unmarked

Parcel gilt bowl with slightly everted rim on a decorated knopped stem; the incurved hexagonal foot resting on a moulded edge; the facets decorated with symbols of the Passion.

On loan from the Irish Franciscans OFM.

1.33 MONSTRANCE
Unidentified maker
Possibly Limerick, *c.* 1714
H: 37cm;
D: (oval foot) 16.7cm x 13cm

Marks: Unmarked

Surmounted with a Crucifixion scene, the glazed receptacle mounted within a sunburst frame on an elaborately decorated knopped baluster stem; the stepped domed oval foot in two tiers with elaborate chased decoration. Inscribed *Orate pro fré Jacobo Madden qui me fieri fecit pro conventu de Milick Anno 1714.*

On loan from the Irish Franciscans OFM.

1.34a CHALICE
Unidentified maker
Silver-gilt,
Possibly Limerick *c.* 1638
H: 18cm; D: (rim) 7.8cm, (foot) 10.5cm

Marks: Unmarked

Bowl with everted rim, on a knopped baluster stem; the octagonal foot with outcurved angles and straight base lines resting on a moulded member; the foot engraved with a Crucifixion scene. Inscribed *Adusum fratris Francisci Madden qui me fieri fecit pro Conventu de Milick anno domini 1638*; a later inscription recording the presentation of the chalice by the Burke family to the Convent of Mercy, Parsons Town [Birr] in 1867.

The foot of this chalice permits the bowl and stem, when unscrewed, to fit inside it, suggesting that this is a travelling chalice.

On loan from St Flannan's (Killaloe) Diocesan Trust.

1.34b PATEN
Unidentified maker
D: 10cm

Marks: Unmarked

Plain slightly dished paten accompanying the Madden chalice.

On loan from St Flannan's (Killaloe) Diocesan Trust.

1.35a CHALICE
Unidentified maker
Silver-gilt,
Possibly Limerick, *c.* 1589
H: 15.5cm; D: (rim) 9.5cm, (foot) 12cm

Marks: Unmarked

Wide conical bowl with knopped hexagonal stem; the colleted knop set with coloured stones; the base of the stem with hexagonal flange; the flattened incurved hexagonal foot decorated. Inscribed *T.P. ET I.E.P. ME FIERI FECERVNT QVORVM ANIMABVS MISERIATVR OMNIPOTENS 1589* (T.P. and I.E.P. [probably the donor and his wife] caused me to be made on whose souls may Almighty God have mercy 1589).

On loan from the Sisters of Mercy, South Central Province, Ireland.

1.35b PATEN
Unidentified maker
Silver-gilt,
Possibly Limerick, *c.* 1589
D: 11.6cm

Marks: Unmarked

Dished with a cinquefoil depression in the centre containing the sacred monogram IHS on a hatched background surmounted by a cross pattée.

On loan from the Sisters of Mercy, South Central Province, Ireland.

SECTION 1 ECCLESIASTICAL

1.36 CHALICE
Richard Fennell
Probably Ennis or
Limerick, *c.* 1670
H: 21.8cm; D: (rim) 8.5cm,
(foot) 12.5cm

Marks: Inscribed underneath foot *Richardus Fennell me fecit*

Parcel gilt bowl with almost straight sides and slightly everted rim on a knopped, flanged baluster stem; the ovoid knop elaborately chased; the stepped domed foot resting on a chased flange. Inscribed *Dominus Terentuis O Kerin Sacerdos me fieri feci ad usum Fratrum Minorum de Quinhy Anno Domini 1670, also Quin Chapel.*

On loan from St Flannan's (Killaloe) Diocesan Trust.

1.37 CHALICE
Unidentified maker
Probably Limerick, *c.* 1627
H: 23cm; D: (rim) 8cm,
(foot) 13.8cm

Marks: Unmarked

Deep parcel gilt bowl with everted rim resting in an engraved calyx of six sepals; the hexagonal stem with six panelled knop, three decorated; the incurved, faceted hexagonal foot with moulded edge; Three facets engraved, one with a Crucifixion scene. Inscribed *Oretur pro. D. Leonardo Creagh et eius uxore Joana White qui hunc calicem cum missae paramentis conventui limericensi fratum minorum dederunt ano 1627*; a later inscription *The gift of D. Kennedy, Gerard Grace, D. Ryan Wm. Tompane, Jn Grace, D. O Brien, M. Hogan to the parish of Burgess 1788. MK PP.*

On loan from St Flannan's (Killaloe) Diocesan Trust.

1.38 CROSS
Philip Lyles
Limerick, *c.* 1624
H: 37.8cm; L: 14cm;
D: (base) 8cm

Marks: Inscribed underneath the base *phi Lyles fecit* with the number 49.

Highly decorated and bejewelled reliquary cross in the Lorraine style, with stepped base. Within its hollow centre the cross contains a relic of St. Ursula and within the base, a piece of ancient finely stitched leather, inscribed *Hanc crucem cum Smae Crucis Xpi particulis antiquissimus fieri fecit Richardus Arthurus Epus Limericen partim sumptibus Ioannae Fox viduae Iacobi Lange et aliorum Ao. D.1625* (Richard Arthur, Bishop of Limerick, had this cross made to contain some very ancient fragments of the most Holy Cross of Christ, partly at the expense of Joanna Fox, widow, James Lange and others AD 1625), underneath the base.

John Hunt concluded that some of the scenes and the enamel and stone settings suggest that elements of the cross may have come from an earlier object related to the O'Dea Mitre and Crosier (also on display in The Hunt Museum) and therefore possibly from the workshop of Thomas O'Carryd.

Courtesy of the Diocese of Limerick and on display at The Hunt Museum.

1.39 CHALICE
Samuel Calbeck
Limerick, *c.* 1722
H: 19.5cm; D: (rim) 7.9cm,
(foot) 11.8cm

Marks: SC flanking lion rampant surmounted by a crown, all within a shield-shaped punch struck twice.

Parcel gilt bowl on knopped baluster stem above a lobed flange; the spreading moulded circular foot engraved with a plain cross. Inscribed *Me fieri fecit Gulielmus Conellan Sacerdos Laonensis Anno Dni 1722*. Later inscribed *Me renovari fecit Jacobus Bowles Parociu de Tulla Anno Domini 1859.*

Father William Conellan died on August 22 1739 aged 84 and had been curate of Tulla parish for 59 years.

On loan from St Flannan's (Killaloe) Diocesan Trust.

1.40 PATEN
Matthew Walsh
Limerick, *c.* 1780
D: 11.3cm

Marks: MW in an oblong punch.

Slightly dished gilt paten engraved with the sacred monogram IHS, surmounted by a cross pattée; the underside engraved with three Nails.

On loan from St Flannan's (Killaloe) Diocesan Trust.

1.41 **BREAD PLATE**
John O'Shea
Limerick, 1986
H: 3.5cm; D: 21cm

Marks: JOS in an oblong punch.

Internally gilded bread plate in the form of shallow circular bowl with convex base. The entire bowl with a hammered finish. Bears two armorials; unidentified. Inscribed *Thomas Barry 1950-1975*.

On loan from the Abbot and Benedictine Community, Glenstal Abbey, Co. Limerick.

Civic, Ceremonial and Commemorative

Conor O'Brien

In this section are some objects customarily associated with civic and institutional governance and pomp. Included are freedom boxes, civic seal matrices, maces, medals, presentation trowels, coins minted in Limerick and some items of Masonic regalia.

FREEDOM BOXES

From the early thirteenth century down to the passage of the Municipal Corporations Reform Act in 1840, the right to vote in municipal elections or to engage in commerce or trade without restrictions within the boundaries of cities incorporated by royal charter was limited to those who held the franchise. Holders of the franchise were known as freemen, and while regulations varied from place to place for qualifying for this privilege, it was generally necessary to have completed a craft or trade apprenticeship under an existing freeman or to be closely related to one through birth or marriage.

Exceptionally, persons were admitted to the franchise by 'grace especial'. In this category were many foreigners who were admitted under an Act of Parliament passed in 1662 to *"encourage Protestant strangers to settle in Ireland"*. Occasionally distinguished visitors such as viceroys and persons with political influence whose support in government was courted might be conferred with honorary freedom. It was usual in such situations to present the certificate of freedom encased in a gold or silver box. The earliest record of such is the presentation of the freedom of the City of Dublin in a purpose-made gold box to the viceroy, James, Duke of Ormond, on 22 July 1662. Thereafter the practice was adopted widely by corporate bodies throughout Ireland, with Limerick prominent early on.

On 1 November 1672 the Limerick City Assembly voted to confer the freedom of the city in a silver box on the Rt. Hon. Henry, Earl of Thomond. A little more than two months later, 23 January 1673, the

Plate 66
Freedom Box, unidentified maker, Limerick c. 1693
Exhibit 2.06

Rt. Hon. Daniell, Lord Viscount Clare, was similarly granted the freedom of Limerick in a silver box, the Corporation records revealing that this box cost £2. A further eight silver freedom boxes were awarded between then and 2 October 1680, testifying to the perceived popularity of the practice as a political relations exercise. None of these early boxes are known to be extant. While Limerick Corporation frequently conferred dignitaries with their honorary freedom in the eighteenth century, specific records of such presentations after 1680 are scanty.

Plate 67
Matrix of the Seal of Kilmallock by Jonathan Buck, Limerick c. 1737
Exhibit 2.02

SEALS

A seal (or, more correctly, a seal matrix) is a stamp of metal or other hard substance incised with a particular design which, pressed into molten sealing wax on a document, is intended to guarantee its authenticity. Silver was commonly employed for seal matrices of corporations and persons of rank. Seals are known to have been used in Ireland since the twelfth century, one of the earliest recorded being the seal affixed to a charter of Domnall Ua Briain, king of Thomond, dated 1168-75.

MACES

Originally club-form weapons carried by sergeants-at-arms to protect the king's person, maces evolved as symbols of authority borne ceremonially in procession by mace-bearers escorting mayors and other dignitaries invested with high office. At deliberative assemblies presided over by mayors, judges, chancellors and similar personages, the mace was displayed in a position of prominence so as to enhance the dignity of the proceedings. The earliest record of the right of carrying maces being accorded to Limerick is contained in the charter of King James I granted in 1609. Most likely the right was also enshrined in earlier charters that have not, unfortunately, survived.

MEDALS

The idea of the medal originated in Renaissance Italy in the fifteenth century, inspired by ancient Greek and Roman coins. Medals were regarded as miniature sculptures and were commissioned to gratify or laud particular individuals. Early medals were produced either by casting or striking, the former by pouring molten metal into a mould, whilst the latter technique involved engraving the design on a steel die, the impression then reproduced by striking the die on a blank disc of the chosen metal. These techniques allowed specific medals to be produced in quantity. Entirely hand-engraved medals are less frequently encountered, since they can only be produced individually.

Medals commemorating Irish personages and events, such as the Duke of Ormond and the Williamite wars were produced by English and Dutch medallists in the later seventeenth century but it was not until a century later that native medallists, such as the Mossops and the Woodhouses, established themselves as medallic artists of the first rank. That said, a large number of very attractive wholly engraved medals were produced by unidentified silversmiths/engravers in the eighteenth and nineteenth centuries throughout the country. They occur as awards to militia, volunteer and yeomanry personnel, as school prizes, and more rarely in the fully engraved form, as prize medals at agricultural shows. In the twentieth century silver (and less frequently gold) medals proliferated as prizes in sports events, and a representative selection is shown in the exhibition.

PRESENTATION TROWELS

The practice of inviting a person of some distinction to formally lay the foundation stone of a major public works undertaking and to present him with a specially wrought silver or gold trowel as a memento of the occasion became an established custom in the late eighteenth century.

COINS

Precious metal coins were used in the Eastern Mediterranean around 500 BC and were struck in England around the time of Christ. In Ireland, however, it was not until around AD 955 that coins were minted, the earliest being silver pennies bearing the name of Sihtric, the Norse king of Dublin. Some of these early coins also bear the name of the moneyer. Since the minting of coins involved skills in cutting dies as well as the ability to assay the relevant precious metal for fineness, it is probable that many moneyers were goldsmiths. Coins were minted in Limerick on three occasions. The earliest was in the period 1190-99 during the Irish lordship of Prince John, and later when King of England. Next was in the period 1461-83 during the reign of King Edward IV. Lastly, coins were minted in considerable quantity in Limerick over a period of some months in 1689/90 during the Williamite wars. These, however, were minted from gun metal, brass, pewter and other base metals and their face value bore no relationship to their very much inferior intrinsic value.

A CELEBRATION OF LIMERICK'S SILVER

Plate 68
Freedom Box by Jonathan Buck
Limerick c. 1726
Exhibit 2.03

Plate 69
Limerick City Mace by John Robinson
Limerick c. 1739
Exhibit 2.04

79

SECTION 2 CIVIC, CEREMONIAL AND COMMEMORATIVE

Plate 70
*Limerick City Seal,
unidentified maker,
probably Limerick c. 1720*
Exhibit 2.05

Plate 71
*Freedom Box by Joseph Johns,
Limerick c. 1760*
Exhibit 2.01

A CELEBRATION OF LIMERICK'S SILVER

Plate 72
Presentation Trowel
by Richard Sawyer, Dublin 1848
Exhibit 2.07

Plate 73
Freedom Box
by Jonas Bull or Jonathan Buck,
Limerick c. 1759
Exhibit 2.08

81

SECTION 2 CIVIC, CEREMONIAL AND COMMEMORATIVE

Plate 74
Certificate of Grant of Freedom to William, Duke of Leinster, 1776
Exhibit 2.09

Plate 75
Freedom Box by Joseph Johns, Limerick c. 1752
Exhibit 2.10

A CELEBRATION OF LIMERICK'S SILVER

Plate 77
University of Limerick's Silver Jubilee Medal by Medal Manufacturing Ireland, Dublin 1997
Exhibit 2.12

Plate 76
University of Limerick Mace by Peter Donovan, Dublin 1989
Exhibit 2.11

SECTION 2 CIVIC, CEREMONIAL AND COMMEMORATIVE

Plate 78
Jim Kemmy Commemorative Medal
by Martin O'Driscoll, Limerick 1992
Exhibit 2.13

Plate 79
Commemorative Trowel
by Richard Sawyer, Dublin 1850
Exhibit 2.14

84

Plate 80
Groat, Edward IV
Limerick 1470-1473
Exhibit 2.15

Reverse

Obverse

SECTION 2 CIVIC, CEREMONIAL AND COMMEMORATIVE

Plate 81
Halfpenny, James II (Gunmoney)
Limerick 1691
Exhibit 2.16

Reverse

Obverse

86

A CELEBRATION OF LIMERICK'S SILVER

Plate 82
Williamite medal, Georg Hautsch
Nuremberg 1691
Exhibit 2.17

Reverse

Obverse

87

SECTION 2 CIVIC, CEREMONIAL AND COMMEMORATIVE

Plate 83
Freedom Box by Jonathan Buck
Limerick and Cork c. 1755
Exhibit 2.19

A CELEBRATION OF LIMERICK'S SILVER

Plate 84
a. Halfpenny, King John
Moneyer: Willem,
Limerick 1207-1211
Exhibit 2.20

b. Penny, King John
Moneyer: Willem,
Limerick 1207-1211
Exhibit 2.21

Reverse

Obverse

89

SECTION 2 CIVIC, CEREMONIAL AND COMMEMORATIVE

Plate 85
Masonic Square
by Gladman & Norman Ltd.,
Birmingham 2002
Exhibit 2.22

A CELEBRATION OF LIMERICK'S SILVER

Plate 86
*Masonic Jewel by Joseph Johns,
Limerick c. 1760*
Exhibit 2.18

SECTION 2 CIVIC, CEREMONIAL AND COMMEMORATIVE

Catalogue

2.01 FREEDOM BOX
Joseph Johns
Limerick, *c.* 1760
D: 9.3cm

Marks: II flanking lion rampant

Circular, of bombé form; cover engraved with the arms of Ennis within a rococo cartouche, the surround inscribed *The freedom of Lucius O'Brien Esqr. Presented him the 1st Novr. 1760 by the freemen of the Burrough of Ennis. Thos. Burton Esqr., Provost.*

Lucius O'Brien (1731-1795) was elected MP for Ennis in 1762. On the death of his father, Sir Edward O'Brien of Dromoland Castle in November 1765, he succeeded to the baronetcy and the Dromoland estate. The minutes of the Michaelmas meeting 1762 of the Corporation of Ennis record 'that £4 stg. be applotted and levied of the Borough as usual and when collected to be paid over to Daniel Lysaght to reimburse him for a silver box given Lucius O'Brien Esqr. with the freedom of said Borough.' Presumably Daniel Lysaght, the Limerick silversmith, had initially been given the commission which was later subcontracted to Joseph Johns.

On loan from the National Museum of Ireland.

2.02 MATRIX OF THE SEAL OF KILMALLOCK
Jonathan Buck
Limerick, *c.* 1737
D: 5.7cm

Marks: IB with pellet between

A circular silver matrix, incised with an ornamental shield framing a castellated tower, the surrounding border incised in reverse lettering: *THE: CORPORATION: SEAL: OF: KILMALLOCK: 1585:* The back of the matrix is fitted with a socket for a wooden handle and is stamped with the maker's mark and is engraved with *ROBt OLIVER JUNr ESQre SOVERAINE.*

The Corporation Book of Kilmallock for the period 1737-1774 recorded the payment of £1 9s 10d on March 21 1737/8 to 'Mr Buck' for the Corporation Seal. Robert Oliver Jun. was sovereign (as the mayor was titled) at the time. This seal is most likely a copy of one probably commissioned by the Corporation in 1585 in the wake of a new charter for the Corporation granted in the previous year by Queen Elizabeth.

On loan from the National Museum of Ireland.

2.03 FREEDOM BOX
Jonathan Buck
Limerick, *c.* 1726
D: 9cm

Marks: IB in an oblong stamped on cover and bottom

Of circular form with a slightly domed cover engraved with the arms of Limerick, a castellated gateway with portcullis, within a baroque cartouche, the surround inscribed *Insignia Armorum Civitatis Limerici Aug. 25: 1726.* Enclosed within an elaborately foliate cartouche on the underside of the bottom are the crest, arms and motto of the recipient of the box, while the inside is inscribed with the text in Latin of the presentation document acknowledging the award of the liberty and franchise of the City of Limerick to the Right Honorable Richard Tighe, of the City of Dublin, on August 25 1726, by John Carr, Mayor of Limerick.

Richard Tighe (1678-1736) was an MP and member of the Irish Privy Council of George I. He was conferred with the freedom of Kilkenny in a gold box on August 2 1718, and the freedom of Cork in a silver box on May 13 1730. It is not known if the Cork box survives. The Kilkenny gold box is now in the collection of the Museum of Fine Arts, Boston. It is engraved with the arms of Kilkenny on the cover and the arms of Richard Tighe and his wife on the underside of the bottom, and on the inside a transcription of the Kilkenny freedom document. Comparison of the two boxes, though eight years apart in date, suggests that the engraving of the Tighe armorials and the presentation particulars on both boxes were executed by the same hand, and contrasts with the less sophisticated treatment of the municipal arms on both boxes. This suggests that Tighe himself, rather than the donor cities, arranged the execution of this aspect of both boxes, probably some years after receiving them.

On loan from the National Museum of Ireland.

2.04 LIMERICK CITY MACE
John Robinson
Limerick, *c.* 1739
L: 85.2cm

Comprising a florally engraved shaft divided by two knops and surmounted with a cup-shaped head supported on the shaft by four boldly-modelled rampant

lions resting with one leg each on the topmost knop; the flat top of the head bears the royal arms of George II and the side of the head is repoussé chased with, (1) arms of Limerick City; (2) a rose and thistle surmounted by a crown (for France); (3) a crowned harp (for Ireland); (4) a crowned fleur-de-lis (for France). The shaft rests on an elaborate base with repoussé chasing, and is inscribed: *Geoe. Sexton, Esqr. Mayor. David Roche & Richd. Graves Esqrs. Shers. 1739.*

This is one of four maces belonging to the City of Limerick. They are all similar in size and design, and are all believed to date from 1739. Only the one exhibited bears a maker's mark. It is thought that originally the head of each mace may have been surmounted by an arched crown, as was customary with civic maces. The rampant lions, as against the more commonly occurring scroll-brackets on contemporary maces, are an unusual feature of the Limerick civic regalia.

On loan from the Limerick City Museum.

2.05 LIMERICK CITY SEAL
Unidentified maker
Probably Limerick, *c.* 1720
D: 5.8cm

Marks: Unmarked

Within a shield outlined in scroll-work, the matrix is incised with the City Arms, depicted as two towers, between them a central gateway with a domed roof surmounted by a Maltese cross, the portcullis in a raised position in the gateway. The surrounding inscription runs *Sigillum Civitatis Limerick, GR.*

The initials GR indicate that this seal was cut in the reign of George I (1714-1727). The right to the use of a seal was mentioned in Queen Elizabeth I's charter of 1575 to Limerick.

On loan from the Limerick City Museum.

2.06 FREEDOM BOX
Unidentified maker
Limerick, *c.* 1693
D: 10.8cm

Marks: Unmarked

A plain circular box, the detachable cover engraved with a version of the City Arms within a cartouche of plumage, and inscribed in the surround *John Craven Esqr. Mayor his and the Corporation of Lymarick's Guift with the freedom of that Citty to Leut. William Brown the 2d day of October 1693.*

Belfast-born Lieutenant William Brown (1658-1725) served in King William's army at Derry, the Boyne, Aughrim and Limerick. He achieved notoriety at Limerick for his innovative execution of mortar fire, enabling three bombs to be fired for one of the enemy's and delivering them with precision. This is the earliest known extant Irish freedom box.

On loan from the Limerick City Museum.

2.07 PRESENTATION TROWEL
Richard Sawyer
Dublin, 1848
L: 36cm

Of standard trowel shape with wood handle decorated in relief with shamrocks, the join with the blade similarly decorated with oak leaves and shamrocks. The blade is inscribed *The first stone of the floating dock of the City of Limerick was laid by John Boyse, Esq. Mayor on Friday 6th July, 1849, on which occasion this trowel was presented by the Commissioners of Public Works. Lieut. Col. Harry D. Jones, R.E., Chairman, Richd. Griffith. Esqr, L.L.D., Deputy Chairman, John Radcliffe Esqr., Willm. T. Mulvany, Esqr., Captn. T.A. Larcom, R.E., Commissioners, Edwd. Hornsby, Esqr., Secty. John Long Esqr. C.E. Resident Engineer.*

The blade is also marked *Law and Son, Dublin.*

An Act of Parliament of 1847 authorised the construction of new port facilities for Limerick. The floating dock was constructed between 1849 and 1853 at a cost of £54,000.

On loan from George Stacpoole.

SECTION 2 CIVIC, CEREMONIAL AND COMMEMORATIVE

2.08 FREEDOM BOX
Jonas Bull or Jonathan Buck
Limerick, *c.* 1759
H: 3.5cm; D: 8.7cm

Marks: IB and STERLING

A circular box with detachable lid engraved with the arms of Limerick; the underside of the box inscribed *The Corporation of the City of Limerick granted this day 3rd September 1759 the FREEDOM of the said CITY to the LORD NEWTON BUTLER for his honourable and upright conduct in the service of this CITY.*

On loan from a private collection.

2.09 FREEDOM BOX
George Halloran
Gold, Limerick, *c.* 1776
H: 3.1cm; D: 7.5cm

Marks: Script initials GH in an oblong punch

A circular box, the detachable cover engraved with the Seal of the City within the inscription *The Corporation of the City of Limerick to his Grace William Duke of Leinster Augt. 29th. 1776.*

The text of the accompanying freedom certificate reads:
County of the City of Limerick His Grace William Duke of Leinster Is Admitted into the Freedom and Franchises of said City, in the time of William Gabbett Esquire Mayor, That is to say, on the thirteenth Day of August One thousand seven hundred and seventy six and in the Sixteenth year of the Reign of our Sovereign Lord George the Third by the Grace of God of Great Britain France and Ireland King Defender of the faith and soforth In Testimony Whereof the Seal of said City is Hereunder affixed the Day and Year above Written William Gabett Mayor Cnts Examine by Robert Hallam.

William FitzGerald (1749-1804) succeeded his father as second Duke of Leinster in 1773. Unlike his brother Lord Edward FitzGerald, the United Irishmen leader, he played no major part in Irish politics, though as the premier Irish peer was one of the first to be consulted about the projected abolition of the Irish parliament and the union of the two kingdoms in 1800, in the event receiving £28,000 compensation for the loss of his Borough influence. He died at Carton, Co. Kildare, October 20 1804.

On loan from a private collection.

2.10 FREEDOM BOX
Joseph Johns
Limerick, *c.* 1752
H: 3.2cm; D: 9.8cm

Marks: II flanking a lion rampant

A circular box with detachable cover with reeded rim and engraved with the arms of Limerick; the surround inscribed *The Corporation of the City of Limerick to The Right Honorable Arthur Gore Baronet.*

Descended from Sir Paul Gore who came to Ireland in the reign of Queen Elizabeth I as an officer in her army, Sir Arthur Gore, the third Baronet, was elected MP for the borough of Donegal in 1741. He was appointed to the Irish Privy Council in 1748. He was admitted to the freedom of Limerick on October 14 1752. Elevated to the peerage as Viscount Sudley of Castle Gore, Co. Mayo, in 1758, he was created Earl of Arran in the county of Galway in 1762. He died in 1773.

On loan from a private collection.

2.11 MACE of the UNIVERSITY of LIMERICK
Peter Donovan
Dublin, 1989
L: 109cm; W: (max) 11.7cm

Cup-shaped head supported on a plain round shaft divided by three knops of flattened spherical form; applied to the sides of the cup are: (1) the Arms of the University; (2) an Irish harp; (3) the Arms of Limerick City; (4) an Irish harp. The rim of the head is bound witha crenellated band on which is inscribed *UNIVERSITATIS LIMERICENSIS X KALENDIS JULII MCMLXXXIX.* The conical dome of the head is surmounted by a cowled figure with staff, representing St. Munchin, patron of learning and of the Diocese of Limerick. On the lower end of the shaft is engraved *THOMAS RYAN, P.R.H.A., DELINEAVIT,* and underneath *PETER DONOVAN, FECIT.*

On loan from the University of Limerick.

2.12 UNIVERSITY OF LIMERICK'S SILVER JUBILEE MEDAL
Medal Manufacturing Ireland
Dublin, 1997
D: 5cm

Marks: Mark of MMI, who struck it, and TR, the initials of Thomas Ryan, its designer.

A circular medal, the obverse depicting the Salmon of Knowledge above flames, a hand with extended thumb supporting it; in the surround UNIVERSITY OF LIMERICK and *An Bradán Feasa*. The reverse shows two crossed images of the University mace, resting on them three armorial shields (1) an Irish harp; (2) the arms of the City of Limerick; (3) the arms of the University; in the surround: *UNIVERSITY OF LIMERICK 25TH ANNIVERSARY 1972-1997*.

The medal was struck to commemorate the first enrolment of students at the University on September 27 1972. The image on the obverse is based on the mythology surrounding Fionn mac Cumhail, the famed leader of the Fianna. As a boy he had been instructed by his mentor, the poet Finn Eces, to cook a particular salmon caught after seven years' efforts by the poet. No ordinary salmon, according to the legend this one (an bradán feasa) had been endowed with all the knowledge in the world which in turn would be passed to the first person to taste its flesh. The young Fionn burnt his thumb when removing the hot salmon from the spit, immediately sucking it to relieve the pain, thereby becoming the first person to taste the salmon, gaining the knowledge that enabled him to lead the Fianna.

On loan from the University of Limerick.

2.13 JIM KEMMY COMMEMORATIVE MEDAL
Martin O'Driscoll
Gold, Limerick, 1992
H: (excluding suspension ring) 8.3cm; W: (max) 5cm

Marks: MOD incuse

Of elongated heptagonal outline, with a straight base and incurved verticals, terminating in a loop for suspension; the edge and motifs in relief. Obverse depicts (1) an opposed pair of geese ascending; (2) a pair of cannon with a pyramid of balls between; (3) in the centre the Treaty Stone flanked by two ink-wells with quills; (4) a scroll beneath, engraved 1691. Reverse is inscribed *Presented to Ald. Jim Kemmy T.D. By the Building & Allied Trade Union in Commemoration of His Mayoralty of The City of Limerick 1991-92*.

Jim Kemmy (1936-1997) was a distinguished Limerick historian and public representative. He served as mayor on two occasions 1991-92 and again in 1995-96.

On loan from the Limerick City Museum.

2.14 COMMEMORATIVE TROWEL
Richard Sawyer
Dublin, 1850
W: 9.5cm

Marks: RS once on upperside of blade

Blade in two sections (one conical, the other triangular) with chased decoration and applied inscription. The handle attached to the blade by a cast foliate detail and the handle terminal is ivory. Inscribed *Presented TO The Knight of Glin BY George Patterson Builder &c &c MARCH 1851* engraved on upperside.

The Limerick Chronicle, March 26 1851, records the founding of the new Glin workhouse: "Monday last the Knight of Glin, chairman of that union, accompanied by the neighbouring gentlemen, proceeded to the site of the intended new workhouse, where they were met by the contractor and his staff, and Mr. Ballantine, the clerk of works, then the ceremony of laying the first stone was proceeded with. The Knight was attended by Mr. Patterson, the contractor, with all the necessary implements, and on his being about to spread the mortar, he was presented with a beautiful chased silver Trowel, bearing the following inscription: - 'Presented to the Knight of Glin by George Patterson, Builder, etc., etc., March 1851'. The Knight acted his part in his usual courteous manner, and in conclusion of his address hoped that this as well as every other institution of the kind in Ireland, would be soon turned from their unprofitable inaction into industrial and self-supporting establishments. Three cheers were then given for the Knight, and the workmen proceeded to expend his gift upon a 'Cruiskeon Lawn'".

John Fraunceis FitzGerald, 25th Knight of Glin (1791-1854), was a keen yachtsman (see Exhibit 3.23) and a popular resident landlord and did much to develop the town of Glin and lay out the grounds and turn the Georgian house into a battlemented castle. He died of cholera caught from performing his duties in the workhouse. We are indebted to Tom Donovan for this reference.

On loan from the Knight of Glin.

2.15 GROAT, EDWARD IV
Limerick, 1470-73
D: 2.4cm

Edward IV groat, Limerick Mint, 1470-73. Obverse: bust in tressure, rose to either side; reverse: cross with three pellets in two of the quarters, and two pellets and a rose in the other quarters. Inscribed: obverse and reverse, edge inscriptions clipped; reverse *CIVITAS LIMIRICI.*

A groat was equivalent to four pennies.

On loan from the Earl of Rosse.

2.16 HALFPENNY, JAMES II (GUNMONEY)
Brass, Limerick, 1691
D: 2.9cm

Obverse: Laurelled and draped bust of James II; in the surround *JACOBUS II DEI GRATIA.* Reverse: Figure of Hibernia seated; in the surround *HIBERNIA 1691,* the letter N of Hibernia reversed.

Endeavouring to save his throne, King James II came to Ireland in 1689 where he found a scarcity of coin. He established mints in Dublin and Limerick to strike the high denominations in base metals, intending to redeem the coins when he regained his throne. In Limerick, after the defeat of James at the Battle of the Boyne, the gunmoney shillings were restruck as halfpennies and farthings. Part of the earlier inscription is visible on one side of the coin exhibited.

On loan from the Earl of Rosse.

2.17 WILLIAMITE MEDAL
Georg Hautsch
Silver, Nuremberg, 1691
D: 4.1cm

Marks: GH

Obverse: bust of William III, laureate and draped; *WILH. III D. G. ANG. SCO. FR. ET HIB. REX DEF. FID.* Reverse: Victory flying, attended by infant genii displaying six shields, each with a plan: *WATERFORT; ATHLONE; LIMERICH; KINSAL; LONDONDERRY; GALOWAY.* Below, an equestrian figure commanding a battle; in the distance *DROGHEDA* and *DUBLIN.* In the exergue *RESTITVTORI HIBERNIAE. MDCXCI.* Edge: *ANNORVM GESTA DVORVM CERNIS: QVID PLVRES FACIENT*

Limerick suffered during the Williamite war (1688-1691), and in particular during the two sieges of 1690 and 1691. The 'gunmoney' coin of James II struck during that period (Exhibit 2.16) and the triumphant medal struck by the victorious William III to commemorate his victory in Ireland (Exhibit 2.17) stand as acknowledgement of an important part of the city's history.

On loan from the Earl of Rosse.

2.18 MASONIC JEWEL
Joseph Johns
Limerick, *c.* 1760
H: 8.1cm; W: (max) 6.9cm

Marks: II flanking a lion rampant

In the form of a vertically sectioned three-necked globular vessel with a straight base, the wide central neck with a false lid partially engraved with lattice pattern and surmounted with strip pierced with five eyelets; the narrower necks protruding on either side with open mouths. The body of the vessel is engraved with a coat of arms within a rococo cartouche incorporating different Masonic insignia and surmounted by a crest – an arm isssuing from clouds holding a trowel erect. Beneath is a scroll bearing the motto: *CONCORDIA FRATRUM.* The reverse side of the item bears the mark of Joseph Johns clearly struck, and is also engraved *No. 296.*

The origins of Freemasonry are obscure but it is generally accepted that the society evolved from the organised brotherhood of stonemasons who built the great cathedrals, abbeys and castles in medieval times. Freemasonry in its modern form has little to do with building skills though it uses stonemasons tools and customs as allegorical guides in its rituals. Organised Freemasonry commenced in

Ireland in 1725 with the formation of a Grand Lodge in Dublin, and this was followed by the establishment of numerous subsidiary lodges throughout the country. The number 296 engraved on the reverse of the object here, identifies it as the property of a Lodge in Tipperary town which obtained a warrant on June 24 1758, surviving until 1832. The Grand Lodge register lists the initial officers as William Chadwicke, Master; Thos. Buchanan and Richd. Lockwood, Wardens. The Lodge appears to have occasionally transferred to Cashel for meetings. The precise significance and symbolism of the jewel on exhibition remains to be elucidated. Similar jewels appear to be unknown in institutional collections in Dublin and London, though an almost identical item, engraved with the same armorials, is in the collection of Limerick City Museum, which might suggest that this form of Masonic jewel was peculiar to lodges in North Munster. The coat of arms, showing two castles above and below a chevron on which is extended a compass, is derived from arms granted in 1473 to the Freemasons' Company of London.

On loan from a private collection.

2.19 FREEDOM BOX
Jonathan Buck
Limerick and Cork, *c.* 1755
D: 7.6cm

Marks: The image of a buck in an oblong punch

Circular, with slightly domed cover engraved with the arms and motto of the City of Cork captioned *Corke Arms*.

This freedom box is one made by a Limerick-born goldsmith who moved to Cork. It bears neither a presentation inscription nor the recipient's arms. The explanation may relate to the fact that Cork Corporation liberally bestowed the freedom of the city in silver boxes on important visitors 'that may be of some use to the Trades of this City', such as officers commanding fleets calling to Cork to be victualled. It would appear that the extent of stay of many such visitors in the city did not always allow time for their personal particulars to be engraved on their freedom boxes.

On loan from a private collection.

2.20 HALFPENNY, KING JOHN
Moneyer: Willem
Limerick, 1207-11
D: 1.5cm

Obverse: crowned bust within triangle; legend *JOHANNE REX*. Reverse: sun, moon and three stars within a triangle; legend *WILLEM ON LIM*.

On loan from a private collection.

2.21 PENNY, KING JOHN
Moneyer: Willem
Limerick, 1207-1211
D: 1.95cm

Obverse: within a triangle, crowned bust of king holding sceptre; legend *JOHANNES REX*. Reverse: a representation of the sun, moon and three stars, all within triangle; legend *WILLEM ON LIME*.

On loan from a private collection.

2.22 MASONIC SQUARE
Gladman & Norman Ltd.
Silver-gilt,
Birmingham, 2002
W: 15cm

Marks: G & N in a shaped punch

A silver-gilt replica of a much corroded old brass square, known as the Baal's Bridge Square, which was discovered under the foundations of the ancient Limerick bridge, known as Ball's (or Baal's) Bridge, when it was being rebuilt in 1830. It was inscribed on one side *I WILL STRIVE TO LIVE WITH LOVE & CARE* and on the other side *UPON THE LEVEL BY THE SQUARE*. It bears the date 1507, and a heart is engraved at each angle.

The ancient brass square is reputed to be one of the earliest Masonic items in the world. The inscribed date 1507 would suggest that the original bridge, which consisted of four arches, was built around this time.

On loan from a private collection.

Sports

Eamonn Noonan and Jim Noonan

The achievements of Limerick sportsmen and women have been recorded and celebrated through the work of goldsmiths and silversmiths. Alone of the sections of this exhibition the vast majority of items exhibited here have not been made in Limerick. Rather they have been won by Limerick men and women in sporting contests with horse, ball or boat and in locations which range from Croke Park to Calcutta and from Cardiff to Clogheen.

The earliest authentic records of sport in Ireland relate to the Tailteann Games. Reference to these national games, contained in ancient manuscripts, are associated with the death and burial of the renowned Queen Tailte, wife of King Eochaidh Mac Erc, the last Firbolg Monarch of Erinn in 1896 BC. The games were originally instituted in her honour. The Tailteann Games were celebrated in ancient Ireland more than a thousand years before the foundation of Rome and more than 400 years before the original Olympic Games in ancient Greece.

Plate 87
GAA All-Ireland
Senior Hurling Medal
by John Miller, Dublin 1918
Exhibit 3.02

These games included athletic, gymnastic and equestrian contests, running, long-jumping, high-jumping, hurling, quoit-throwing, spear-casting, sword-and-shield contests, wrestling, boxing, swimming, horse-racing, chariot-racing, spear or pole jumping, slinging contests, bow-and-arrow exhibitions and every sort of contest exhibiting physical endurance and skill. In addition, there were literary, musical, oratorical and story-telling competitions; singing and dancing competitions, and tournaments of all kinds. They also included competitions for goldsmiths, jewellers and artificers in the precious metals; for spinners, weavers and dyers, and the makers of shields and weapons of war. The Tailteann Games became famous all over Europe as an essential component of the *Aonach* or national assembly which was last celebrated in 1169.

From the medieval period sporting activities were local in nature with each village or parish having its own sporting events on feast days. Throughout the centuries sporting events in Ireland were influenced by invasions, wars, internal strife, famine and constant attempts of suppression. The Famine in 1847 had a devastating effect on the Irish people and sporting activities disappeared throughout the land.

In the 1860s sports such as cricket and rugby were introduced into Ireland. Both games became very popular in Limerick, especially rugby of which there are at least ten clubs in the city. These clubs have over many years provided the mainstay of the Munster team, winning many honours over the years, none more so than the defeat of New Zealand's legendary All-Blacks in Thomond Park in 1978 and the Heineken Cup victory in 2006. Many Limerick rugby players have also distinguished themselves at international level playing for their country. This great rugby tradition is marked by two gold Munster Cup medals won by the Cunneen brothers – Jack and Paddy, of Singland Cross, Limerick – and also by the Student European Rugby Championship (SERC) winner's medal won by Jerry Flannery with UCC in 2001, and the same player's Heineken Cup winner's medal won with Munster in 2006.

Limerick has also a great tradition in the field of Gaelic games played under the auspices of the Gaelic Athletic Association (GAA), founded in 1884. The GAA organises the annual All-Ireland Championships in both hurling and Gaelic football. The first of these championships took place in 1887 and the football victors were Limerick Commercials, a member of which club was Malachy O'Brien whose winner's medal is included herein (Exhibit 3.03). The medals were not presented until 1912 due to the financial state of the GAA. It is interesting to note that this medal has the goldsmith's mark of Duffner of Tipperary stamped on the rear with Dublin assay marks and date letter for 1911-1912. It is also interesting to note that the Munster crest is engraved on the front (this is an All-Ireland medal.) Also in this exhibition is an 1897 All-Ireland hurling medal won by Mike Downes of Kilfinnane GAA Club representing Limerick (Exhibit 3.16). The inclusion of All-Ireland hurling medals won by Mick Mackey and by father and son, Ned and Eamonn Cregan, as well as the camogie medals won by Eamonn Cregan's daughter, Niamh, attest to the strength of the Gaelic Athletic Association in this part of Ireland and its incalculable contribution to Limerick's sporting life.

In the ninteenth and twentieth centuries the majestic River Shannon, which flows through Limerick city, was the scene of many colourful regattas in which Limerick's four rowing clubs Athlunkard, St. Michael's, Shannon and Limerick Rowing Club, participated and competed against each other and

Plate 88
GAA All-Ireland
Senior Gaelic Football Medal
by A. Duffner, Tipperary 1911-1912
Exhibit 3.03

Plate 89
GAA All-Ireland
Senior Hurling Medal
by John Miller, Dublin 1936
Exhibit 3.04

SECTION 3 **SPORTS**

Plate 90

A collection of GAA medals won by three generations of the Cregan family.

Exhibits 3.05a, 3.05b, 3.05c, 3.06a, 3.06b, 3.06c, 3.12a and 3.12b

numerous visiting clubs. This great sporting tradition is represented by the presence in the exhibition of a number of the historic trophies competed for on this mighty river.

Salmon and trout fishing was a popular sporting pastime down through the years. Fishing competitions were regular events in the region. Picturesque Doonass and Castleconnell were particularly popular locations for these events. John Enright, born in Castleconnell in 1848, was renowned for the making of cane fishing-rods and tackle. He broke many world records in competitions throughout the world for fly casting until his death in 1908.

The Limerick Fish Hook, known throughout the world and still referred to to-day, was made by Daniel O'Shaughnessy at the beginning of the ninteenth century. The business was carried on later by his son Robert, who was a goldsmith of George's Street, Limerick.

Limerick sportsmen dominated the Olympic Weight Throwing events from 1900 to 1920. John Flanagan from Martinstown, Co. Limerick, won three gold medals for the 16 lb. shot in 1900, 1904 and 1908 and on each occasion broke the world record. Matthew McGrath of Tipperary won a gold medal for the same event in 1912 as did Paddy Ryan of Pallasgreen, Co. Limerick, in 1920. This was the first occasion that the Olympic symbol of five intertwining coloured rings was introduced.

A CELEBRATION OF LIMERICK'S SILVER

Plate 91
Rathkeale Volunteers Medal
by William Pitts
Exhibit 3.24

Plate 92
Gold Olympic Commemorative Medal
Exhibit 3.07

Reverse

101

SECTION 3 **SPORTS**

Plate 93
*Silver Olympic Medal,
by Josué Dupon, 1920*
Exhibit 3.08

Plate 94
*Collection of angling medals won
by John Enright, 1848-1908.*

Exhibits 3.09a, 3.09b, 3.09c, 3.09d
and 3.09e

102

A CELEBRATION OF LIMERICK'S SILVER

Plate 95
Trophy by John Smith, Dublin 1872-1873
Exhibit 3.10

Plate 96
Trophy by John Smith, Dublin 1873-1874
Exhibit 3.11

Plate 97
*GAA All-Ireland Senior Hurling Medal
by Moore & Co., Dublin 1898*
Exhibit 3.16

SECTION 3 **SPORTS**

Plate 98
The Assolas Punch Bowl
by John or James Robinson,
Limerick c. 1729
Exhibit 3.13

Plate 99
GAA All-Ireland
Senior Hurling Medal
by John Miller, Dublin 1936
Exhibit 3.14

Plate 100
Munster Junior Cup Rugby Medal
Exhibit 3.15

Plate 101
Munster Challenge Cup
Rugby Medal
by O'Connor 1925-1926
Exhibit 3.17

A CELEBRATION OF LIMERICK'S SILVER

Plate 102
Salver
Exhibit 3.23

Plate 103
Students European Rugby Championship Medal
Exhibit 3.18

Plate 104
Heineken Cup Winners Medal (reverse shown)
Exhibit 3.19

Plate 105
Limerick Civic Carnival Medal
Exhibit 3.20

105

SECTION 3 **SPORTS**

Plate 106
Beaker, unidentified maker,
Birmingham 1870-71
Exhibit 3.21

Plate 107
Pair of footed salvers,
unidentified maker, Dublin c. 1745
Exhibit 3.22

A CELEBRATION OF LIMERICK'S SILVER

Plate 108
*The Greenmount Cup
by George Angell,
London 1860*
Exhibit 3.01

107

Catalogue

3.01 THE GREENMOUNT CUP
George Angell
London, 1860
H: (max. incl. cover) 21.5cm
W: (max.) 41cm

Marks: GA in quatrefoil punch struck once under the bowl and once inside the lid, London assay marks

Of basic campanula form, the whole profusely encrusted with figural representations of fox hunting, with detachable domed cover. Inscribed *PRESENTED to Edward Green, Esqr. of Greenmount. IN RECOGNITION OF HIS MANY KIND & SOCIAL QUALITIES & OF THE LIBERAL & SPIRITED MANNER IN WHICH HE HAS HUNTED THE COUNTRY SINCE ASSUMING THE MASTERSHIP OF THE LIMERICK HOUNDS 1860.*

On loan from a private collection.

3.02 GAA ALL-IRELAND SENIOR HURLING MEDAL
John Miller
Gold, Dublin, 1918
H: 3.7cm; W: 3.2cm

Marks: JM in an oblong punch, Dublin hallmarks for 1918

Traditional Celtic cross design with a central harp in a shield. Obverse: *Éire* and around the outer perimeter of the medal *Cumann na gCleas Luith Gaedheal*. Reverse: *All Ireland Hurling Championship 1918 won by Limerick*.

The 1918 All-Ireland Senior Hurling Final between Limerick and Wexford was not played until January 26 1919 due to the 1918 viral influenza epidemic. This medal was won by Paddy (Feeney) Shanny, Claughaun GAA Club, Limerick. The final score was Limerick 9 goals 5 points, Wexford 1 goal 3 points. It is interesting to note that Paddy Shanny and his friend Michael Downey, when returning from the funeral of Henry Clancy who was murdered by the Black and Tans on May 1 1921, were fired on by Crown Forces. Paddy Shanny escaped but Michael Downey was fatally wounded.

On loan from a private collection.

3.03 GAA ALL-IRELAND SENIOR FOOTBALL MEDAL
A. Duffner
Gold, Tipperary, 1911-12
H: 4.2cm; W: 3.5cm

Marks: A. Duffner and Dublin hallmarks for 1911-12

Traditional Celtic cross design with the Munster crest engraved in a central shield surmounted with the word *Éire*. Obverse: *GAA Central Council C'ship 1887*. Reverse: *First All-Ireland F. Championship, won by Limerick Commercials.*

The first All-Ireland GAA Championships played in both football and hurling took place in 1887. This is one of the 1887 football medals won by Malachi O'Brien (nicknamed "Little Wonder" due to his small stature) when Limerick Commercials beat Young Irelands (Dundalk) at the Clonskeagh Grounds (also known as The Big Bank) in Co. Dublin. Final score: Limerick Commercials - 1 goal 3 points, Young Ireland 3 points. This was the only time that the championship was not divided into counties; Commercials were the then champion club of Limerick. These football medals were not presented to the players on match day; it was not until 1912, twenty-five years after the event, that it was presented. Apparently this was due to lack of funds.

On loan from Mr and Mrs John McStay.

3.04 GAA ALL-IRELAND SENIOR HURLING MEDAL
John Miller
Gold, Dublin, 1936
H: 3.7cm; W: 3.3cm

Marks: JM in an oblong punch, Dublin hallmarks for 1936

Traditional Celtic cross design with an Irish harp engraved in a central shield. Obverse: *Éire* across the centre and engraved around the edge *Cumann Lúith-Chleas Gaedheal*. Reverse: *Craobh Iomána na h-Éireann Sinnsear 1936 Luiminig a Bhuaigh*.

This medal was won by Michael Cross, Cloughaun GAA Club, Limerick. This match was played in Croke Park between Limerick and Kilkenny. The final score was Limerick 5 goals 6 points, Kilkenny 1 goal 5 points. Michael Cross also won an All-Ireland Senior Hurling Medal in 1934.

On loan from a private collection.

3.05a GAA ALL-IRELAND SENIOR HURLING MEDAL
John Miller
Gold, Dublin, 1934
H: 3.7cm; W: 3.3cm

Marks: JM in an oblong punch, Dublin hallmarks for 1934

Traditional Celtic-style cross design with a central shield chased with an Irish harp. Obverse: *Éire* and engraved around the edge *Cumann Lúith-Chleas Gaedheal*. Reverse: *Craobh Iomána na h-Éireann Sinnsir Luimneach a bhuaidh - Bliadhain Lubhaile 1934*.

This match was a replay from the previous drawn game against Dublin and was played in Croke Park on September 30 1934. The final score was Limerick 5 goals 2 points, Dublin 2 goals 6 points. This was Ned Cregan's third Senior Hurling Medal awarded in 1934.

On loan from Conor Cregan and family.

3.05b GAA NATIONAL LEAGUE HURLING MEDAL
John Miller
Gold, Dublin, 1935
H: 3.7cm; W: 3.3cm

Marks: J.M in oblong punch and Dublin hallmarks for 1935

Medal in the form of a Celtic cross engraved with a round tower and other Celtic revival images in a centre circle. The outer perimeter having raised enamel and gold symbols of the four provinces of Ireland. No inscription on the front. Reverse: *An Connradh Náisiúnta Iomána Luimnigh a bhuaidh 1934-5*

This League Final was played in Pairc na nGael, Limerick, and Ned Cregan was on the Limerick team that defeated Dublin. The final score was Limerick 3 goals 6 points, Dublin 3 goals 3 points. This was the first of five National League Finals that Limerick won in a row.

On loan from a private collection.

3.05c GAA MUNSTER SENIOR HURLING MEDAL
Unidentified maker
Gold, 1934
H: 3.6cm; W: 3.3cm

Marks: Not noted

Nine carat gold circular medal with Celtic entwined lacing with an enamel and gold Munster crest in the centre. Obverse: *Craobh na Mumhan*. Reverse: *Iomán Aosánach 1934 Luimneach a bhuaidh*.

This medal was won by Ned Cregan, Newcastle West GAA Club, in the Munster Final between Limerick and Waterford. The match was played in the Cork Athletic Grounds. Limerick defeated Waterford by 3 goals 7 points to 1 goal 2 points.

On loan from a private collection.

3.06a GAA ALL-IRELAND SENIOR HURLING MEDAL
John Miller
Gold, Dublin, 1973
H: 3.7cm; W: 3.2cm

Marks: JM in an oblong punch, Dublin hallmarks for 1973

Celtic-style cross design medal with an engraved Irish harp in a shield in the centre. Obverse: *Éire* across the centre and engraved around the edge *Cumann Lúth Chleas Gael*. Reverse: *Craobh Iomána na hÉireann 1973 - Luimneach*.

Limerick defeated Kilkenny in the final in Croke Park on September 2 1973. Eamonn Cregan played centre back for Limerick when they defeated Kilkenny by 1 goal 21 points to 1 goal 14 points. The President of Ireland, Mr. Erskine Childers, viewing his first hurling game said: "This is the greatest game I've seen in my lifetime and I am speaking of all games."

On loan from Eamonn Cregan.

3.06b GAA ALL-IRELAND NATIONAL HURLING MEDAL
John Miller
Gold, Dublin, 1971
H: 3.6cm; W: 3.2cm

Marks: J.M in an oblong punch and Dubliin hallmarks for 1971

Medal in the form of a Celtic cross with two crossed hurleys and a sliotar engraved in a central circle and the crest of each of the four provinces of Ireland set in enamel on the arms of the cross. Reverse:

SECTION 3 SPORTS

An Connrad Náisiúnta 1971 Luimneach.

Eamonn Cregan, Claughaun GAA Club, and son of Ned Cregan played for Limerick against Tipperary in the final at Cork Athletic Grounds. The final score was Limerick 3 goals 12 points and Tipperary 3 goals 11 points.

On loan from Eamonn Cregan.

3.06c GAA MUNSTER SENIOR HURLING MEDAL
Gold, Dublin 1973
D: 3.4cm

Marks: L.B and Dublin hallmarks for 1973

Medal featuring Celtic motifs and the Munster crest in enamel and gold in the centre. Obverse: *Craobh na Mumain.* Reverse: *Iomaint na Sinnsir 1973,* also inscribed *Bowman Dungarvan* (probably retailer).

This final was played on July 29 1973 at Thurles. Eamonn Cregan played centre back on the Limerick team. The final score was Limerick 6 goals 7 points, Tipperary 2 goals 18 points. The winning point was scored in the final seconds.

On loan from a private collection.

3.07 COMMEMORATIVE MEDAL
Gold, Birmingham, 1908
D: 3.1cm

Marks: I.M and Birmingham assay marks

Commemorative medal for world record hammer throw at the London Olympic Games, 1908. The front has a series of circles with inscriptions and in the centre there is a winged wheel symbol. The back has an inscription amidst a dense tuft of leaves. Inscribed (obverse) *Amateur Athletic Association*; (reverse) *Hammer Record - J.J. Flanagan 170ft.-4 $^{1}/_{4}$ in. Olympic Games 14th July 1908.*

John Flanagan won three Olympic gold medals for the 16 lb. hammer throw event in Paris 1900, St. Louis USA 1904, and in London 1908. He broke the world distance record on all three occasions. John also won a silver medal for the 56 lb. hammer throw at the St. Louis Olympics in 1904. He was born in the parish of Knocklong/Glenbrohane, Co. Limerick, on January 28 1868. There is a bronze monument erected to his memory opposite Martinstown church in Co. Limerick. He was buried in Ballingaddy cemetery near Kilmallock, Co. Limerick, on June 3 1938.

On loan from his grand-niece Angela Lyons.

3.08 OLYMPIC MEDAL
Designed by Josué Dupon
Belgium 1920
D: 6cm

Mint: Coosemans, Brussels

Olympic medal, silver, won by Patrick (Paddy) James Ryan at the 1920 Summer Olympics held in Antwerp, Belgium, for the 56 lb. weight throw. Obverse showing victorious athlete bringing back the palm of Victory; Fame sounding a trumpet in the background; inscribed on a frieze *VII OLYMPIADE.* Below the feet of the athlete the medallist's name, Josué Dupon, is inscribed. The reverse showing the monument of Antwerp which commemorates of the legend of Brabo (a Roman soldier), killer of the giant which terrorised the river Scheldt, in relief with the cathedral and port of Antwerp in the background; inscribed on the top *ANVERS MCMXX.*

The 1920 Summer Olympics in Antwerp, Belgium, were officially known as the Games of the VII Olympiad. Antwerp was the first place that the Olympic flag, bearing five interlocking rings, was displayed. 1,250 medals were minted for the event; 450 were of gold, 400 of silver and 400 of bronze. The medals were designed to commemorate the Classical origins of the games and to celebrate the host city. Paddy Ryan (1883-1964), a native of Pallasgreen, Co. Limerick, also won a gold medal for the 16 lb. hammer at the same event.

On loan from a private collection.

3.09a WORLD FLY-FISHING MEDAL
Vaughton Ltd.
Gold, Birmingham, 1896
H: 3.1cm; W: 2.8cm

Marks: Birmingham assay marks for 1896

Maltese-style engraved cross. The obverse inscription is on a circular piece attached to the body of medal. Obverse: *J Enright, WIMBLEDON TOURNAMENT 1896.* Reverse: *CLASS II,*

CHAMPIONSHIP PRIZE FOR 20FT SALMON RODS.

On loan from Marty O'Brien Enright.

3.09b　SILVER ANGLING MEDAL
Vaughton Ltd.
Birmingham, 1896
H: 3.8cm; W: 3.7cm

Marks: Vaughton and Birmingham hallmarks for 1896

Engraved silver medal won by John Enright at the Wimbledon Tournament in 1896. Obverse: *J Enright WIMBLEDON TOURNAMENT 1896.* Reverse: *CLASS I, FIRST PRIZE*

On loan from Marty O'Brien Enright.

3.09c　ANGLING MEDAL
Vaughton Ltd.
Gold, Birmingham, 1896
H: 3.9cm; W: 2.6cm

Marks: Vaughton and Birmingham hallmarks for 1896

Medal comprising a circle, surmounted by a crown, enclosing a shield. Obverse: *J Enright WIMBLEDON TOURNAMENT 1896.* Reverse: *[CL]ASS 9 CHAMPIONSHIP PRIZE* around the ring, and in the centre shield *FOR 16FT SALMON RODS.*

On loan from Marty O'Brien Enright.

3.09d　ANGLING MEDAL
Vaughton Ltd.
Gold, Birmingham, 1896
H: 3.1cm; W: 2.1cm

Marks: Vaughton and Birmingham hallmarks for 1896

Nine carat shield-shaped medal. Obverse: *J Enright, WIMBLEDON TOURNAMENT 1896.* Reverse: *CLASS 7 CHAMPIONSHIP PRIZE FOR 14FT TROUT ROD.*

On loan from Marty O'Brien Enright.

3.09e　COMMEMORATIVE MEDAL
Medallist, Jules-Clément Chaplain (1839-1909)
Paris, *c.* 1900
D: 6.4cm

A commemorative medal in two halves for the Universal Exposition, Paris 1900; the obverse depicts the head of France 'Marianne' with a laurel wreath and the inscription *REPUBLIQUE FRANÇAISE.* The reverse shows the figure of Victory bearing a laurel wreath and palm branch above the legend *EXPOSITION UNIVERSELLE INTERNATIONALE - 1900 - J.C. Chaplain.*

This medal was won by John Enright at the Paris angling exhibition on the river Seine in 1900 for creating a world record in the 19 ft. fly casting event. The Universal Exposition attracted more than 50 million people to Paris and coincided with what was known later as the Second Olympic Games of the modern era.

On loan from Marty O'Brien Enright.

3.10　ROWING TROPHY
John Smith
Dublin, 1872-73
H: 45.5cm; W: 28cm

Marks: J.S in a rounded oblong punch, Dublin assay marks for 1872-3

Spherical bowl surmounted by a capstan-shaped top (finial lacking), linked to the bowl by four oars; two dolphin-capped scroll handles; supported on spreading base by three sea-creatures; the spreading circular base chased with a band of shamrock. Two panels on bowl chased with shamrocks with interstitial stippling; one panel enclosing the arms of Limerick under a banner *Limerick Annual Regatta.* The opposite panel inscribed *1873 Limerick Challenge Cup. Won by Shannon Rowing Club D Blue B O'Donnell M Madigan T Mackey (Str) S Shanks (Cox).*

On loan from a private collection.

3.11　ROWING TROPHY
J. Smith
Dublin, 1873-74
H: 44.2cm; W: 24cm

Marks: J.S in a rounded oblong punch, Dublin assay marks for 1873-4

The bowl of spherical form with a neck construction surmounted by a cup applied with Neptune masks; the bowl chased with panels of chased foliage and applied with two plaques, one chased with the arms of Limerick, the opposite plaque inscribed *1872, the Limerick cup won by The Shannon*

Rowing Club and names of the crew. Two ring-topped handles: the chased baluster base reinforced with scroll-form brackets.

On loan from a private collection.

3.12a GAA ALL-IRELAND INTERMEDIATE CAMOGIE MEDAL
Medal manufacturing
Ireland, 1996
H: 3.2cm; W: 2.8cm

Marks: MMI

Circular medal in the Celtic cross style with a decorated Celtic *C* in the centre; a hurley rests diagonally across the letter. Obverse: *COMÓGAÍOCHT IOIRMHEÁNACH*. Reverse: *1996*.

Niamh Cregan (daughter of Eamonn Cregan, grand-daughter of Ned Cregan), Croagh-Kilfinny Camogie Club, played with Limerick when Limerick defeated Down at the Limerick GAA Grounds. The final score was Limerick 2 goals 10 points, Down 1 goal 6 points.

On loan from Niamh Cregan.

3.12b GAA MUNSTER JUNIOR CAMOGIE MEDAL
D: 2.7cm

Marks: No maker's mark. Stamped 925

Circular silver medal with a decorated Celtic *C* in the centre; a hurley rests diagonally across the letter and superimposed on this is a Munster provincial crest. Obverse: *Cumann Comógaíocht na Mumhan*. Reverse: *Craobh na Mumhán* [sic], *Idir Mheanach 1995*.

This medal was won by Niamh Cregan (daughter of Eamonn Cregan, grand-daughter of Ned Cregan), Croagh-Kilfinny Camogie Club, when Limerick beat Tipperary in the Munster Junior Camogie Final played in Burgess. Limerick defeated Tipperary by 2 goals 8 points to 1 goal 7 points.

On loan from Niamh Cregan.

3.13 THE ASSOLAS PUNCH BOWL
John or James Robinson
Limerick, *c.* 1729
H: 20.2cm; D: 29cm

Marks: I.R in an oval punch

Of plain hemispherical form on a spreading moulded foot, with moulded rim; engraved with the figure of a highwayman withdrawing his pistol, captioned *Mc Heath* underneath, and to his side *Hark;* around the bowl the inscription *This Plate was given by Capt. Mackheath of the County of Clare and his Gang and won at Assolas in the s'd County on the 25th Augt. 1729*. A later inscription states that the bowl was *Bequeathed to Sr. Jn. Blackwood, Bt. By Edwd. Bailie Esqr.*

The inscription refers to the highwaymen, Captain Macheath and his Gang, characters in John Gay's satirical play with songs, *The Beggar's Opera*, staged first in London, January 29 1728. The ballad opera's popularity spread rapidly throughout the British Isles.

Situated between Dromoland and Quin, Assoslas is now known as Ardsollus. The 1842 OS map of Co. Clare shows the 'Old Racecourse' traversing several townlands in the district, the extent of the circuit being about 1½ miles. No records appear to survive for the August 1729 meeting. Ten years later an advertisement in *Pue's Occurrences,* May 5 1739, gave particulars of a 4-day meeting, Monday to Thursday, June 11 to June 14, 1739. It probably reflects the programme for the event of a decade earlier. Monday's race, for 5-year olds and under, was to be run in three heats for a prize of £20 worth of linen of Clare manufacture. Tuesday's race, again in three heats, was for galloways under 14 hands and carrying 9 stone the highest, weight for inches downwards, 10 lbs. allowed for the first inch and 7 lbs. for every inch after. The entrance fee was one pistole, the prize was a purse of £15 sterling. Wednesday, being the Fair Day of Spancil Hill, was devoted to buck hunting and *'Stakes run for by Grass Horses'*. Thursday's event, for a prize of £20 sterling, was again a 3-heat race,for horses, mares or geldings, carrying 10 stone. The entrance fee was one guinea and the prize £20. The advertisement stressed that *'There will be Buck-hunting every Morning, good Ordinaries [meals] every day and Balls and good other Entertainments for the Ladies at Night'*. Race meetings took place intermittently at Assolas during the eighteenth and nineteenth centuries up to around 1819 when they ceased at that Clare venue.

This bowl was previously shown at the exhibition *Historic Silver in Ulster* held February-March 1956 at the Belfast Museum and Art Gallery.

On loan from a private collection.

3.14 GAA ALL-IRELAND SENIOR HURLING MEDAL
J. Miller
Gold, Dublin, 1936
H: 3.7 cm; W: 3.3 cm

Marks: J.M in an oblong punch with Dublin hallmarks marks for 1936

Medal of a traditional Celtic cross design with an Irish harp engraved in a shield in the centre. Obverse: *ÉIRE* engraved across the centre and around the edge *Cumann Lúith-Chleas Gaedheal*. Reverse: *Craobh Iomana na h-Éireann Sinnsear 1936 Luimnigh a Bhuaidh*.

This medal was won by Mick Mackey, Ahane GAA Club, who played in the 1936 All-Ireland Hurling Final between Limerick and Kilkenny. The match was played in Croke Park and the score was Limerick 5 goals 6 points, Kilkenny 1 goal 5 points. Mick Mackey captained the Limerick Team and was presented with The Liam MacCarthy Cup by the GAA President, Mr Bob O'Keeffe. Mick Mackey also won an All-Ireland Senior Hurling Medal in 1934 and again in 1940.

On loan from Barbara Mackey.

3.15 MUNSTER JUNIOR CUP RUGBY MEDAL
Gold, Dublin, 1943
D: 2.6cm

Marks: S&S with Dublin hallmarks for 1943

Nine carat gold medal engraved with the Munster crest in the centre. Obverse: *I.R.F.U.* and underneath the crest *Mun. Junior Cup*. Reverse: *P. S. C. 1942-43*.

Richmond beat UCC 8 points to 0. This match was played in Thomond Park. Patrick (Paddy) Stephen Cunneen was a brother of Jack Cunneen who played with Garryowen Rugby Club.

On loan from Ann McNamara.

3.16 GAA ALL-IRELAND SENIOR HURLING MEDAL
Moore & Co.
Gold, Dublin, 1898
H: 3.6cm; W: 3.2cm

Marks: M & Co. in a lozenge shaped punch with Dublin hallmarks for 1898

Nine carat gold medal of traditional Celtic cross design. The front has a shield-shape design with an Irish harp stamped in the centre. Obverse: *Gaelic Athletic Association*. Reverse: *Hurling Championship 1897*.

Limerick won its first GAA All-Ireland Hurling Medal in 1897 when Kilfinane Club representing Limerick beat Tullaroan, Kilkenny, by 3 goals 4 points to 2 goals 4 points. The match was played in Tipperary. This medal was won by Mike Downes of Kilfinane. This is possibly the only known medal surviving from this event.

On loan from a private collection.

3.17 MUNSTER CHALLENGE CUP RUGBY
O'Connor
Gold, Dublin, 1925-26
D: 2.6cm

Marks: O'C and Dublin hallmarks for 1925-26

Medal with Celtic interlace design, with shamrocks on each arm of the cross. The centre of the medal has the Munster crest surmounted with letters *I.R.F.U.* and inscription underneath *Munster Challenge Cup*. Obverse: *I.R.F.U.* and inscription underneath *Munster Challenge Cup*. Reverse: *John Cunneen, Garryowen R.F.C. 1925-1926*.

This match was played at The Markets Field, Limerick. The final score Garryowen 11 points, Bohemians 0. Jack Cunneen was on the winning Garryowen team.

On loan from Melda O'Connor.

3.18 STUDENTS EUROPEAN RUGBY MEDAL
D: 5cm

A gilded round medal with a facet-cut border and a stamped image of rugby goal posts and ball. Obverse: top *The Times Trophy* and around the lower border *The European Students' Championship*. Reverse: *Jerry Flannery*.

Jerry Flannery played with UCC RFC in the 1999 final of the Students European Rugby Championship. The match against Grenoble University was played at Donnybrook, Co. Dublin, on the morning of January 30 1999, the

SECTION 3 SPORTS

final score UCC 14, Grenoble 10. The UCC RFC team was honoured on the pitch at Lansdowne Road that afternoon at half-time in the Heineken Cup Final between Ulster and Colomiers.

On loan from a private collection.

3.19 EUROPEAN HEINEKEN CUP RUGBY MEDAL
No maker's mark
D: 6.5cm

Circular gilded medal with enamelled vertical rectangular plaque, which has the Heineken Cup inscription above a stamped image of rugby goal posts and ball. The medal is suspended on a green ribbon. Obverse: *Heineken Cup*. Reverse: *Heineken Cup Final 2006 Winners Biarritz Olympique Pays Basque .v. Munster Rugby Millennium Stadium Cardiff 20/05/2006*.

In this never to be forgotten Heineken Cup final, Munster defeated Biarritz Olympique by 23 points to 19.

On loan from a private collection.

3.20 MEDAL
Maker unidentified
Gold, Dublin 1930-31
H: 3.75cm; W: 2.6cm

Marks: Dublin hallmarks for 1931

Retailer's mark overstruck N FINE LIMERICK

Medal in the form of a Maltese cross with an applied Celtic harp at its centre. The obverse is chased and engraved with Celtic ornament surmounted by a pair of crossed hurleys. Inscribed *LIMERICK CIVIC CARNIVAL 1931*

On loan from a private collection.

3.21 BEAKER
Maker unidentified
Birmingham 1870-71
H: 13cm; D: (rim) 9.5cm, (base) 6.8cm

Marks: HP & Co and Birmingham hallmarks for 1870-71

Plain tapering beaker with moulded rim. *CALCUTTA C.C. ATHLETIC SPORTS/ LONG JUMP/ Won by/ T.O. Fitz Gerald/ 2/19 Reg.t/ 2nd Feby 1871*. Engraved on base *COOKE & KELVEY, CALCUTTA*. Bears scratched inscription on base *19 feet 9 inches/ a fine jump*.

This beaker was won by Thomas Otho FitzGerald (1849-1878). He was the son of John Fraunceis Eyre FitzGerald, 25th Knight of Glin. After Sandhurst he entered as a Lieutenant the Bengal Staff Corps and served with the 27th Punjab Infantry. He was heroically killed in the Kyber Pass at the fort of Ali Masjid on November 21 1878 rescuing the body of his Commanding Officer Major Birch. He was buried at Peshawar. His medals and memorabilia are at Glin Castle.

The retailers Cooke & Kelvey were founded in Calcutta in 1858. The firm is still in business today.

On loan from the Knight of Glin.

3.22 PAIR OF FOOTED SALVERS
Maker unidentified
Dublin, c. 1745

Marks: Dublin hallmarks for c. 1745, no date letter

Circular salvers each with moulded rim and capstan foot. A band of flat chased scrolling floral and foliate ornament in the surround with a mounted jockey in the centre. Inscribed *Won by Richard Fitzgerald of Glin Esq his horse STERLING at Clogheen.*

These footed salvers were won by Richard FitzGerald of Glin at the races at Clogheen, Co. Tipperary, and are recorded in *Faulkner's Dublin Journal*, July 14-18 1747. The paper records that there was *"a vast concourse of Nobility and Gentry of the neighbouring country"* at these races. Two of Richard FitzGerald's horses were winners and *"the Plate may be seen at Mr. Dolier's, Goldsmith, on Cork-hill, Dublin[and] at Lucas's coffee house"*. These races were held from the July 6-11 and a further description follows noting £20 Plates and the age, weight and type of horses.

Richard FitzGerald (1706/07-1775), was the third son of John FitzGerald, 19th Knight of Glin. He inherited the title after the death of his elder brother Edmund in 1773. He was a keen sportsman, sailor and admirer of the ladies and lived in a house in Newtown Pery in Limerick. He had no male heir and the title went to his younger brother Thomas, ancestor of the present line of the Knights of Glin. We are indebted to Thomas J. Byrne for this reference.

On loan from the Knight of Glin.

3.23 YACHTING TROPHY
Birmingham 1834-35
H: 4cm; D: 41.0cm

Marks: W&S and Birmingham hallmarks for 1834-35

Large silver salver with raised shell scroll rim. Base has a central inscription flanked by four scenes each in a cartouche, 1) sea view with lighthouse and yachts; 2) a small sailing ship and yacht; 3) three curraghs each wth three oarsmen; 4) two yachts. The cartouches are separated by a rose scroll decoration, which also incorporated nautical symbols, telescopes, tridents, anchors, rudders etc. Three scroll feet. Inscribed *Royal Western Yacht Club Galway Bay Regatta August 1834 won by the Rienvella 30 Tons The Knight of Glin owner.*

The Royal Western Yacht Club founded in 1827 had its first regatta in 1832. It was very active around the coast of Ireland from Belfast to Cork through the 1830s up to about 1860. The Club was reactivated in 1984 and is based in Kilrush, Co. Clare. They hold a regatta on the River Shannon every August. John Fraunceis FitzGerald, 25th Knight of Glin (1791-1854) was on the original sailing committee and an active yachtsman with his 30 ton cutter *Rienvella*. A booklet with a list of members, their yachts, flags etc. was published in Limerick in 1837.

On loan from the Knight of Glin.

3.24 RATHKEALE VOLUNTEERS MEDAL
William Pitts
Late 18th century
D: 7.5cm

Marks: WP and London hallmarks

Circular silver medal, the front engraved with two uniformed soldiers standing outside a sentry box. The outer raised rim and suspension loop have engraved and punch marked decorations. The back is engraved with an armorial crest within a circle surmounted by the Irish harp amidst two tufts of shamrocks. Inscribed (obverse) *Rathkeale Volunteers First Formed 1797*; (reverse) *Tria Juncta in Uno* within two circles, *ICH DIEN* underneath within an engraved ribbon. Rim inscribed *For the best shot transferable prize medal.*

The Rathkeale Volunteers was a regiment of foot formed in 1779 (note error on medal!) The unit consisted of one company of grenadiers and one company of light infantry. Their colonel was George Leake.

On loan from a private collection.

Modern

John McCormack

In the context of this section, the term 'modern' may be taken to mean the period which began in about 1830, lasting up to the present day. As far as the story of Limerick's silver trade is concerned it is a period which began with rapid decline, followed by a long period in the doldrums, an attempted renaissance in the 1950s which petered out, and evidence of a revival, hopefully a sustainable one, at the present time.

The Act of Union of 1800 abolished the Irish parliament. The United Kingdom of Great Britain and Ireland came into effect on 1 January 1801. In 1824 an Act allowing free trade between Ireland and Britain, in certain classes of manufactured goods, was passed by the Westminster parliament. The Irish market was fully opened up to Britain's industrial production capability. Many indigenous, smaller-scale enterprises suffered and failed. Artisan goldsmiths could not compete on price grounds against the new competition, especially as, in many cases, their client base too, was suffering in similar fashion. The problems were more acute for the provincial silversmiths, many of whom were forced in smaller markets, such as Limerick, to diversify into retailing new categories of imported goods, such as toys, fishing equipment, jewellery, watches, etc.

Plate 109
Decanter Labels by Cosmacs Ltd., Limerick 1958
Exhibits 4.01, 4.02 and 4.03

In Limerick the silversmiths who survived in the trade were those who made such diversifications. Indeed it may be said with certainty that very little, if any, silver was actually made in Limerick for many years after 1830. This was a common problem throughout the entire country, as comparison of the figures for the quantity of silver passing through the Dublin Assay Office shows. In 1787 approximately 80,000 ounces of silver was assayed, in 1835 the comparative figure was a mere 6,000 ounces.

Amongst the Limerick silversmiths who traded in the city having diversified their businesses, were Samuel Purdon, who became a manufacturing jeweller as well and operated until the late 1840s, and Robert O'Shaughnessy who was also a jeweller and watchmaker,

and additionally dealt in fishing tackle up to 1840. Later in the Victorian era, there were a number of businesses listed in Limerick trade directories which included the term silversmith in their description. These include Richard Wallace (1856-1930) and JC Blundell (1867-1938).

Henry L Stewart, of 104 George's Street, Limerick, described as a *"High Class Art Goldsmith, Jeweller and Watchmaker"* registered his maker's mark with the Dublin Company of Goldsmiths in 1889. Similarly Conrad Cromer registered his mark in 1907. Examples of the work of both of these are included in the exhibition.

February 1959 saw the establishment of the firm of Cosmacs Ltd. of Ennis Road, Limerick; the name being an acronym of the company's founders: G. Clancy, T. O'Brien, H. Sexton, E. & T. McCarthy. The firm was founded with a view to the commercial production of silver, both secular and ecclesiastical. One of the first pieces of plate produced by the firm was a replica of the National Museum of Ireland's de Burgo-O'Malley chalice of 1494. Several items produced by the firm such as decanter labels are included in the exhibition. Unfortunately, demand was insufficient to sustain the business, which closed in 1964.

Plate 110

Cream Jug and Sugar Bowl by Cosmacs Ltd., Limerick 1960
Exhibits 4.04 and 4.05

SECTION 4 **MODERN**

Plate 111
Table Snuffbox by Susan McCarthy,
Limerick 2007
Exhibit 4.06

In more recent years there has been a more promising revival of the practice of the ancient trade of the goldsmith in Limerick, or amongst Limerick people. Those represented include Martin O'Driscoll, silversmith, who served his apprenticeship at the Kilkenny Design Centre from 1970-75, worked at the Braddon Centre in Dublin from 1975-80 and again at Kilkenny Design from 1980-91. He came to Limerick in 1992 and operated a business on the Mathew Bridge until 2006 when he returned to Kilkenny.

Another Limerick goldsmith of the modern era is Susan McCarthy, who studied at the Kent Institute of Art and Design and graduated with an honours degree in Goldsmithing, Silversmithing and Jewellery Design. She holds also a Higher Diploma in Teaching Art and Design. She has won several awards including two Precious Metal Bursary awards from the Worshipful Company of Goldsmiths in London and in 1995 registered her maker's mark there, doing similarly in Dublin in 1999. An example of her work, specially commissioned for this exhibition is shown.

A unique place in the pantheon of Limerick goldsmiths is occupied by Edward Walsh, who holds doctoral degrees in Nuclear and Electrical Engineering and was the founding President of the University of Limerick, 1989-98. Whilst lecturing students he wanted to demonstrate that it is possible to learn anything from a book! Borrowing a book on the craft of the goldsmith, he duly taught himself, and whilst President, he personally made over 100 presentation spoons bearing the arms of the university. Amongst the distinguished recipients of his spoons are the King of Spain and Charles, Prince of Wales. Several examples of his work are featured herein.

A CELEBRATION OF LIMERICK'S SILVER

Plate 112

a. Brooch by Martin O'Driscoll, Limerick 1994
Exhibit 4.08

b. Necklace by Martin O'Driscoll, Limerick c. 1995
Exhibit 4.09b

c. Brooch by Martin O'Driscoll, Limerick c. 1995
Exhibit 4.09a

d. Presentation Medal by Martin O'Driscoll, Limerick c. 1997
Exhibit 4.10

e. Brooch by Martin O'Driscoll, Limerick c. 1994
Exhibit 4.07

SECTION 4 **MODERN**

Plate 113
Brooch (pheasant)
by Cosmacs Ltd., Limerick c. 1960
Exhibit 4.13

Brooch (peacock)
by Cosmacs Ltd., Limerick c. 1954
Exhibit 4.11

Brooch (horse-drawn coach)
by Cosmacs Ltd., Limerick c. 1960
Exhibit 4.12

Plate 114
Bowl by Edward Walsh,
Limerick 2007
Exhibit 4.14

A CELEBRATION OF LIMERICK'S SILVER

Plate 115
*Bowl by Edward Walsh,
Limerick 2006*
Exhibit 4.15

Plate 116
*Toast Rack by Edward Walsh,
Limerick 2007*
Exhibit 4.24

*Spoon by Edward Walsh,
Limerick c. 1987*
Exhibit 4.21

121

SECTION 4 **MODERN**

Plate 117

a. *Bracelet by Edward Walsh,*
Limerick c. 2001
Exhibit 4.23

b. *Necklace by Edward Walsh,*
Limerick
Exhibit 4.17

c. *Necklace by Edward Walsh,*
Limerick
Exhibit 4.16

d. *Finger Ring (with emerald)*
by Edward Walsh, Limerick
Exhibit 4.20

e. *Finger Ring (reef knot design)*
by Edward Walsh, Limerick c. 2000
Exhibit 4.19

f. *Brooch*
by Edward Walsh, Limerick
Exhibit 4.22

Plate 118

Necklace by Edward Walsh, Limerick
Exhibit 4.18

Catalogue

4.01 DECANTER LABEL
Cosmacs Ltd.
Limerick, 1958
W: (label) 6.6cm

Marks: C.Ltd in dumbbell-shaped punch, Dublin hallmarks for 1958

Of curved form decorated in high relief zoomorphic Celtic style; set with a faceted colourless stone; suspended from a Celtic decorated annular ring by two chains. Inscribed *GIN*.

On loan from the Limerick City Museum.

4.02 DECANTER LABEL
Cosmacs Ltd.
Limerick, 1958
W: (label) 6.6cm

Marks: C.Ltd in dumbbell-shaped punch, Dublin hallmarks for 1958

Of curved form decorated in high relief zoomorphic Celtic style; set with a faceted sherry-coloured stone; suspended from a Celtic decorated annular ring by two chains. Inscribed *SHERRY* and on reverse *Cosmacs Ltd*.

On loan from the Limerick City Museum.

4.03 DECANTER LABEL
Cosmacs Ltd.
Limerick, 1958
W: (label) 6.6cm

Marks: C.Ltd in dumbbell-shaped punch, Dublin hallmarks for 1958

Of curved form decorated in high relief zoomorphic Celtic style; set with a faceted red stone; suspended from a Celtic decorated annular ring by two chains. Inscribed *PORT* and on reverse *Cosmacs Ltd*.

On loan from the Limerick City Museum.

4.04 CREAM JUG
Cosmacs Ltd.
Limerick, 1960
H: 7.6cm; W: 8.5cm

Marks: C.Ltd in a dumbbell punch with Dublin hallmarks for 1960

Hemispherical bowl with flared foot and scroll handle; a narrow band of Celtic decoration applied to rim and foot. Stamped incuse underneath with *FINE LIMERICK*.

On loan from George Stacpoole.

4.05 SUGAR BOWL
Cosmacs Ltd.
Limerick, 1960
H: 7.6cm; W: 8.6cm

Marks: C.Ltd in a dumbbell-shaped punch, Dublin hallmarks for 1960

A hemispherical bowl with a flared foot and two scrolled handles; a narrow band of Celtic decoration applied to rim and foot. Stamped incuse underneath with *N. FINE LIMERICK* .

On loan from George Stacpoole.

4.06 SNUFFBOX
Susan McCarthy
Limerick, 2007
H: 3.9cm; W: 5.5cm

Marks: SMcC in an oblong punch, Dublin hallmarks for 2007

Of oblong shape with rounded ends and detachable lid decorated with applied curled elements.

The curled elements in the design of this box represent the leaves of the tobacco plant from which snuff is derived.

On loan from a private collection.

4.07 BROOCH
Martin O'Driscoll
Gold, Limerick, *c.* 1994
H: 3.7cm; W: 3.7cm

Marks: MOD incuse and Dublin hallmarks

The form of the brooch is inspired by the arms of Limerick.
Inscribed *Limerick*.

On loan from a private collection.

4.08 BROOCH
Martin O'Driscoll
Gold, Limerick, *c.* 1994
H: 2.1cm; W: 6.4cm

Marks: MOD incuse and Dublin hallmarks

Bar brooch, the design of which is inspired by the arms of Limerick.
Inscribed *Limerick*.

On loan from a private collection.

SECTION 4 **MODERN**

4.09a BROOCH
Martin O'Driscoll
Gold, Limerick, *c.* 1995
H: 5.1cm; W: 2.5cm

Marks: MOD incuse struck twice, Dublin hallmarks

Floral bar brooch with three applied flowers of several petals.

On loan from a private collection.

4.09b NECKLACE
Martin O'Driscoll
Gold, Limerick, *c.* 1995
L: 41cm

Marks: MOD incuse, Dublin hallmarks

Three triple-petalled flowers suspended from a simple gold chain.

On loan from a private collection.

4.10 PRESENTATION MEDAL
Martin O'Driscoll
Gold, Limerick, *c.* 1997
H: 3.4cm; W: 3.4cm

Marks: MOD incuse

Circular medal commemorating Limerick 800. Reverse inscribed *Society Golf Champions* and obverse showing a golfing scene and inscribed *1197-1997 LIMERICK 800*.

On loan from a private collection.

4.11 BROOCH
Cosmacs Ltd.
Limerick, *c.* 1954
H: 4cm

Marks: C.LTD in dumbbell punch, STERLING incuse

Brooch in the form of a peacock set with marcasite and gemstones.

On loan from a private collection.

4.12 BROOCH
Cosmacs Ltd.
Limerick, *c.* 1960
H: 2.5cm; W: 3.5cm

Marks: "Test Piece"

Brooch depicting horse-drawn coach, set with marcasite and gemstones.

On loan from a private collection.

4.13 BROOCH
Cosmacs Ltd.
Limerick, *c.* 1960
H: 1.7cm; W: 5.1cm

Marks: CLtd and STERLING incuse

Brooch in the form of a pheasant, set with marcasite.

On loan from Marilyn Clancy Keogh.

4.14 BOWL
Edward Walsh
Limerick, 2007
H: 7cm; W: 17cm

Marks: EMW incuse struck once, Dublin hallmarks for 2007

Bowl with irregularly scalloped edge.

On loan from a private collection.

4.15 BOWL
Edward Walsh
Limerick, 2006
H: 4.5cm; W: 7.5cm

Marks: EMW incuse struck once, Dublin hallmarks for 2006

Circular footed bowl bearing arms of the University of Limerick.

On loan from a private collection.

4.16 NECKLACE
Edward Walsh
Limerick
L: (of chain) 72cm,
(max of each panel): 4.5cm

Marks: EMW incuse struck once on each pendant panel, no hallmarks

Simple chain and link necklace with two oblong pendant panels; each panel is set with one gemstone.

On loan from a private collection.

A CELEBRATION OF LIMERICK'S SILVER

4.17 NECKLACE
Edward Walsh
Limerick
L: (of chain) 47cm,
(max of two panels) 8cm

Marks: EMW incuse struck once on each pendant panel, no hallmarks

Wedge-shaped link and ring chain necklace with two oblong pendant panels; one panel, which is longer than the other, has applied gold pieces; the other panel is set with gemstones.

On loan from a private collection.

4.18 NECKLACE
Edward Walsh
L: (of cord) 32.5cm,
(max pendant piece) 7cm

Marks: Unmarked

Necklace of leather cord, the ends of which are bound together with silver wire, and a wood pendant piece. The pendant depicts a cross-legged man; the face is of applied silver while there is an enamelled panel on the chest.

On loan from a private collection.

4.19 FINGER RING
Edward Walsh
Silver gilt, Limerick, c. 2000
H: 1.9cm; W: 1cm

Marks: EMW struck once on each ring

Two rings with a reef knot design; the rings are joined together at the knots.

On loan from a private collection.

4.20 FINGER RING
Edward Walsh
Limerick
H: 2.5cm; W: 2cm

Marks: EMW in an oblong punch, Dublin hallmarks

Finger ring with an oval emerald in a claw setting.

On loan from a private collection.

4.21 SPOON
Edward Walsh
Limerick, c. 1987
L: 13cm; W: (of bowl) 3cm

Marks: EMW incuse struck once, Dublin hallmarks

Hammered spoon with the arms of the University of Limerick.

On loan from a private collection.

4.22 BROOCH
Edward Walsh
Limerick
W: (max) 5cm

Marks: Unmarked

U-shaped fish skeleton brooch; the head set with a gemstone for an eye.

On loan from a private collection.

4.23 BRACELET
Edward Walsh
Limerick, c. 2001
W: 7.9cm x 6.2cm

Marks: EMW incuse struck once, Dublin hallmarks for 2001

Bracelet of hammered silver; the terminal of each end is wrapped three times around the other.

On loan from a private collection.

4.24 TOAST RACK
Edward Walsh
Limerick, 2007
H: 9.5cm; W: 9.4cm

Marks: EMW incuse struck once, Dublin hallmarks for 2007

Four slice toast rack of hammered silver with scrolled central handle.

On loan from a private collection.

Flatware

John R. Bowen

Flatware, as its name suggests, comprises that class of utensils used in the preparation, service and consumption of food and drink, which in the course of use lie flat upon the table or work surface on which the utensils are being used. This was the most numerous class of items produced by Limerick goldsmiths and silversmiths and also, because of regular use, that class of items which suffered the greatest level of attrition by wear and tear. Limerick produced a considerable quantity of flatware mostly for use in the city and surrounding areas. No items of Limerick flatware exhibit different styles than those generally known to have been the mainstream of taste and fashion at the time though some particular late eighteenth-century bright-cut engraved patterns are identified with Limerick.

Plate 119
a. Pair of Table Forks
by William Fitzgerald, Limerick 1801
Exhibit 5.22

b. Table Fork
by Joseph Johns, Limerick c. 1740
Exhibit 5.06

The earliest spoons had fig-shaped bowls and plain rectangular section handles. These were known as slip-topped spoons. No Limerick examples are known to have survived. These spoons were made during the period of the fourteenth to the sixteenth centuries. They were followed by a flat-handled derivative, easier to use and called a 'Puritan' spoon because of its emergence during the period of the Commonwealth in the middle of the seventeenth century.

In turn the puritan style made way for the trefid-ended spoons, named for the three-lobed or cleft terminal, and frequently also exhibiting a rat-tail ridge on the underside of the bowl. This style too had its variants including the dog nose spoon.

In the early eighteenth century the 'Hanoverian' pattern began to make its appearance. This was characterised by a rounded upturned terminal, an oval bowl and a ridge, termed a rat-tail, emerging from the handle along the bowl's underside. Over time this rat-tail became shorter and eventually disappeared to be replaced by a sometimes decorated drop. This type of spoon usually had its owner's crest displayed on

the reverse of the handle, as the fashion of the time was to set the table with the bowl facing the table rather than upwards.

The Hanoverian pattern was in the mid-eighteenth century replaced by the still popular 'Old English' pattern, in which the rounded terminal was turned down. This pattern was initially undecorated but as fashion for decorated flatware dictated, Old English pattern spoons in the early 1770s were engraved with grooves along the edge of the handle which became known as 'feather edge' pattern. That style was soon superseded by bright-cut engraved patterns to the handles. As the eighteenth century drew to a close the pointed-end pattern made its appearance. This was sometimes called 'Celtic point' because of its popularity in Ireland and in Scotland, and was usually enhanced with bright-cut decoration.

In the early part of the nineteenth century the 'fiddle pattern' began to appear named after the French 'violin' pattern on which it was modelled. This pattern with its characteristic, almost rectangular, handle remains extremely popular today.

Limerick flatware is to all intents and purposes similar to that made in Dublin or Cork, and exhibits no discernible regional difference in design. What it frequently exhibits, however, is the use of a three-plumed decorative engraved device on the handle. The origin of this device is unclear. A further feature peculiar to Limerick flatware of the very late eighteenth and early nineteenth centuries is the impressed trefoil device struck on the backs of the handles, which may denote the payment of some local taxation, details of which await discovery.

Plate 120
a. Dividing Spoon
by Thomas Burke, Limerick c. 1790
Exhibit 5.03

b. Basting Spoon
by Thomas Burke, Limerick c. 1790
Exhibit 5.08

SECTION 5 **FLATWARE**

Plate 121
a. Soup Ladle
by Joseph Johns, Limerick c. 1760
Exhibit 5.27

b. Pair of Sauce Ladles
by Garrett Fitzgerald, Limerick c. 1770
Exhibit 5.07

c. Soup Ladle
by Joseph Johns, Limerick c. 1750
Exhibit 5.10

Plate 122
a. Pair of Basting Spoons
by Patrick Connell, Limerick c. 1790
Exhibit 5.29

b. Pair of Tablespoons
by Matthew Walsh, Limerick c. 1790
Exhibit 5.34

c. Basting Spoon
by William Ward, Limerick c. 1800
Exhibit 5.20

Plate 123
a. Pair of Sauce Ladles
by Thomas Burke, Limerick c. 1790
Exhibit 5.09

b. Soup Ladle
by Henry Downes, Limerick c. 1787
Exhibit 5.25

Plate 124
a. Soup Ladle
by Patrick Connell, Limerick c. 1790
Exhibit 5.11

b. Soup Ladle
by Maurice Fitzgerald, Limerick c. 1780
Exhibit 5.12

c. Soup Ladle
by George Halloran, Limerick c. 1775
Exhibit 5.26

129

SECTION 5 **FLATWARE**

Plate 125

a. Tablespoon
by Collins Brehon, Limerick c. 1750
Exhibit 5.38

b. Tablespoon
by Jonathan Buck, Limerick c. 1735
Exhibit 5.23

c. Tablespoon
by Jonathan Buck, Limerick c. 1720
Exhibit 5.24

d. Pair of Dessertspoons
by Joseph Johns, Limerick c. 1750
Exhibit 5.13

e. Tablespoon
by Joseph Johns, Limerick c. 1740
Exhibit 5.33

Plate 126

a. Celtic-point Tablespoon by Samuel Johns, Limerick c. 1790. [not on display]

b. Pair of Tablespoons by Daniel Lysaght, Limerick c. 1790. Exhibit 5.28

c. Tablespoon by Thomas Walsh, Limerick c. 1820. Exhibit 5.21

A CELEBRATION OF LIMERICK'S SILVER

Plate 127
Set of Six Teaspoons
by John Purcell, c. 1790
Exhibit 5.16

SECTION 5 **FLATWARE**

Plate 128
a. Sifter Spoon
by Samuel Johns, Limerick c. 1765
Exhibit 5.19

b. Salt-spoon
by Maurice Fitzgerald, Limerick c. 1795
Exhibit 5.35

c. Caddy Spoon
by Samuel Purdon, Limerick c. 1820
Exhibit 5.05

d. Pair of Salt Shovels
by Jonathan Buck, Limerick c. 1750
Exhibit 5.32

e. Pair of Toddy Ladles
by John Purcell, Limerick c. 1795
Exhibit 5.14

Plate 129
Pair of Teaspoons
by Daniel Lysaght, Limerick c. 1790
Exhibit 5.15

A CELEBRATION OF LIMERICK'S SILVER

Plate 130
a. Pair of Sugar Tongs
by William Fitzgerald, Limerick c. 1795
Exhibit 5.18

b. Skewer
by Matthew Walsh, Limerick c. 1790
Exhibit 8.02

c. Meat Skewer
by Patrick Connell, Limerick c. 1790
Exhibit 5.02

d. Sugar Tongs
by Thomas Burke, Limerick c. 1795
Exhibit 5.31

Plate 131
a. Dessertspoon
by Patrick Connell, Limerick c. 1790
Exhibit 5.36

b. Pair of Dessertspoons
by Thomas Burke, Limerick c. 1795
Exhibit 5.30

133

SECTION 5 **FLATWARE**

Plate 132
a. Marrow Scoop
by Philip Walsh, Limerick c. 1780
Exhibit 5.01

b. Pair of Poultry Skewers
by William Fitzgerald, Limerick c. 1800
Exhibit 5.04

c. Marrow Scoop
by Jonathan Buck, Limerick c. 1745
Exhibit 5.37

d. Marrow Scoop
by Maurice Fitzgerald, Limerick c. 1780
Exhibit 5.17

Plate 133
Teaspoon
by Robert O'Shaughnessy, Limerick c. 1810
Exhibit 5.39

Catalogue

5.01 MARROW SCOOP
Philip Walsh
Limerick, *c.* 1780
L: 21.5cm

Marks: PW in a laterally crowned harp-shaped punch, struck twice on back

On loan from a private collection.

5.02 MEAT SKEWER
Patrick Connell
Limerick, *c.* 1790
L: 27.5cm

Marks: P.C in an oval punch, struck twice flanking a single STE also in an oval punch

Of ring-top form with typically Irish shoulders and bright-cut decoration.

On loan from a private collection.

5.03 DIVIDING SPOON
Thomas Burke
Limerick, *c.* 1790
L: 29cm

Marks: Struck twice with makers mark T.B in an oblong punch, flanking incuse STERLING

Of Celtic-point pattern and bright-cut both on the handle and along the top of the divider, the spoon's handle also displays the three-plumes. Bears crest; a bull's head with three ears of wheat in its mouth.

On loan from a private collection.

5.04 PAIR OF POULTRY SKEWERS
William Fitzgerald
Limerick, *c.* 1800
L: 16.5cm

Marks: WFG in oblong punch, STERLING in oblong punch

Of ring-top form, otherwise plain.

On loan from a private collection.

5.05 CADDY SPOON
Samuel Purdon
Limerick, *c.* 1820
L: 8cm; D: (bowl) 3cm

Marks: S*P in oblong punch also STERLING in oblong punch

Of fiddle pattern form and with a round bowl.

On loan from a private collection.

5.06 TABLE FORK
Joseph Johns
Limerick, *c.* 1740
L: 20.5cm

Marks: II flanking a lion rampant in an irregular punch, struck twice flanking STERLING in an oblong punch

Of plain Hanoverian pattern with three tines. Bears crest; a chained monkey (Fitzgerald).

On loan from a private collection.

5.07 PAIR OF SAUCE LADLES
Garrett Fitzgerald
Limerick, *c.* 1770
L: 23cm; D: (bowl) 6.5cm

Marks: Struck twice GFG in engrailed oblong punch flanking a single STERLING in an oblong punch

Of hook-handled form and with wrythen fluted bowls. Bears crest; a chained monkey (Fitzgerald).

On loan from a private collection.

5.08 BASTING SPOON
Thomas Burke
Limerick, *c.* 1790
L: 30.5cm

Marks: TB in an oblong punch and STERLING incuse both struck once. Trefoil device incuse also struck once

Of Celtic-point form and including three plumes design on the handle.

On loan from a private collection.

5.09 PAIR OF SAUCE LADLES
Thomas Burke
Limerick, c. 1790
L: 21cm; D: (bowl) 5.5cm

Marks: TB in an oblong punch and STERLING incuse both struck once. Trefoil device incuse struck once

Of bright-cut Celtic-point form and with plain round bowls.

On loan from a private collection.

SECTION 5 FLATWARE

5.10 SOUP LADLE
Joseph Johns
Limerick, *c.* 1750
L: 40.5cm; D: (bowl) 10cm

Marks: II flanking a lion rampant in an irregular punch struck once. STERLING in an oblong punch struck once

Of plain Onslow-handled form and with a round bowl chased with graduated flutes.

On loan from a private collection.

5.11 SOUP LADLE
Patrick Connell
Limerick, *c.* 1790
L: 38cm; D: (bowl) 9.5cm

Marks: P.C in an oval punch struck twice flanking a single STE also in an oval punch

Of bright-cut Celtic-point form and with a round bowl chased with radiating flutes.

On loan from a private collection.

5.12 SOUP LADLE
Maurice Fitzgerald
Limerick, *c.* 1780
L: 35cm; D: (bowl) 10cm

Marks: MFG in an oblong punch struck thrice

Of fluted round bowl with Celtic-point form, and with flat-chased floral and foliate deoration to handle, it also bears decoration on the reverse at the junction of the bowl and handle. Bears crest; a stag's head.

On loan from a private collection.

5.13 PAIR OF DESSERTSPOONS
Joseph Johns
Limerick, *c.* 1750
L: 17cm

Marks: II flanking two pellets in a heart shaped punch struck once. STERLING in an oblong punch struck once

Of plain Hanoverian pattern. Bears crest; a demi-lion rampant.

On loan from a private collection.

5.14 PAIR OF TODDY LADLES
John Purcell
Limerick, *c.* 1795
L: 16.5cm D: (bowl) 3.5cm

Marks: IP in an oblong punch struck twice. Trefoil device incuse

Of plain Celtic-point pattern handles with round bowls. Bears crest; a griffin rampant.

On loan from a private collection.

5.15 PAIR OF TEASPOONS
Daniel Lysaght
Limerick, *c.* 1790
L: 13cm

Marks: DL in an oblong punch struck twice

Of bright-cut Celtic-point form. Initialled *G* over *A*F.*

On loan from a private collection.

5.16 SET OF SIX TEASPOONS
John Purcell
c. 1790
L: 14cm

Marks: IP in an oblong punch struck thrice. Trefoil device incuse struck once

Of plain Celtic-point form. Bears crest; a stag's head.

On loan from a private collection.

5.17 MARROW SCOOP
Maurice Fitzgerald
Limerick, *c.* 1780
L: 22.5cm

Marks: MFG in an oblong punch struck twice

Bears crest; a demi-griffin displayed issuing from a coronet.

On loan from a private collection.

5.18 PAIR OF SUGAR TONGS
William Fitzgerald
Limerick, *c.* 1795
L: 16cm

Marks: WFG in an oblong punch struck once. STERLING incuse struck once

U-form, bright-cut and with acorn shaped grips. Bears initials in monogram.

On loan from a private collection.

5.19 SIFTER SPOON
Samuel Johns
Limerick, c. 1765
L: 18.5cm; D: (bowl) 4cm

Marks: SJ in script in an oblong punch struck twice. STERLING in an oblong punch struck twice

Plain with hooked pointed terminal.

On loan from a private collection.

5.20 BASTING SPOON
William Ward
Limerick, c. 1800
L: 32.5cm

Marks: WW in an oblong punch struck twice flanking STERLING incuse

Celtic point bright-cut with plume of feathers.

On loan from a private collection.

5.21 TABLESPOON
Thomas Walsh
Limerick, c. 1820
L: 23.5cm

Marks: TW in an oblong punch struck twice flanking a trefoil device incuse. STERLING incuse struck once

Tablespoon in the still popular fiddle pattern.

On loan from a private collection.

5.22 PAIR OF TABLE FORKS
William Fitzgerald
Limerick, 1801
L: 20.4cm

Marks: WFG in an oblong punch, Dublin hallmarks for 1801

Pair of plain fiddle pattern dinner forks. Bears crest; an armoured knight on horseback.

On loan from a private collection.

5.23 TABLESPOON
Jonathan Buck
Limerick, c. 1735
L: 20.5cm

Marks: I.B in an oblong punch struck twice flanking STER in an oblong punch

This spoon in the Hanoverian pattern. Initialled *HBVO*.

On loan from a private collection.

5.24 TABLESPOON
Jonathan Buck
Limerick, c. 1720
L: 20.5cm

Marks: I∗B in an oblong punch struck twice

This spoon is in the Hanoverian pattern. Initialled *E∗W* above *E∗A*.

On loan from a private collection.

5.25 SOUP LADLE
Henry Downes
Limerick, c. 1787
L: 34cm; D: (bowl) 9.5cm

Marks: HD in an oblong punch struck twice flanking STERLING in an oblong punch

Bright-cut Celtic-point handle with plain round bowl. Bears crest; a demi-lion rampant looking backwards.

On loan from a private collection.

5.26 SOUP LADLE
George Halloran
Limerick, c. 1775
L: 36cm; D: (bowl) 9.5cm

Marks: GH in script in an oblong punch struck twice

Feather-edged and with a fluted bowl, the handle has a hooked terminal.

For a note on these 'Irish' type spoons, see 24A.17 in *500 years of Irish Silver* published by the National Museum of Ireland.

On loan from a private collection.

5.27 SOUP LADLE
Joseph Johns
Limerick, c. 1760
L: 40cm; D: (bowl) 10.5cm

Marks: II flanking a lion rampant in an irregular oblong punch struck twice flanking STERLING in an oblong punch. Also GR in an oblong punch struck once

Fluted bowl with chased floral rococo decoration to handle which

SECTION 5 **FLATWARE**

has a hooked terminal. Bears crest; an armoured arm embowed grasping a dagger.

The presence of a later maker's mark, that of George Robinson (fl. 1750-1784), may be explained by the possibility that the decoration was undertaken by Robinson in order to conform to later fashion.

On loan from a private collection.

5.28 PAIR OF TABLESPOONS
Daniel Lysaght
Limerick, *c.* 1790
L: 23.5cm

Marks: DL in an oblong punch struck twice flanking STERLING in an oblong punch

Plain Celtic-point handle. Bears crest; an armoured arm embowed grasping three flowers (Tait).

On loan from a private collection.

5.29 PAIR OF BASTING SPOONS
Patrick Connell
Limerick, *c.* 1790
L: 31cm

Marks: P.C in an oval punch struck twice flanking STE in an oval punch

Celtic-point pattern and with bright-cut decoration to the handle. Bears crest; a demi-horse rampant issuing from a coronet (Studdert).

On loan from a private collection.

5.30 PAIR OF DESSERTSPOONS
Thomas Burke
Limerick, *c.* 1795
L: 18cm

Marks: TB in an oblong punch struck twice flanking STER in an oblong punch

Celtic-point pattern and wth bright-cut decoration to the handle. Bears monogram.

On loan from a private collection.

5.31 SUGAR TONGS
Thomas Burke
Limerick, *c.* 1795
L: 15cm

Marks: TB in an oblong punch and STERLING incuse applied once each

U-form and with bright-cut decoration to the arms, acorn-shaped grips.

On loan from a private collection.

5.32 PAIR OF SALT SHOVELS
Jonathan Buck
Limerick, *c.* 1750
L: 9cm

Marks: IB in an oblong

Of spade form with decorative acanthus leaf-chased handles with flat terminals

These delightful salt shovels were formerly in the collection of M S D Westropp.

On loan from a private collection.

5.33 TABLESPOON
Joseph Johns
Limerick, *c.* 1740
L: 20.5cm

Marks: II flanking a lion rampant in an irregular punch, STERLING in an oblong punch, each struck once

Hanoverian pattern with rat-tail under bowl. Bears crest; a full-canopied deciduous tree.

On loan from a private collection.i.

5.34 PAIR OF TABLESPOONS
Matthew Walsh
Limerick, *c.* 1790
L: 26cm

Marks: MW in an oblong punch struck twice, flanking STERLING incuse

Celtic-point with bright-cut decoration. Monogrammed.

On loan from a private collection.

5.35 SALT-SPOON
Maurice Fitzgerald
Limerick, *c.* 1795
L: 10cm

Marks: MFG in an oblong punch struck twice

Celtic-point pattern with an oval bowl and with bright-cut decoration to the handle.

On loan from a private collection.

5.36 DESSERTSPOON
Patrick Connell
Limerick, *c.* 1790
L: 7.8cm

Marks: P.C in oval punch struck twice, once overstruck by STERLING in an oblong punch

Celtic point with bright-cut decoration. Bears crest; a demi-lion rampant holding a serpent. Initialled *TLL*.

On loan from a private collection.

5.37 MARROW SCOOP
Jonathan Buck
Limerick, *c.* 1745
L: 22cm

Marks: IB in oblong struck twice on back

Standard form.

On loan from a private collection.

5.38 TABLESPOON
Collins Brehon
Limerick, *c.* 1750
L: 21.8cm

Marks: CB struck twice on back flanking STARLING in an oblong punch

Tablespoon of Hanoverian pattern with prominent rib. Initial *M* engraved verso at junction of bowl and handle.

On loan from a private collection.

5.39 TEASPOON
Robert O'Shaughnessy
Limerick, *c.* 1810
L: 13cm

Marks: RoS in oblong struck twice, flanking trefoil device incuse

Bright-cut celtic point handle with a depiction of a plume of three feathers at the terminal.

On loan from a private collection.

Treasury

John R. Bowen

Treasury is indeed an appropriate title for this section of the exhibition, conjuring as it does a sense of excitement. The craftsmanship of Limerick's goldsmiths and silversmiths was indeed of a very high order, and the excitement of seeing the scale of their achievement is well justified. This section demonstrates very well the breadth of their craft in the form of beautifully executed objects of style and durability. These range from tankards to card trays and from sauceboats to saucepans.

The earliest item in this section, a tankard by Robert Smith, dates from the third quarter of the seventeenth century, though most of the items date from the eighteenth century, the golden age of Limerick silver. Several pieces are the work of one of Limerick's most accomplished and most prolific silversmiths, Joseph Johns who, as well as practising his craft, was active both in the city's civic government and in a local Masonic lodge. Johns was mayor of Limerick in 1773, having previously served at various times as sheriff, burgess and chamberlain. He was also active in the life of his parish where he is noted as having acted as churchwarden.

Plate 134
Two-handled Cup by John Robinson, Limerick 1729
Exhibit 6.03

Robert Smith too played his part in the civic life of Limerick having also been elected mayor, in 1685. Other goldsmiths who served as mayor of Limerick were James Robinson in 1698 and John Robinson in 1742.

The range and variety of fine quality items of antique Limerick silver brought together here is testimony both to the workmanship of those craftsmen of another era, and to the essential quality of the items they produced, which continue today to defy the passage of time. Having assumed the incomparable patina of age, they stand in eloquent testimony to the skills and standards of those who wrought them, as well as the taste and judgement of their clients who originally either commissioned or simply acquired them.

The finely crafted detail of the sauceboat by Philip Walsh has provided this exhibition with its signature image, namely its serpent-form handle. Walsh was one of a number of Limerick goldsmiths whose maker's mark was struck in the form of a laterally-crowned harp-shaped punch, frequently thought to mimic the King's Majesty punch of the Crowned Harp applied to sterling standard silver submitted to the Assay Office in Dublin.

Plate 135
Pair of sauceboats by Collins Brehon, Limerick c. 1750
Exhibit 6.02

SECTION 6 **TREASURY**

A CELEBRATION OF LIMERICK'S SILVER

Plate 136
Tankard, unidentified maker, probably Limerick c. 1695
Exhibit 6.07

Plate 137
Footed Bowl by Joseph Johns, Limerick c. 1750
Exhibit 6.06

SECTION 6 **TREASURY**

Plate 138
Salver by Joseph Johns,
Limerick c. 1750
Exhibit 6.08

Plate 139
Sugar Bowl by William Fitzgerald,
Limerick c. 1795
Exhibit 6.09

A CELEBRATION OF LIMERICK'S SILVER

Plate 140
*Sauceboat by Jonathan Buck,
Limerick c. 1745*
Exhibit 6.10

Plate 141
*Brandy Saucepan
by Jonathan Buck,
Limerick c. 1730*
Exhibit 6.16

SECTION 6 **TREASURY**

Plate 142
Footed Salver by Joseph Johns,
Limerick c. 1745
Exhibit 6.12

A CELEBRATION OF LIMERICK'S SILVER

Plate 143
Cream Jug by Joseph Johns,
Limerick c. 1745
Exhibit 6.13

Plate 144
Bowl by Joseph Johns,
Limerick c. 1735
Exhibit 6.14

SECTION 6 **TREASURY**

Plate 145
*Two Cups by Samuel Johns,
Limerick c. 1770*
Exhibit 6.04

Plate 146
*Sauceboat by Philip Walsh,
Limerick c. 1780*
Exhibit 6.11

Plate 147
*Sauceboat by Joseph Johns,
Limerick c. 1770*
Exhibit 6.17

SECTION 6 **TREASURY**

Plate 148
Pair of Salvers by Jonathan Buck,
Limerick c. 1740
Exhibit 6.19

Plate 149
Pair of Candlesticks by Collins Brehon,
Limerick c. 1765
Exhibit 6.18

Plate 150
Pair of Salvers by Joseph Johns,
Limerick c. 1760
Exhibit 6.20

Plate 151
Tankard by Robert Smith,
Limerick c. 1675
Exhibit 6.05

SECTION 6 **TREASURY**

Plate 152
Cream Jug by Joseph Johns,
Limerick c. 1750
Exhibit 6.15

Plate 153
Sugar Bowl by Joseph Johns,
Limerick c. 1755
Exhibit 6.01

Catalogue

6.01 SUGAR BOWL
Joseph Johns
Limerick, *c.* 1755
H: 6.8cm; D: (rim) 12.5cm

Marks: IJ flanking a lion rampant in an irregular punch struck once

Wrythen-fluted round bowl with everted flat-chased scalloped rim; three lion-mask knuckled paw feet. Initialled *RMM*.

On loan from a private collection.

6.02 PAIR OF SAUCEBOATS
Collins Brehon
Limerick, *c.* 1750
H: (to pouring lip) 11.7cm;
L: 23.5cm; W: (rim) 12.5cm

Marks: CB crowned flanking a lion rampant in an irregular punch

Of heavy gauge oval form with everted scalloped rims and wide pouring lip; three shell-knuckled feet; complex scroll handle with shell-form attachment. Each bears a scratch weight of *14 oz. 10dwt*.

On loan from a private collection.

6.03 TWO-HANDLED CUP
John Robinson
Limerick, 1729
H: (to rim) 17.8cm;
D: (at rim) 14.8cm

Marks: IR flanking three pellets in an oblong punch, Dublin hallmarks for 1729

Bell-shaped body with threaded moulded rim on a circular moulded drum foot. Harp form handles with shield-shaped join to body. Bearing armorials in rococo cartouche, possibly for Montgomery of Killee, Mitchelstown.

On loan from a private collection.

6.04 TWO CUPS
Samuel Johns
Limerick, *c.* 1770
H: (to rim) large 18cm;
small 15cm;
D: (at rim) large 13cm;
small 10.8cm

Marks: SJ in script in an oblong punch struck once on each

Bell-shaped body with leaf-capped scroll handles, on top of a stepped domed foot. Each bearing two armorials.

On loan from a private collection.

6.05 TANKARD
Robert Smith
Limerick, *c.* 1675
H: 14.6cm

Marks: R∗S in a bilobed punch, flanked by an 8-pointed star-form device in a quatrefoil, with a two-towered castle in a similar punch

Tapering cylindrical form on a moulded foot, an S-scroll handle with hoof-form terminal; raised platform hinged lid with double C-scroll thumbpiece; chased opposite the handle with a set of armorials.

The armorials represent the union of a lady of the Bailey family of Tralee with one of the Blennerhassets of County Limerick.

On loan from the National Museum of Ireland.

6.06 FOOTED BOWL
Joseph Johns
Limerick, *c.* 1750
H: 10.2cm;
D: (at rim) 18.5cm

Marks: IJ flanking a lion rampant in irregular punch, STERLING in an oblong punch, each applied once

Plain round bowl with moulded rim on moulded spreading circular foot. Scratch weight *18.12*. Bears crest, an inverted eagle's leg; later crest, a demi lion with its sinister paw resting on a rosette, surmounted by a coronet.

On loan from a private collection.

6.07 TANKARD
Unidentified maker
Probably Limerick, *c.* 1695
H: (to top of lid handle) 19.1cm;
(to top of lid) 16.5cm;
D: 11.2cm;
(of base) 12.9cm

Marks: IP in an oblong flanked by a six pointed star in a quatrefoil struck twice

Of tapering cylindrical form with scroll handle and hinged lid incorporating later rococo chased decoration. Bears scratch weight *31=00*. Monogrammed *PSR*.

On loan from the Limerick City Museum.

SECTION 6 TREASURY

6.08 SALVER
Joseph Johns
Limerick, *c.* 1750
W: 14.2cm

Marks: II flanking lion rampant in an irregular punch with STERLING in an oblong punch each struck once

Circular salver with flat chased rococo decoration Chippendale border on three shell feet. Bears crest; collared dog passant.

On loan from a private collection.

6.09 SUGAR BOWL
William Fitzgerald
Limerick, *c.* 1795
H: 10.9cm;
D: (rim) 12cm

Marks: WFG in an oblong punch struck once

Of circular form on a domed spreading circular foot; the body profusely decorated.

On loan from a private collection.

6.10 SAUCEBOAT
Jonathan Buck
Limerick, *c.* 1745
H: 11cm; W: 20.5cm

Marks: IB in an oval punch and STERLING in an oblong punch

Of oval form with everted rim and broad spout; S and C leaf-capped scroll handle; three lion-mask paw feet. Bears crest; a bird's head; also later applied armorials of the Westropp family. Scratch weight *13.3*.

On loan from a private collection.

6.11 SAUCEBOAT
Philip Walsh
Limerick, *c.* 1780
H: (to pouring lip) 6.5cm

Marks: PW in laterally crowned harp-shaped punch struck once

Of lipped oval form with flat bottom, the top of the body flat-chased all around with shells, flutes and fruit elements. The back of the body raised in fluted incurved corkscrew terminal to which is attached the head of the serpent-form handle. An applied conforming moulded and chased band around the body, which is supported on three shell knuckle hoof-feet. Bears crest; a boar's head.

On loan from a private collection.

6.12 FOOTED SALVER
Joseph Johns
Limerick, *c.* 1745
H: 6.5cm;
D: (top) 19.9cm;
(foot) 8.5cm

Marks: II flanking a lion rampant in an irregular shield-shaped punch struck once

Of plain shallow-dished moulded form attached to a spreading trumpet foot. Bears scratch weight *12oz 2d.* Bears contemporary armorials.

On loan from a private collection.

6.13 CREAM JUG
Joseph Johns
Limerick, *c.* 1745
H: (to pouring lip) 10.5cm

Marks: II flanking two pellets in a heart-shaped punch, struck once

Of upright lipped helmet form on three lion mask knuckle feet with scalloped rim and applied moulded band; leaf-capped S and C scroll handle. Bears scratch weight *7oz 2d.* Initialled *IS*.

On loan from a private collection.

6.14 BOWL
Joseph Johns
Limerick, *c.* 1735
H: 7 cm;
D: (at rim) 11.8cm

Marks: II flanking two pellets in a heart-shaped punch struck once

Round bowl with moulded rim on spreading moulded circular foot. Bears scratch weight *10oz 10d.* Initialled *I:M* surmounted by *U*.

On loan from a private collection.

6.15 CREAM JUG
Joseph Johns
Limerick, *c.* 1750
H: 11cm; W: 14cm

Marks: II flanking a lion rampant in an irregular oblong punch

Of helmet shape with reeded mid-band; on three tail-enwrapped lion mask feet; S and C leaf-capped scroll handle.

On loan from a private collection.

6.16 **BRANDY SAUCEPAN**
Jonathan Buck
Limerick, *c.* 1730
H: (bowl) 10.4cm;
L: (handle, max) 18.4cm;
W: (incl spout) 15.5cm;
D: (bowl top) 11.3cm

Marks: IB in a crowned punch twice flanking STERLING in an oblong punch

Wooden handled saucepan with deep globular bowl, dished base, rolled everted rim and beak-shaped pouring lip. The uplifted handle joined to the bowl by a heart-shaped cut-card detail. Bears armorials of Meade, Earls of Clanwilliam.

On loan from the Limerick City Museum.

6.17 **SAUCEBOAT**
Joseph Johns
Limerick, *c.* 1770
H: (rim) 7.3cm; L: 15.7cm

Marks: II flanked by a lion rampant in an irregular oblong punch, struck twice

Of oval form with slightly everted wavy rim and raised lip on three shell knuckle hoof feet. The S and C scroll leaf-capped handle attached at rim and to the body with an oval cut-card detail. Bears crest; a goat statant with dexter paw raised.

On loan from a private collection.

6.18 **PAIR OF CANDLESTICKS**
Collins Brehon
Limerick, *c.* 1765
H: (both) 22.5cm

Marks: CB flanking a lion rampant

Six-lobed foot with palmette feet and folds between each foot; baluster stem with knop; six-petalled stylised flower extending to form another knop; slightly everted spool-shaped socket with two rings at each end.

On loan from the National Museum of Ireland.

6.19 **PAIR OF SALVERS**
Jonathan Buck
Limerick, *c.* 1740
D: 14cm

Marks: IB in oblong punch struck once on bottom with STERLING

Pair of salvers of moulded chippendale form with applied shaped border on three hoof feet. Bears crest; a tacked, unmounted horse trippant above a coronet.

On loan from a private collection.

6.20 **PAIR OF SALVERS**
Joseph Johns
Limerick, *c.* 1760
D: 18.3cm

Marks: II flanking a lion rampant in an irregular punch and STERLING

Of moulded Chippendale form with applied shaped border, on three scroll feet. Bears crest; a martlet displayed with a foliate spray in its beak.

On loan from a private collection.

Miscellany

John R. Bowen

Frequently the use of the term 'miscellaneous', or any of its derivatives, suggests a mixed bag of items unconnected with each other and incapable of being attached coherently to any other section. In this instance the term has a much more positive meaning, showing as it does the sheer variety of, mostly personal, objects which Limerick silversmiths made to satisfy the demands of their clients.

The items in this section include a beautiful set of silver buttons by Samuel Johns, which feature wonderfully engraved contemporary scenes of country sporting pursuits. Other items of note are a pair of shoe buckles by George Halloran and a remarkable, mounted, shell snuffbox by Jonathan Buck probably made by him following his move to Cork, possibly for economic reasons, during the late 1740s or thereabouts. Personal items of particular interest include gold rings, pocket watches, a spectacle case and a remarkable combination corkscrew and personal seal.

One curious inclusion is the commemorative American spoon from the Montana mining exhibit at the Chicago World Fair of 1893, for which the model for the figure of Justice depicted on the spoon's finial was the celebrated Limerick-born actress, Ada Rehan.

The inclusion in this section of a pair of salvers by Collins Brehon, formerly in the collection of Sir Charles Jackson, and now in the collection of the National Museum of Wales, serves to link this miscellany with the wider and perhaps better known corpus of Limerick's silver.

The goldsmith's craft lent itself to the manufacture of a vast panoply of articles, some practical, others efficacious, and still others, decorative. Any consideration of the breadth of objects shown serves to confirm that this was as true in the case of Limerick as anywhere.

Plate 154
Lidded Box by Joseph Johns,
Limerick c. 1750
Exhibit 7.15

Plate 155
Snuffbox by Jonathan Buck, Limerick c. 1750
Exhibit 7.05

Plate 156
Limerick Union Medal, unidentified maker, c. 1775
Exhibit 7.01

CHAPTER 7 **MISCELLANY**

Plate 157
Pair of Shoe-Buckles by George Halloran, Limerick c. 1775
Exhibit 7.02

Plate 158
Snuffbox by Jonathan Buck, Limerick and Cork c. 1760
Exhibit 7.09

158

A CELEBRATION OF LIMERICK'S SILVER

Plate 159
*a. Pocket Watch
Movement by Richard Wallace,
Limerick c. 1830*
Exhibit 7.12

*b. Pocket Watch
Movement by Henry L. Stewart,
Limerick c. 1890*
Exhibit 7.11

*c. Pocket Watch
Movement by Conrad Cromer,
Limerick c. 1920*
Exhibit 7.13

Plate 160
a. Finger Ring by Jonathan Buck, Limerick c. 1740. Exhibit 7.19
b. Finger Ring by Joseph Johns, Limerick c. 1746. Exhibit 7.10

CHAPTER 7 **MISCELLANY**

Plate 161
Spectacles Case by Henry L. Stewart,
Limerick 1905
Exhibit 7.07

Plate 162
*Touchstone by Thomas Burke,
Limerick c. 1785*
Exhibit 7.03

CHAPTER 7 **MISCELLANY**

Plate 163
Snuffbox by Jonathan Buck,
Limerick c. 1742
Exhibit 7.14

A CELEBRATION OF LIMERICK'S SILVER

Plate 164
*Montana Silver Spoon
by H. Johnston & Co.,
New York c. 1893*
Exhibit 7.08

CHAPTER 7 MISCELLANY

Plate 165
*Set of Twelve Buttons
by Samuel Johns,
Limerick c. 1780*
Exhibit 7.06

164

A CELEBRATION OF LIMERICK'S SILVER

Plate 166
*Pair of Salvers
by Collins Brehon,
Limerick c. 1750*
Exhibit 7.17

Plate 167
*Pill Box
by Collins Brehon,
Limerick c. 1755*
Exhibit 7.16

165

CHAPTER 7 **MISCELLANY**

Plate 168
*Combined Seal and Corkscrew
by Joseph Johns,
Limerick c. 1740*
Exhibit 7.18

Catalogue

7.01 LIMERICK UNION MEDAL
Unidentified maker
Probably Limerick, *c.* 1775
D: 3.5cm

Marks: Unmarked

Circular medal with engraved edge depicting (obverse) the Limerick City arms under a banner *Limerick Union* with in exurge *1776*; (reverse) two hands grasped in friendship under a banner *AMICITIA JUNCTA*.

Hanging loop detached.

On loan from a private collection.

7.02 PAIR OF SHOE-BUCKLES
George Halloran
Limerick, *c.* 1775
H: 5.2cm; W: 6.1cm

Marks: GH crowned in oblong punch

Of oval curved form with decoration. Initialled *LDS* or *IDS*.

On loan from the Limerick City Museum.

7.03 TOUCHSTONE
Thomas Burke
Limerick, *c.* 1785
L: (overall) 18.2 cm

Marks: TB in oblong punch and STERLING in oblong

Silver-mounted basaltic stone, said to have been used in the workshop of Thomas Burke.

For details of how the touchstone was used, refer to page 10.

On loan from the Limerick City Museum.

7.04 STICK PIN
Unidentified maker
Gold, *c.* 1900
L: 7.0cm

Marks: Unmarked

A gold pin, the terminal mounted with a green pear-shaped gemstone, encased in a velvet-lined box labelled *R. WALLACE LIMERICK*.

On loan from a private collection.

7.05 SNUFFBOX
Jonathan Buck
Limerick, *c.* 1750
W: 7.5 cm

Marks: I.B in a rounded oblong, and a left-facing buck in an engraved oblong

Escutcheon shaped with concealed integral hinge, the lid chased with scrolls, inset with an agate plaque.

On loan from a private collection. With thanks to the Waterford Museum of Treasures.

7.06 SET OF TWELVE BUTTONS
Samuel Johns
Limerick, *c.* 1780
W: 2.6cm

Marks: S.J in script in an oblong punch applied on eleven, one unmarked

Of slightly domed circular form with fixed loops; the fronts engraved with various country sporting motifs within engraved borders.

On loan from a private collection.

7.07 SPECTACLES CASE
Henry L Stewart
Limerick, 1905
L: 17.7cm; W: 3.65cm

Marks: HLS in an oblong punch, with Dublin hallmarks for 1905

End opening, lined with velvet. Initialled *W O'G*.

On loan from the Limerick City Museum.

7.08 MONTANA SILVER SPOON
H Johnston & Co.
New York, *c.* 1893
L: 14cm

Souvenir spoon, the finial with an image of Ada Rehan for Justice standing atop the globe, an eagle beneath. Inscribed *Montana Silver Statue and H. Johnston & Co., 17 Union Square, New York.*

Ada Crehan, one of the greatest actresses of her age, was born at 1 Shannon Street, Limerick, in 1860. Her family moved to New York where Ada made her acting debut. A typographical error in an early theatre programme rendered her surname as Rehan by which name she was known for the rest of her career. She was renowned for playing leading Shakespearian and other roles throughout both Europe and America, making her initial Broadway appearance in 1879. Her portrait by John Singer Sargent hangs in New York's Metropolitan Museum of Art. In 1893 she was invited to be the model for the lifesize figure of Justice to be executed in silver for the Montana Mining Exhibition at that year's Chicago World Fair. This souvenir spoon commemorates what was one of

CHAPTER 7 MISCELLANY

the great sights of that exhibition. Ada Rehan retired from acting in 1905 and died in 1916.

On loan from a private collection.

7.09 SNUFFBOX
Jonathan Buck
Limerick and Cork, *c.* 1760
L: 9cm

Marks: Right-facing buck in an oblong punch

An elongated shell-mounted snuffbox with its internally gilded lid profusely chased with rococo themes.

On loan from a private collection.

7.10 FINGER RING
Joseph Johns
Gold, Limerick, *c.* 1746
D: 2cm

Marks: Rubbed, apparently Joseph Johns

Plain band, with slight D-shaped cross section. Engraved inside *OOP* (very worn) and *Octbr. 13 1746*.

On loan from the Limerick City Museum.

7.11 WATCH MOVEMENT
Henry L Stewart
Limerick, *c.* 1890
D: 5.3cm

Marks: Engraved *Henry L. Stewart, Limerick* and serial no. *382573* on the back plate

Watch movement with contemporary London silver case.

On loan from a private collection.

7.12 WATCH MOVEMENT
Richard Wallace
Limerick, *c.* 1830
D: 5cm

Marks: Engraved *Wallace, Limerick*, serial no. *2827*, on the back plate

Watch movement with contemporary 18 carat gold London-assayed watch case.

On loan from a private collection.

7.13 WATCH MOVEMENT
Conrad Cromer
Limerick, *c.* 1920
D: 5.3cm

Marks: Engraved *Conrad Cromer, Limerick*, serial no. *29843* on the back plate

Silver watch case with Chester hallmarks.

On loan from a private collection.

7.14 SNUFFBOX
Jonathan Buck
Limerick, *c.* 1742
H: 7.6cm; W: 6.0cm

Marks: Right-facing buck in a plain oblong

Silver-mounted cowrie shell with hinged lid. Bears engraved initials *AG* and the date *1742*.

Silver-mounted cowrie shells, warm water molluscs from the Indo-Pacific regions, were popular as snuffboxes in the 18th century.

On loan from a private collection.

7.15 LIDDED BOX
Joseph Johns
Limerick, *c.* 1750
H: 3cm; D: (base) 9.1cm

Marks: II flanking lion rampant in irregular oblong struck once

Circular box with detachable domed lid, later chased in repoussé rococo style; the inside gilded. Bears two later crests inside base, 1) a serpent pierced by five arrows and 2) a long-necked bird displayed.

On loan from a private collection.

7.16 PILL BOX
Collins Brehon
Limerick, *c.* 1755
D: 5.7cm

Marks: CB flanking a lion rampant in an irregular punch

Cylindrical, the detachable lid inscribed with two crossed lines, a dot in each angle; inscribed inside on the base *One Pill daily before dinner* and the prescription *Rx. Pil. Rufi gr IV f Pil Mitti VI*. Initialled *L.T.C.*

The prescription is an abbreviation of the Latin recipe *Pitula Rufi, grania IV; fiat Pitula, Mitte VI* which translates to 'Take a Rufus Pill, 4 grains; make a Pill, send six'; the initials below the prescription are probably those of the physician. Rufus's Pills were long in use as a laxative until the early 20th century; the principal ingredient was an extract from aloe plants.

On loan from the National Museum of Ireland.

7.17 PAIR OF SALVERS
Collins Brehon
Limerick, *c.* 1750
D: 15.2cm

Marks: CB flanking a lion rampant in an oval punch

Circular with a lobed edge on three curved feet terminating in scallops; the rim with applied scrolls and five shell motifs. Inscribed on the underside *XVII = VIII* and *XVII = VIIII* respectively.

Originally in the collection of Sir Charles Jackson (the noted early 20th century authority on silver) and subsequently acquired by the National Museum of Wales.

On loan from Amgueddfa Cymru - National Museum Wales, purchased with the assistance of The National Heritage Memorial Fund and The Art Fund, 2001.

7.18 COMBINED SEAL AND CORKSCREW
Joseph Johns
Limerick, *c.* 1740

Marks: II flanking a five-pointed star

An unusual dual function item, it is inscribed *Martin Corbitt 1743* around the neck of the intaglio seal engraved armorial.

It is believed to have descended through the now extinct Corbett family of Limerick, its first owner, Martin Corbitt, or Corbett, thought to have been a relative of a Corbett who settled in Limerick c. 1700 as a teacher of music. The latter's son, Patrick Corbett, of Rutland Street, Limerick, a property owner in the city, was the proprietor of The Hibernia Music Warehouse, a composer, and a subscriber to Ferrar's *History of Limerick,* 1784. Patrick's grandson, Edward Joseph Corbett, was to inherit the music and instrument business in 1836.

Corbett and Gillman families, by descent (private collection).

7.19 FINGER RING
Jonathan Buck
Gold, Limerick, *c.* 1740
D: 2.4cm

Marks: IB with possibly a star between the two letters in an oblong punch; rubbed

Claddagh-style finger ring; two hands holding a crowned heart. Inscribed *IMB* on inside of ring.

On loan from the Limerick City Museum.

Food and Drink

John R. Bowen

Since the earliest times, vessels and utensils made from silver have been used in connection with the preparation, service and consumption of food and drink. As this was so closely connected with the rituals associated with the giving of hospitality, and the celebration of significant family occasions and other events, the use of precious metals in this fashion was both a statement of the importance of the ritual and the sincerity of the hospitality.

Silver as a metal is possessed of several extraordinary properties, not least of which is its ability to be easily worked and reworked into almost any shape imaginable, and to retain that shape indefinitely, unless subjected to significant force. It is also possessed of the fact of being self-sterilising, meaning that bacteria cannot live on its surface, a fact observed by medical practitioners of earlier times who noted fewer post-operative complications from infection, when surgical procedures were performed using silver instruments.

The existence and use of communal drinking vessels, such as 'loving cups' and their earlier Celtic predecessors, methers – had gradually given way during the eighteenth century to more refined and genteel table manners, inspired by the French court and copied in England. These eventually found their way to Ireland, and to Limerick. This fact, coupled with increasing economic prosperity, meant a significant increase in the demand for the silversmiths' wares, both in quantum and in the sorts of items required.

Thus we see refined and elegant articles such as the incomparable soup tureen by Joseph Robinson which dates to about 1760, and the pair of chased and pierced decanter coasters by George Moore dating to the 1780s. As well as these very refined pieces, other less elaborate silver items inhabited the kitchens of the affluent, who were content to keep part of their wealth in the form of plate, confidence in banking systems being far less than we take

Plate 169
Soup Tureen by Joseph Robinson, Limerick c. 1760
Exhibit 8.08

for granted today. In this context we find items like the skewer by Matthew Walsh, and the basting and dividing spoons typical of Limerick flatware, as part of the equipment of a prosperous Georgian kitchen. The brandy saucepan by Joseph Johns, unlike its name suggests, was used to warm brandy over a spirit lamp in a genteel dining context rather than in the kitchen.

A curious and particularly Irish item is the dish ring, sometimes mistakenly called a potato ring, particularly when fitted with a glass liner and used as a serving dish. In fact these items were a very decorative form of trivet, designed to keep hot serving dishes away from contact with the polished surface of the dining table.

The service of tea, coffee and chocolate beverages was attended by particular ritual and we see the development of recognisable forms of vessels or pots designed for each beverage. Also in attendance on such occasions were the sugar bowls and cream jugs in various shapes as shown.

The techniques available to silversmiths to work the metal are several and include raising, seaming, spinning, stamping and casting. The curious rococo cast salt cellars by Samuel Johns are rare Limerick examples of this latter technique.

Plate 170
Sugar Tongs by Maurice Fitzgerald, Limerick c. 1795
Exhibit 8.25

SECTION 8 **FOOD AND DRINK**

Plate 171
Strawberry Dish
by Maurice Fitzgerald,
Limerick c. 1775
Exhibit 8.05

Plate 172
Sugar Bowl by Jonathan Buck,
Limerick c. 1745
Exhibit 8.07

172

Plate 173
*Tumbler Cup by Joseph Johns,
Limerick c. 1750*
Exhibit 8.27

Plate 174
*Cream Jug by George Halloran,
Limerick c. 1760*
Exhibit 8.22

SECTION 8 **FOOD AND DRINK**

Plate 175
Sauceboat by George Moore,
Limerick c. 1780
Exhibit 8.13

Plate 176
Saucepan by Joseph Johns,
Limerick c. 1740
Exhibit 8.03

A CELEBRATION OF LIMERICK'S SILVER

Plate 177
Pair of Coasters by George Moore, Limerick c. 1785
Exhibit 8.04

Plate 178
Dish Ring by George Halloran, Limerick c. 1780
Exhibit 8.11

175

SECTION 8 **FOOD AND DRINK**

Plate 179
*Sauceboat by George Moore,
Limerick c. 1770*
Exhibit 8.18

Plate 180
*Mug by John Robinson,
Limerick c. 1725*
Exhibit 8.06

A CELEBRATION OF LIMERICK'S SILVER

Plate 181
Sauceboat by John Strit,
Limerick c. 1775
Exhibit 8.19

Plate 182
Dish Ring by Joseph Johns,
Limerick c. 1760
Exhibit 8.16

177

SECTION 8 **FOOD AND DRINK**

Plate 183
*Coffee Pot by Samuel Johns,
Limerick c. 1770*
Exhibit 8.09

A CELEBRATION OF LIMERICK'S SILVER

Plate 184
*Wine Funnel by Joseph Johns,
Limerick c. 1735*
Exhibit 8.20

Plate 185
*Pair of Trencher Salts
by Samuel Johns, Limerick c. 1760*
Exhibit 8.01

SECTION 8 FOOD AND DRINK

Plate 186
Lemon Strainer by Samuel Johns,
Limerick c. 1760
Exhibit 8.17

Plate 187
Sauceboat by Henry Downes,
Limerick c. 1780
Exhibit 8.21

Plate 188
Saffron Pot by Jonathan Buck,
Limerick c. 1740
Exhibit 8.23

Plate 189
Nutmeg Grater by Joseph Johns,
Limerick c. 1750
Exhibit 8.14

SECTION 8 **FOOD AND DRINK**

Plate 190
*Pap boat by Joseph Johns,
LImerick c. 1760*
Exhibit 8.15

Plate 191
*Punch Strainer by Joseph Johns,
Limerick c. 1740*
Exhibit 8.24

A CELEBRATION OF LIMERICK'S SILVER

Plate 192

*Sugar Nips by Samuel Johns,
Limerick c. 1765*

Exhibit 8.12

Plate 193

*Spouted Pot by Joseph Johns,
Limerick c. 1760*

Exhibit 8.10

SECTION 8 **FOOD AND DRINK**

Plate 194
Brandy Ladle,
unidentified maker, 18th century
Exhibit 8.29

Plate 195
Pickle Fork
by William Fitzgerald, Limerick c. 1800
Exhibit 8.26

Plate 196
Coffee Pot
by John Smith, Dublin 1850
Exhibit 8.28

SECTION 8 **FOOD AND DRINK**

Catalogue

8.01 PAIR OF TRENCHER SALTS
Samuel Johns
Limerick, *c.* 1760
H: 3.5cm; L: 8cm

Marks: SJ in script in an oblong punch with STERLING in an oblong punch struck once each

The bodies of heavy cast two piece construction in rococo style with the inset dished oval tops sculpted to conform with the bodies.

On loan from a private collection.

8.02 SKEWER
Matthew Walsh
Limerick, *c.* 1790
L: 27cm

Marks: MW in an oblong punch and with STERLING incuse

Of plain ring-top form with typically Irish shoulders and decorated with stylised engraved foliage.

On loan from a private collection.

8.03 SAUCEPAN
Joseph Johns
Limerick, *c.* 1740
H: (to lip) 11.3cm;
D: (at rim) 11.4cm

Marks: II flanking a lion rampant in an irregular punch struck once

Of tapering circular form with a moulded edge and notched pouring lip; the silver and turned wood handle affixed to the body by a heart-shaped cut-card application; base slightly moulded. Bears scratch weight *16oz 15d*.

On loan from a private collection.

8.04 PAIR OF COASTERS
George Moore
Limerick, *c.* 1785
H: 3.7cm; D: 12.2cm

Marks: G.M in an engrailed oblong punch and STERLING in an oblong punch struck once each on both coasters

Circular, with pierced and chased sides, decorated with classical urns and swags; turned wood bases. Bears crest; a stag's head.

On loan from a private collection.

8.05 STRAWBERRY DISH
Maurice Fitzgerald
Limerick, *c.* 1775
H: (to rim) 2cm;
D: 15cm

Marks: MFG in an oblong punch and STERLING in an oblong punch

Plain fluted dish in twenty divisions.

On loan from a private collection.

8.06 MUG
John Robinson
Limerick, *c.* 1725
H: 10.6cm; D: 7.8cm

Marks: IR flanking a star in an oval punch and STERLING in an oblong punch struck once each

Of plain baluster form with a capped scroll handle on a spreading circular foot.

On loan from a private collection.

8.07 SUGAR BOWL
Jonathan Buck
Limerick, *c.* 1745
H: (to rim) 7.1cm;
D: (rim) 12.5cm

Marks: IB in an oval punch and STERLING in an oblong punch struck once each

Of raised plain circular form with an everted scalloped rim standing on three lion-mask feet. Bears crest; a lion's head within a cartouche.

On loan from a private collection.

8.08 SOUP TUREEN
Joseph Robinson
Limerick, *c.* 1760
H: 21cm; W: 28cm

Marks: IR in an oblong punch and STERLING in a scroll punch

Bowl of bombé form on four foliated legs with two flower-capped handles with an applied gadroon band to rim. Lid chased with a band of gadrooning divided by four acanthus leaves and surmounted by a handle in the form of an applied flower and stem. Inscribed *The gift of the Silver Mines Company to Quintin Dick Esqr. for the many*

Compliments they received from him. Bears crest on body and lid; a leopard sejant, (Dick). Scratch weight *55 6.*

The building in which O'Meara's Hotel (Nenagh) was housed was originally built about 1734 by Mr Quintin Dick, a Scottish gentleman. He died in 1768 aged 87 years. His family was subsequently represented by Hume of Humewood, Co. Wicklow. The Silvermines Company had extensive mining interests in the vicinity.

On loan from a private collection.

8.09 COFFEE POT
Samuel Johns
Limerick, *c.* 1770
H: 27.1cm;
D: (of footring) 11.3cm;
(of body) 13cm

Marks: S.J in script in an oblong punch

Pyriform pot standing on plain moulded footring with C-scroll wood handle and domed lid with pineapple finial; bears extensive later chased rococo decoration. Scratch weight *34oz 7d.* Initialled *NFA.*

On loan from the Limerick City Museum.

8.10 SPOUTED POT
Joseph Johns
Limerick, *c.* 1760
H: (to top of finial) 15cm

Marks: II flanking a lion rampant in an irregular punch

Vase shaped, with gadrooned rim and wicker-covered S and C scroll handle; circular spreading foot with gadrooned border; hinged domed lid surmounted by a wrythen finial. Inscribed *FORTIS PRO PATRIA.* Bears crest on body.

The function of this unusual vessel is uncertain. The insulation on the handle indicates it was a container for hot liquids, e.g., gravy. A virtually identical spouted pot, by Stephen Walsh, Cork, c. 1760, has been noted.

On loan from the National Museum of Ireland.

8.11 DISH RING
George Halloran
Limerick, *c.* 1780
H: 8.5cm; D: 19cm

Marks: GH in script in an oblong struck twice

Of waisted circular form pierced and chased with rococo decoration. Bears armorial; possibly Macgillicuddy.

On loan from a private collection.

8.12 SUGAR NIPS
Samuel Johns
Limerick, *c.* 1765
L: 11.6cm

Marks: SJ in script within an small oblong punch applied once inside each grip

Scroll-form scissors action.

On loan from a private collection.

8.13 SAUCEBOAT
George Moore
Limerick, *c.* 1780
H: (to lip) 9.2cm

Marks: G.M in an engrailed oblong punch struck once

Of lipped oval shape with slightly everted plain rim; double C and S scroll handle; standing on three shell knuckle hoofed feet.

On loan from a private collection.

8.14 NUTMEG GRATER
Joseph Johns
Limerick, *c.* 1750
H: 2.4cm; W: 5cm

Marks: II flanking two pellets in a heart-shaped punch

Oval shaped with hinged cover and base; integral steel rasp.

On loan from the Limerick City Museum.

8.15 PAP BOAT
Joseph Johns
Limerick, *c.* 1760
L: 10cm

Marks: II flanking a lion rampant in an irregular punch and STERLING in an oblong punch

A shallow vessel with prominent, wide lip. Initialled *W I* which may indicate a weddding or christening gift.

Pap boats were used for feeding infants. They are rarely found in Irish silver.

From the Hunt Collection.

SECTION 8 **FOOD AND DRINK**

8.16 DISH RING
Joseph Johns
Limerick, *c.* 1760
H: 10cm;
D: (base) 20.5cm;
(top) 17.7cm

Marks: II flanking a lion rampant struck twice with STERLING in an oblong

Of waisted pierced cylindrical form profusely chased with rococo rustic motifs.

On loan from the Limerick City Museum.

8.17 LEMON STRAINER
Samuel Johns
Limerick, *c.* 1760
L: (from outer edges of handles) 21.2cm;
D: (outer edge rim) 11.2cm

Marks: SJ in script in an oblong punch struck once

Perforated plain bowl with decorated rim and ornate rococo handles.

On loan from the Limerick City Museum.

8.18 SAUCEBOAT
George Moore
Limerick, *c.* 1770
W: 16.5cm; D: 10cm

Marks: G.M in an engrailed oblong punch

Of oval form profusely chased with raised lip and slightly everted rim; three shell-capped hoof feet; a caryatid and leaf-capped S and C scroll handle.

On loan from a private collection. With thanks to the Waterford Museum of Treasures.

8.19 SAUCEBOAT
John Strit
Limerick, *c.* 1775
H: (to lip) 9.2cm

Marks: IS in a laterally crowned harp-shaped punch struck twice

Of oval lipped form with slightly everted punched rim and wavy fluted body; standing on three shell knuckle hoof feet; with S and C scroll handle. Bears crest; a martlet. Bears initials *B* above *C.B.*

On loan from a private collection.

8.20 WINE FUNNEL
Joseph Johns
Limerick, *c.* 1735
H: 10.5cm;
D: (at rim) 7.5cm

Marks: II flanking two pellets within a heart-shaped punch

Of conical form with a moulded rim; the outlet curved. Bears crest; a griffin rampant.

On loan from a private collection.

8.21 SAUCEBOAT
Henry Downes
Limerick, *c.* 1780
L: (pouring tip to handle) 16.2cm; (to lip) 9.2cm

Marks: HD in an oblong punch struck twice flanking STERLING in an oblong punch

Of lipped oval form with slightly everted rim and raised pouring lip; standing on three shell knuckle hoof feet; double C and S leaf-capped scroll handle. Initialled *MI.*

On loan from a private collection.

8.22 CREAM JUG
George Halloran
Limerick, *c.* 1760
H: (to pouring lip) 10cm;
D: (from lip to handle) 15cm

Marks: GH in an oblong punch

Helmet shaped with everted wavy rim on three human mask feet; the body reinforced by a central band and chased in rococo taste with scrolls, floral, foliate and avian themes; with leaf and caryatid-capped scroll handle.

On loan from Mary MacNamara, Jr. With thanks to the Waterford Museum of Treasures.

8.23 SAFFRON POT
Jonathan Buck
Limerick, *c.* 1740
H: (with lid) 5.9cm

Marks: IB in an oblong punch struck twice

Of spherical form with straight spout, turned wood handle and detachable lid.

A saffron pot sometimes known as a tisane pot was used for the brewing of infusions of medicinal herbs.

On loan from the Limerick City Museum.

8.24 PUNCH STRAINER
Joseph Johns
Limerick, *c.* 1740
L: (across handles) 28.5cm

Marks: II flanking lion rampant in an irregular punch struck twice

Of circular form with repeating floral border; punched in a pattern radiating from centre; with two flat, shaped handles; flat chased with foliate scrolls and shells. Bears crests; 1) a bull's head, (Massey of Elm Park, Clarina, Co. Limerick); 2) another.

On loan from a private collection.

8.25 SUGAR TONGS
Maurice Fitzgerald
Limerick, *c.* 1795
L: 15.9cm

Marks: MFG in an oblong punch struck thrice

U-form bright-cut sugar tongs. Bears crest; an eagle issuing from a coronet.

On loan from a private collection.

8.26 PICKLE FORK
William Fitzgerald
Limerick, *c.* 1795
L: 14.6cm

Marks: WFG in an oblong punch struck twice flanking single incuse trefoil device

Of plain Celtic-point form; its bowl pierced over the lower two-thirds of its length; the top formed into four short tines. Bears crest, a sleeved hand grasping a broken arrow. Initialled *P* in script.

On loan from a private collection.

8.27 TUMBLER CUP
Joseph Johns
Limerick, *c.* 1750
H: 6cm; W: 6.5cm

Marks: II flanking a lion rampant in an irregular punch, STERLING in an oblong

Of rounded beaker form with heavy base.

On loan from a private collection.

8.28 COFFEE POT
John Smith (or Smyth)
Dublin, 1850
H: 24cm; W: 26.5cm

Marks: JS in an irregular punch struck once, Dublin hallmarks for 1850.

Retailer: Waterhouse & Co., 25 Dame Street, Dublin.

Bears inscription *Presented by J. Joy & Dudley Digges, Esqrs., to Edward Joseph Corbett, Esq., in return for many favours received during Miss Catherine Hayes' visit to her native City Feb'ry 1850.* Bears armorial of Corbett.

This coffee pot forms part of a four-piece tea and coffee service presented in 1850 to Edward Joseph Corbett, principal of Corbett & Son, Music Warehouse, 108 George's Street, Limerick. Corbett was a well-known Limerick impresario as well as a prominent and highly-regarded local businessman. The presentation reflected the success of two concerts given at The Theatre Royal, Limerick, in November 1849, by the Limerick-born prima donna Catherine Hayes (1818-1861), Mr John Joy being the singer's manager, Mr Dudley Digges has not yet been clearly identified. The diva's career continued until her death in London in 1861. Buried in Kensal Green Cemetery, in northwest London, the restoration of her funerary monument was completed by The Limerick Civic Trust.

Corbett and Gillman families, by descent (private collection).

8.29 BRANDY LADLE
Maker unidentified
18th century,
possibly Irish
L: 36cm; D: (bowl) 6cm

Marks: Unmarked

Bowl chased with floral decoration and vacant cartouche. Base of bowl set with a coin. The ladle has a spiral whalebone handle with a silver finial. Inscribed on handle *A Bumper Dear Knight, Prosperity to Ireland.*

This ladle is believed to date from between 1773 and 1775 when Richard FitzGerald inherited the title of Knight of Glin. His elder brother Edmund accumulated huge debts and had been in the Marshalsea debtors' prison in Dublin for at least four years, and the Glin estate was run by his brother Richard.

On loan from the Knight of Glin.

A Directory of the Goldsmiths of Limerick
(includes some allied trades)

John McCormack and Conor O'Brien

Croker Barrington

CROKER BARRINGTON was a son of Benjamin, a pewterer, and grandson of Benjamin, a watchmaker who was Mayor of Limerick in 1724. Croker was baptised at St. John's Church on 7 September 1727. He became a freeman of Limerick, 12 October 1747, and later moved to Cork where in 1759 he was described as a jeweller and later, in 1762, as a silversmith of the City of Cork.[1] He died there in October 1807. His wife Elizabeth was a daughter of Thomas Keyes of Knockagarry who owned lands at Castleconnell, Co. Limerick.[2]

JOHN C. BLUNDELL, described as a jeweller and silversmith, watch and clockmaker and optician, 22 George's (O'Connell) Street, Limerick, he is listed in Limerick Trade Directories 1867–1938.

ROBERT BRADFORD was a son of George, a Limerick clothier, and Mary his wife. In 1770 he was described as a Limerick jeweller when he leased a house in High Street to George Halloran, the deed being witnessed by John Cullum and Thomas Bumbury, both silversmiths.[3] Robert's marriage to a Miss Hinchy was reported in the *FLJ* of 23-26 May 1770, when he was described as a silversmith.

Collins Brehon *Collins Brehon*

COLLINS BREHON, goldsmith, was granted the freedom of Limerick, 7 May 1747. He advertised in the *MJ* of 30 September 1765 and 31 March 1766 (see plate 20) claiming that his shop 'At the Two Blue Posts, opposite the Exchange, Limerick' had been 'enlarged in a spacious Manner, in order to carry on the Watch-making and mending business, together with the Goldsmith's Trade.' Collins died on 29 June 1768 and was buried in St. Mary's. On 11 August 1768 Elizabeth, his widow, advertised in the *LC* that 'she is selling by lottery her stock of watches, touched plate and jewellery in order to pay her husband's creditors and she humbly hopes that the humane gentlemen and ladies of this City will favour her their protection and encouragement.' She died in July 1810, aged 92.

GEORGE BRUSH, jeweller, was admitted a freeman of Limerick, 1 October 1750, and was listed at Main Street, Englishtown, 1769. He is possibly the George Brush buried in St. John's, 30 May 1785.

Adam Buck

ADAM BUCK, goldsmith, may be the Adam Buck who obtained the freedom of the Dublin Goldsmiths Company in February 1690 by paying a fine of £2 10s. He was then residing in Dublin but moved some few years later, evidenced by his being fined for non-attendance at meetings in Goldsmiths' Hall in the early 1690s. He seems to have become established in Limerick around this time, sending some plate to be assayed in Dublin, e.g., 12 salts in June 1694 and unspecified parcels in 1705-09 and 1712-13. It is likely that he was father of Jonathan Buck (see next listing). Nothing appears to be known of how or why the Buck family settled in Limerick. Possibly Adam was a son of George Buck, a burgess of Limerick Corporation, who regularly attended Corporation Assembly meetings 1672-80,[4] and who may

have been the George Bockendoght, a sheriff of Limerick in 1670; it was not unusual at the time for Huguenot and Dutch immigrants to anglicise their names to ease assimilation with the local people. George Buck is listed in August 1679 as one of the Earl of Orrery's Limerick tenants,[5] and is presumably the Alderman George Bucke, listed as having made his will in 1695.[6] Adam Buck's will was proved at Limerick in 1725.

JONATHAN BUCK obtained his freedom of Limerick in 1731.[7] He and his wife Faith had eleven children baptised in Limerick between 1727 and 1742, seven of whom were buried in St. Mary's during those years,[8] a poignant reminder of the infant and child mortality rate in those times. The minutes of the Dublin Goldsmiths' Company for 29 July 1729 reveal that when Thomas Walker brought a cup made by 'Buck of Lymrick' to the Hall for inspection, it was found to be of substandard silver and falsely marked with the Harp Crowned soldered in from another article. This must refer to Jonathan Buck since Adam was dead by 1725. Jonathan attracted unfavourable attention from the Revenue Commissioners in 1731 when it was reported that he had purchased a quantity of Danish silver that had been robbed from a vessel, *The Golden Lyon* belonging to the Danish East India Company. The ship, whose cargo included twelve chests of coin and bullion silver to the value of nearly £20,000, had been stranded near Ballyheige, Co. Kerry, on 7 November 1730.[9] The Bucks moved to Cork between 1743 and 1755, where Jonathan died in Castle Street in October 1762. His widow Faith died in Dublin, February 1766.

JONATHAN BUCK, son of the preceding, married Elizabeth Stedman in April 1751 at St. John's, Limerick. He was admitted a freeman of Limerick, 11 May 1762, but lived in Cork where he died on Fenn's Quay in 1786 and was buried at Christchurch; his widow Elizabeth following him to the grave in 1817. They had three children, Adam and Frederick becoming very accomplished miniaturists, and a daughter Faith.

JOHN BUCKNOR, 'of the Cittie of Limerick, goldsmith' is first encountered when he petitioned the Lord Deputy on 10 January 1664 seeking redress for an assault committed on him by the quarter master of Lord Grandison's troop then garrisoned in Limerick.[10] Bucknor pointed out, that at the Earl of Orrery's request, he and other inhabitants had provided quarters in their private houses for commissioned officers. A dispute having arisen over the billeting costs due to Bucknor, the officer quartered in his house 'fell violently upon him in the open street and beate your petitioner'. The incensed Bucknor, feeling that the army 'being now in command and not immediately subject to common law', sought the Lord Deputy's authorisation to the mayor and sheriff to resolve the matter. The outcome is unclear, but two years later Bucknor himself appears to have been elected as one of the two city sheriffs.[11] The Orrery archives show that Bucknor had frequent dealings in plate with the Earl in 1665 and 1666, including

Jonathan Buck *Jonathan Buck*

Jonathan Buck *Jonathan Buck*

Jonathan Buck *Jonathan Buck*

John Bucknor

supplying him with two communion cups in December 1666. He was one of Orrery's tenants in High Street, Limerick, in the 1660s. Bucknor's background is obscure but it seems likely that he had a family connection with a John Bucknor who had substantial property interests in the districts around Youghal and Lismore, 1620-1660 (regions over which the Earl of Orrery exercised considerable influence.)[12] Burke's *Family Records* reveal that in December 1679 Mary, daughter of John Bucknor of The Grange, Co. Limerick, married Edward Croker of Raleighstown, Co. Limerick, a later (1709) High Sheriff of County Limerick.[13] Probate of John Bucknor's will was taken out in 1671. Mary Croker died in 1732.

JONAS [aka **JONES**] **BULL**, silversmith, was admitted a freeman of Limerick in October 1750. A son of John and Catherine Bull, he was baptised at St. Mary's in August 1727. He moved to Waterford sometime in the 1750s and worked there as a silversmith, apparently very successfully, and amassed a large property portfolio. All this time he retained his links with Limerick, evidenced by his membership of the Annuity Society of Limerick,[14] and after the death of his first wife in March 1768, he married, in November 1768, Elinor, daughter of Mitchell Bennis, a Limerick saddler. By 1797 he had married his third wife, Mary Ann Dyer, otherwise Malone, and had retired to an estate near New Ross, Co Wexford.[15]

Jonas Bull (possibly)

THOMAS BUMBURY (also written as Bunbury), silversmith, witnessed a deed in 1770 (see Robert Bradford). No further information about him has come to light.

JOHN BURBRIDGE, described as a silversmith when he acted as a bailsman in the Tholsel Court in Limerick in 1774. Reporting her death in Limerick on 23 September 1790, the *Clonmel Gazette* described Mrs Burbridge as relict of the late Mr John Burbridge, buckle maker.

PHILIP BURBRIDGE, silversmith and bucklemaker; working 1745. Describing himself as a silversmith, he acted, in conjunction with the above John Burbridge, as a bailsman in a case heard in the Tholsel Court in 1774. His death in Galway was reported in October 1780,[16] but whether he had moved to that city from Limerick or was merely visiting it at the time is not clear.

THOMAS BURKE, silversmith, of Quay Lane, Limerick, when in compliance with the 1783 Act he registered in Dublin in 1784. He was among the subscribers to Ferrar's *History of Limerick,* published in 1787. He advertised frequently between 1789 and 1792 in the *Limerick Herald* and *Limerick Chronicle*, describing himself as Thomas John Burke, Jeweller and Goldsmith of Bridge Street, formerly Quay Lane. His advertisement in the *LC* of 15 December 1791 requested, among other things 'those that are in his debt will be so good as to discharge the amount of their accounts preparitery *(sic)* to the New Year, as it will prevent the trouble of his making

Thomas Burke

application.' His advertisement in the *LC*, 22 March 1792, threatened legal proceedings against those debtors 'for years who seem inclined never to pay'. An announcement inserted by Roman Catholics in the *LC*, 19 August 1779, (see entry for George Halloran) includes the name Thomas Bourke, probably the goldsmith. His will was proved in 1800.

JOHN CALBECK (Caldbeck, Coleback), silversmith, Limerick, was a witness to the marriage articles of John Gloster, silversmith, 16 September 1752.[17] In October 1773 the engraver Alexander Guppy, being a defendant in a case at the Tholsel Court, had both John Calbeck and John Gloster act as his bailsmen. John Calbeck had four children of whom a son William, baptised at St. John's in February 1752, was the only one to survive the neonatal year. The death of Mr. John Caldbeck, formerly of the city of Limerick, silversmith, was reported in the *Freeman's Journal*, 21-23 March 1782. The death of his widow was reported in *The Waterford Herald*, 17 January 1792.

SAMUEL CALBECK (Coldbeck), silversmith of Limerick, was a witness to a deed dated 5 November 1726 to which William Cherry (see below) was a party. An advertisement in the *LJ* of 11 August 1741 announced that 'The House where Samuel Coldbeck, goldsmith, lately dwelt near Mr John Creagh's, Merchant, in the Englishtown, Limerick, is to be let for a year or Term of Years'. Samuel is likely to have been the father of John Calbeck (see preceding).

Samuel Calbeck

WILLIAM CARROLL, jeweller, acted as a bailsman in the Tholsel Court in 1791. In later years he was given the description silversmith in the *LJ* of 16 March 1803, when reporting a theft from him. He registered in Goldsmiths' Hall, Dublin, in 1805 as of Bank Place, Newtownperry, Limerick.

JOHN CHERRY, silversmith, admitted a freeman of Limerick 7 October 1754. He is probably the son of William and Ann Cherry, baptised 1 September 1730 (St. Mary's). An entry in the Dublin Assay Office ledgers in 1754 of parcel of plate weighing 18oz submitted by 'Cherry, Country' most likely refers to him.

JOHN CHERRY, jeweller, Merchant's Quay, Limerick; children of Elizabeth Cherry and the foregoing John were baptised at St. Mary's in 1840 and 1844.

WILLIAM CHERRY, goldsmith, Limerick, was eldest son of John and Sarah Cherry who held lands at Knockardnegallagh in the Liberties of the City, evidenced by a lease of July 1713 from Lord Shelbourne. At the behest of his widowed mother, William assigned this property to his brother George in 1726, a witness to the conveyance being Samuel Calbeck, the silversmith.[18] William also held lands at Cahirdavin in the North Liberties. His mother Sarah (1738), William (1751) and George (1740) were all buried in St. Munchin's Church. Various children of William and Ann (Anstice) Cherry were baptised at St. Mary's in the period 1728-1749.

CALEB COLBECK, is listed by Westropp as a goldsmith 'mentioned' 1720, 1730, but Westropp's source has not been identified. A parcel of plate (12lb 9oz) was assayed in Dublin on 5 July 1728 for 'Calback, Limerick', and three parcels in 1730 for 'Callbeck'. These parcels may, however, have been sent in by Samuel Calbeck. That Caleb Colbeck was a freeman is indicated by his having voted in the parliamentary elections of 1731.[19]

JAMES COLLOPY, silversmith, acted as a bailsman in the Tholsel Court in 1774. Nothing further about him has been uncovered.

PATRICK CONNELL, silversmith, was a witness to a deed of April 1779 to which George Halloran, goldsmith, was a party. In April 1795 he became a tenant of a George Halloran house in High Street at a rent of £60 sterling p.a.[20] He registered under the 1783 Act as of Main Street, Englishtown. Four years later he was listed as a jeweller and goldsmith in Mary Street. Like many of his colleagues, he acted as a bailsman in the Tholsel Court in 1789.

Patrick Connell

JAMES CONWAY, described as a silversmith in June 1780 when, along with Daniel Lysaght, silversmith, he witnessed a deed to which Samuel Johns was a party.[21] He later moved to Cork where in 1807 he joined colleagues in signing a petition to the Government seeking an assay office in Cork, albeit in vain. In 1810 he was recorded as a watchmaker in Grand Parade, Cork.

COSMACS Ltd., Ennis Road, Limerick, was registered in February 1959, the name being an acronym based on the surnames of the company's founders, G. Clancy, T. O'Brien, H. Sexton, E. & T. McCarthy. One of the earliest pieces of plate produced by the firm was a replica of the de Burgo–O'Malley chalice of 1494 preserved in the National Museum. As well as varied ecclesiastical plate, Cosmacs produced small items such as decanter labels, napkin rings and souvenir goods. The firm ceased operations in 1964.

Cosmacs Ltd.

JOHN HERBERT CROAN (or CRONE), a watch and clockmaker who, having been apprenticed to Robert Latch & Son, entered into partnership with Samuel Johns 1770-74. He was probably a son of John Crone of Doneraile and Limerick. He advertised in the *LC*, 19 August 1779 seeking an apprentice.

CONRAD CROMER, Limerick, registered a maker's mark in the Dublin Assay Office in 1907. As Cromer Brothers (1929), Cromer & Evans (1930) and Cromer Ltd. (1969), silversmiths, fishing rod & tackle maker, watch & clockmaker, jeweller etc., and watchmaker, the firm is listed in street directories from 1870.

Conrad Cromer

JOHN CULLUM, silversmith, working 1751; Ferrar gives his address at Baal's Bridge in 1769. He was witness to a deed in 1770 to which the silversmith Robert Bradford was a party, and he acted many times as a bailsman in the Tholsel Court from 1773 to 1786. He is probably the John Cullen *(sic)*, Ballsbridge, Limerick, who registered in Goldsmiths' Hall,

Dublin, in 1784. *The Clonmel Gazette* reported his death in February 1788. His wife predeceased him in December 1775, as noted by the *LC*.

EDWARD DONEGAN, jeweller & silversmith, listed at 46 Thomas Street, Limerick, 1856.

HENRY DOWNES, silversmith, was listed as of Bridge Street, Limerick, in 1788. The *LC* of 13 February 1786 carried an advertisement from Henry Downes, 'gold and silver worker from Dublin', offering commodious lodgings in Quay Lane; he was also seeking an apprentice. Henry Downes died in March 1788 and was buried in St. Mary's.

RICHARD FENNELL, information about Fennell has proved elusive. He is known only through his signature as maker of three chalices associated with Franciscan friaries in Co. Clare and dating to 1670-71. It is probable that he was a silversmith who worked in the North Munster region around this period.

Henry Downes Richard Fennell

GARRETT FITZGERALD, working in Limerick, 1768. He is almost certainly the Garrett Fitzgerald, son of Richard Fitzgerald of Limerick, gentleman, who was apprenticed to William Townsend in Dublin in 1760. His request for freedom of the Dublin Company was refused in August 1770 because he had failed to complete the full seven years apprenticeship under Townsend. He died in May 1780.

Garett Fitzgerald Maurice Fitzgerald

MAURICE FITZGERALD, Mary Street Limerick, working 1760-1817. He is possibly the Maurice Fitzgerald, son of James Fitzgerald (no address given), who was apprenticed to Vere Forster, a Dublin goldsmith in 1752. He obtained his freedom of Limerick in October 1774. He served as a bailsman in the Tholsel Court in 1787 and 1789. His advertisement in the *LH*, 7 December 1789, announced his moving 'to Bridge St (formerly Quay Lane) where Geo. Moore had his shop, and has received from London and Dublin a fashionable assortment of silver and plate work'. He leased part of his Rutland Street dwelling in 1815.[22] He died in Rutland Street in May 1817 and was buried in St. John's; his wife predeceased him in November 1815.

WILLIAM FITZGERALD, jeweller of Mary Street, advertised in the *LC*, 3 September 1794, saying 'There has arrived at this port from Sheffield per the Brig, Peggy (Capt. Meade), a large assortment of new patterns, etc.' He resided in Patrick Street, Limerick, when registering under the Act in Dublin in 1800 and recorded his maker's mark on a pewter plate in the Assay Office. His advertisement in the *LC* of 3 March 1804 announced that he 'is now in Dublin selecting from Messrs Miller, Settle and Garmanstown, wholesale jewellers from London, a nice assortment … of every article in his different branches, which … he will offer for sale the ensuing Assizes … Those who are indebted to him for years are requested to discharge same.' In the *LC* on 25 July 1804, he advertised stock direct from London and that 'He will let his house furnished for the Assizes week.' On 27 March 1805 in

William Fitzgerald

the same newspaper he announced his intention of going to England shortly and requested those indebted to him to pay the amount of their account at the ensuing Assizes, and offered 'best finished watches from 5 to 30 guineas each engaged'. *The General Advertiser and Limerick Gazette*, 6 October 1807, carried an advertisement for William Fitzgerald's Club of Real Value for the sale of several new and fashionable articles consisting of Plate, Plated Ware, Gold and Silver Watches, Jewellery, best London Guns and Pistols, etc. Will commence drawing on the 2th *(sic)* of next month: 'There are many large Benefits for Half a Guinea each Ticket.' 'Intending to retire from business', he advertised in the *LC* a clearance sale of his stock, to commence on 25 July 1823.

JOHN GLOSTER, silversmith, eldest son of Thomas Gloster, the Land Carriage Officer and Waiter for Limerick Port and District, was admitted a freeman of Limerick in October 1752. In the same year he married Elinor Goggin, his fellow silversmith John Calbeck, witnessing the marriage articles.[23] Gloster obtained a lease on lands at Cahirunardorish, known by the name of Lurraga in Mungret Parish, also in the same year.[24] In January 1755, describing himself as a goldsmith of Quay Lane, he advertised the letting of c. 16 acres of land adjoining 'Loughmore in the Liberties of Limerick City' in *The Munster News*. In 1773, he and John Calbeck acted as bailsmen in a case in the Tholsel Court in which Alexander Guppy, the engraver, was defendant. John Gloster was buried in St. Mary's in September 1789, and his widow was buried there in May 1804.

ALEXANDER GUPPY was described as a silversmith by the Limerick printer, Andrew Welsh, in an advertisement placed in the *Dublin Courant*, 5 January 1748, offering a reward for the apprehension of his apprentice, Owen Sweeny of Limerick, who in December 1747 had 'run away ... from the service of his master', apparently intent on taking passage to Lisbon. Sweeny 'went off in the company of one Lacy, apprentice to Mr. Alexander Guppy, silversmith'.[25] It is, however, as an engraver of Parade, Limerick, that Guppy was listed by Ferrar in 1769. He was a defendant at the Tholsel Court in a case in October 1773. Three children (two daughters and a son) were born to his wife Rebecca between February 1739 and June 1744 while two unnamed children were buried in St. Mary's in 1742 and 1747.

WILLIAM GUPPY. The death on 14 December 1775 of the wife of William Guppy, engraver, was reported by the *LC*.

JOHN HACKETT, of Pennywell Road, registered in 1784 in compliance with the 1783 Act. He is listed by Westropp as 'mentioned ' in 1770.

GEORGE HALLORAN (O'HALLORAN), jeweller and goldsmith, advertised in the *MJ* in September 1766 that he had just returned from London and had a greater variety than ever of 'Chased Tea Kettles, Lamps and Stands, double bellied fluted chased, embossed and polished Coffee Pots, Cream Pails and

Ladies and Cream Jugs' at his shop and warehouse at the 'Sign of the Golden, Pearl and Ring, near the Exchange, Limerick'. Two years later he was advertising in the *LC* 'Locket buttons in silver for 1s 6d to 5s 5d. Gold buttons 16s 3d to £2 5s 6d. With every other article in his business properties as he keeps a number of workmen and manufactures almost every article himself 'tis impossible for anyone to sell better or cheaper.' Difficulties with a rather young member of staff became apparent in his advertisement of 1 December 1768 in the *LC* announcing that 'His apprentice Michael McMahon aged 11 years ran away, possibly to Clonmel where an aunt of his lived and thence to Kilkenny and Dublin. He had been disposing of several parcels of goods to different persons in this City. I will give a reward of 5 guineas to any person who will secure or lodge him in his Majesty's Jails within six months after this date. In order to find out where any of the articles have been disposed of, I will give the value of these articles to the person who finds them.' In the *LJ*, 22 February 1770, Halloran advertised for sale a newly built house near the Post Office, while in the same paper on 8 July 1771 he announced his return from London whence he had supplied himself with 'every article in the jewellery, goldsmithing, watch and toy business', adding that he 'has lately taken the large and commodious house opposite Quay Lane, lately occupied by Mr Michael Stritch, deceased, in order to carry on said business more effectively. He will let the house he lately lived in near the Exchange', while two weeks later he advertised the letting of the 'house back of his office at Quay Lane, Limerick'. After another trip to London two years later, he advertised in the *LC* on 16 August 1773 that he had just imported 'a capital and elegant assortment of the newest fashion, chased, embossed and plain plate, a curious collection of jewellery work in the Diamond and Paste way. Great choice of stones, watches, etc, etc. He has a very good house back of his to let, lately tenanted by Capt. John Cudmore, and a double shop and Apartments backward, under Bouchiers Coffee House'. Second son of Michael O'Halloran and his wife Mary McDonnell, George belonged to a prominent County Limerick Catholic family. An older brother was the noted Dr. Sylvester O'Halloran (1728-1807) who published and lectured widely on both eye surgery and Irish history. Another brother joined the Jesuit order and lived in Bordeaux, becoming bishop of that diocese. George married a Miss Connolly and they had three children, one of whom, Major O'Halloran-Gavin, was MP for Limerick City. George was one of over 60 Roman Catholic prominent inhabitants of Limerick City whose names were published in August 1779 as contributors to a fund established by Robert Maunsell, esq., aimed at encouraging enlistment to a local military force.[26] He announced his retirement in the *LC* in February 1786. The *LJ* of 19 May 1804 carried notice of his death.

George Halloran

CHARLES HARRISON, a son of George Harrison, a whitesmith located at the Sign of the Cross Keys near the Market House in Irishtown. Charles was described by Ferrar in 1769 as a watch and bitmaker, bookseller and

stationer, whose shop was in Main Street, Englishtown. Ferrar bought out his stationery and bookselling business in 1770.[27] In 1772 his shop was located in Quay Lane (now Bridge Street) and displayed the sign of a clock painted on a wooden board with the hands pointing to 12.15.[28] His advertisement in the *LC* of 3 June 1779 announced that he had just imported from his native Staffordshire a large assortment of Queen's Ware and a variety of glasses. In July 1786 his *LC* advertisement announced that he had just removed to Creagh Lane to Main Street opposite St. Mary's Church, and in this year also he is recorded as a maker of money weights for use in Ireland,[29] an occupation usually handled by goldsmiths. He died at his house in Mary Street on 21 July 1812 in his 88th year.

JOSEPH HARTMANN, jeweller and silversmith, watch and clockmaker, 2 Patrick Street, Limerick, listed in street directories from 1906.

JOHN HAWLEY, of Main Street, Irishtown, Limerick, when registered in Dublin in 1784 in compliance with the 1783 Act.

RANDAL HICKS, goldsmith, obtained a 21-year lease in High Street, Limerick, from the Earl of Orrery, commencing 28 March 1668. He was still being listed as one of Orrery's tenants in 1678 and 1679.[30]

SAMUEL HILL, a whitesmith of Limerick whose will was admitted to probate in 1753.[31] A parcel of plate weighing 3lbs 2oz was assayed in Dublin, October 1727, for a Mr. Hill, Limerick. A Limerick goldsmith of that name has not been identified. It is suggested that Samuel Hill the whitesmith may have secured a commission for special articles of iron to which silver mounts were attached.[32]

Joseph Johns *Joseph Johns*

JOSEPH JOHNS, goldsmith, became a freeman of Limerick in 1731. In September 1740 he witnessed a deed which mentioned the recent death of Samuel Johns, carpenter, while a deed of two years earlier recorded that Samuel's eldest son and heir was Bartholemew Johns, chandler.[33] It seems likely that Joseph Johns was also a son of Samuel, the carpenter. However, while Joseph Johns proved to be the most prolific and arguably the most successful of Limerick goldsmiths, elucidating with certainty his family background and connections is difficult because of the contemporaneous existence in Limerick of different Johns families, many members sharing the same forenames, e.g., Bartholemew, Joseph and Samuel. Joseph Johns was listed as of Main Street, Englishtown, opposite Fanning's Castle, in 1769, and was Treasurer of Freemason's Lodge no. 9 in that year. He was also then a churchwarden of St. Mary's. He held many important municipal offices: Sheriff 1755, Burgess 1756, Chamberlain 1769, Mayor 1773. He married, 29 August 1737, in St. Munchin's, Ann Hincks and had issue, Samuel, baptised in St. Mary's 7 October 1739, Mary, Sarah and another child who died in 1746. Joseph Johns was a subscriber to Ferrar's 1767 edition of *An History of Limerick*, whose publisher his eldest daughter Mary married a year later.[34]

While mayor, he laid the foundation stone for the so-called House of Industry (the Poor House) on 10 March 1774, designed by Revd. Deane Hoare. He died in September 1775.

JOSEPH JOHNS, silversmith, a son of Samuel (see below) and Catherine Power, was witness to a deed of his father's in 1786.[35]

SAMUEL JOHNS, silversmith, was admitted a freeman of Limerick, 10 September 1756, and on the same day, another Samuel Johns, son of Sheriff Johns (i.e., Joseph the goldsmith), also obtained his freedom. The parallel existence of two of the same name occasionally gives rise to identification uncertainties. Ferrar (1769) lists a Samuel Johns as a Commissioner of Oaths, Public Notary and an Attorney of the Tholsel Court, residing in Main Street, while a Samuel Johns, silversmith, also resided there and was a Warden of the Smiths' Corporation. The attorney died 28 August 1799. Samuel the silversmith seems to have been the son of Joseph and Bridget Johns, who was baptised in St. Mary's in January 1732-3. An advertisement in the *LC* of 12 March 1770, announced that Samuel Johns 'of the Golden Cup, Englishtown' has wares just arrived from London (see plate 23). Catherine Power, Samuel's first wife, died in January 1771 and was buried at St. Mary's, and no less than four months later he agreed marriage articles with Honora Donovan, widow of a Captain Donovan, the agreement being witnessed by James Conway and Daniel Lysaght, both silversmiths.[36] Reporting his marriage, the *LC* of 28 May 1771 referred to 'the agreeable Mrs Donovan ... with a fortune of £1,000'. In the following year a deed to which he was a party named Catherine Jones otherwise Power, his late wife, and their children Bridget and Joseph Johns – the names of the children, Bridget and Joseph, tending to support the presumption above that Samuel was the child of parents of the same Christian names.[37] The name Samuel Johns is listed amongst the Roman Catholics contributing to Robert Maunsell's fund towards raising a military company in Limerick in 1773 (see George Halloran above). However, Samuel's contribution was a mere 3 guineas whereas Halloran's was 20 guineas. An advertisement in the *LC*, in August 1774 stated he was then a silversmith at the corner of Mill Lane carrying on the clock and watchmaking business with John Herbert Croan. In 1774 and 1778 he acted as a bailsman in the Tholsel Court.

Samuel Johns *Samuel Johns*

A downturn in his fortunes is suggested by an announcement in *The Dublin Gazette* of 10 March 1778 naming Samuel Johns, late of the city of Limerick, silversmith, amongst those petitioning the House of Commons to be included as insolvent in the schedules annexed to a Bill for the Relief of Insolvent Debtors.

A deed of 2 June 1780 shows him assigning a house he had lately built at the upper yard end of Mill Street in trust as an annuity to his wife Honora should he die before her.[38] In the event, he survived her, she dying in November 1788. Samuel's daughter married Felix O'Neill, Master of the brig

Flora (*LC*, 15 May 1791). Another daughter married a John Scott, cordwainer, in December of the same year. Samuel married his third wife, Ann Taylor, on 25 April 1792 (*LC*) In February 1793 it was reported in the *Ennis Chronicle* that 'Samuel Johns, lately married to the widow of Thomas Taylor who kept an inn outside the Square, has taken the noted Inn at the height of Thomond Gate by the name of Black Horse Inn ... said Johns continues to be employed as Auctioneer'. *The Clare Journal* of 23 February 1795 reported the death four days earlier 'in the Square, Limerick, after two days illness, Mr Samuel Johns, Master of the New Inn'. Five months later the same newspaper reported the marriage on 16 July 1795 to William Ryan of Cahirconlish of 'the widow of Samuel Johns of the Square, Limerick'. Sic transit gloria Samuel!

JOSEPH KELSO, silversmith, acted as a bailsman, jointly with Daniel Lysaght, in the Tholsel Court in 1786. No further information about him has been uncovered.

THOMAS KINRAGHTE [Enright], goldsmith of Kilmallock, was mentioned 18 January 1569.[39]

EDMUND (Edward) **ROCHE KINSELAGH** (son of Joseph and Mary), was baptised 7 June 1739 in St Mary's. A jeweller, he obtained the freedom of Limerick, 11 May 1762, but by then had moved to Cork where he later became coroner. He died there 6 November 1799.

NICHOLAS KNIGHT, jeweller, watch and clockmaker, gold and silversmith, listed in street directories as of 20 George's Street in 1838 and 31 George's Street in 1840.

JOHN LAING, watch and clockmaker, jeweller and goldsmith, listed as of 1 Thomas Street in 1846.

ROBERT LATCH, the elder, watch and clockmaker, advertised that he 'begs leave to inform the public that he has removed to the New Quay between Baal's Bridge and Assembly House', *LC*, 20 May 1771. He was buried in St. Mary's, April 1774.

ROBERT LATCH, the younger, obtained the freedom of Limerick in October 1760. He announced in the *LC* of 13 October 1768, that he had joined his father in the watch and clockmaking business, having worked in the principal cities of Europe. In contrast to Charles Harrison (see above) the clock over his shop in Nicholas Street near the Exchange showed the time of 11.45. After a period of illness he informed the public that 'having had the misfortune to be afflicted with illness for some time and fearing during his indisposition, ... he is able to attend now and also has a good workman from Dublin as an Assistant, and that he will make it a study to give general satisfaction to all that are pleased to employ him'.[40] The deaths of both himself and his widow were reported in the *LC* in September 1792.

THOMAS le ORFEURE (the goldsmith) was acquitted in court on 12 June 1307 at Ardard, Co. Kerry, before John Wogan, the justiciar, of receiving a piece of gold, value half a mark, stolen from Sibilla la Grass by her maidservant, and then sold to him. A month later he appeared before the Justiciar at Kilmallock court at the suit of Walter the cleric of Limerick and others seeking to recover monies owed by him, the jury finding against him.[41]

JOHN LYLES, goldsmith, Limerick, acted as an arbiter in 1608 in a dispute which had arisen in 1602 between Edmond Sexten, Esq., and William Creagh FitzJohn over a boundary wall in Limerick.[42]

PHILIP LYLES, as 'Phi Lyles fecit.' his signature on the Arthur Altar Crucifix dated 1625 (see exhibit 1.38). He is most likely the Philip Layles who was admitted a freeman of Cork, 17 October 1614, and who was remunerated there for minding the municipal clock, an undertaking frequently entrusted at the time to goldsmiths.[43] Other contemporary goldsmiths in Munster bearing anglicised variants of the Gaelic name Laighléis include William Lewles in Youghal, 1601; Patrick Leyles in Youghal, 1614; Morice Lyles in Cork, 1617, and in Youghal, 1620, as Morrish Lawless; and James Lawless in Youghal, 1625. It is suggested that these were members of a hereditary Gaelic family of goldsmiths surviving in Munster in the early seventeenth century.[44]

Philip Lyles

ARTHUR LYNCH, of 2 Mungret Street, Limerick, registered in 1784 under the 1783 Act.

JAMES LYNCH, of Margaret [Mungret ?] Street, Limerick, when registered in 1784.

ROBERT LYNCH, of John's Street, Limerick, when registered in 1784.

DANIEL LYSAGHT, Limerick, silversmith, in company with James Conway, also a silversmith, were witnesses to a deed dated 2 June 1780 to which the silversmith Samuel Johns was a party. Daniel resided at Mary Street, Limerick, when registering in 1786 in compliance with the 1783 Act. He served as a bailsman, jointly with Joseph Kelso, silversmith, in the Tholsel Court in 1786. Having in 1788 married a daughter of James McLoughlin, an Ennis merchant, he later moved to that town and was duly listed as a businessman there by the *Clare Champion* in February 1797. By 1802 he had become bankrupt. He was alive in 1804.

Daniel Lysaght *Susan McCarthy*

SUSAN McCARTHY, a native of Limerick, is a graduate of the Kent Institute of Art and Design, specialising in Silversmithing, Goldsmithing and Jewellery Design; she has won several prestigious awards.

GEORGE MARTIN, listed as a manufacturing jeweller and silversmith, 5 Francis Street, Irishtown, Limerick, in 1846.

DONALD MECGYLLYSAGHTA [Lysaght], goldsmith of Limerick, is named in State documents of 1559.[45]

JOHN MILLS, goldsmith, advertised in the *LC* of 29 April 1782 the rental of the upper part of the house where he lived opposite Thomas Alley.[46]

GEORGE MOORE, silversmith, obtained the freedom of Limerick in September 1748. He married Mary Foot in February 1752 in St. Mary's. His advertisement in the *LC* of 11 August 1768 announced that he had moved from the corner of Pump Lane to Quay Lane, two doors below the New Printing-Office, adding that 'said Moore will take an Apprentice well recommended to the above business'. Along with other goldsmiths, he was listed as a member of the Annuity Society of Limerick City, by the *LJ* of 13 March 1769. Indicative, perhaps, of either necessity or business acumen, his August 1773 advertisement in the *LC* showed him branching into another trade in parallel with silversmithing, announcing that he 'has lately laid in an assortment of goods'; these mostly consisted of various kinds of luxury fabrics. He was still resident at Quay Lane when registering in Dublin in 1784 but by December 1789 his shop in Quay Lane, now named Bridge Street, had been taken over by Maurice Fitzgerald.

George Moore

WILLIAM D. MOORE, jeweller (from City of Dublin), admitted a freeman 5 May 1762. His advertisement in the *LC* of 19 August 1779 gives his address as 'within one door of the Exchange'.

THOMAS O'CARRYD, maker of a mitre for Bishop Cornelius O'Dea of Limerick in 1418.[47]

GILLADUFFE O'COWLTAYN, goldsmith of Limerick, named in State documents of 1559.[48]

MARTIN O'DRISCOLL, goldsmith, served his apprenticeship, 1970-75, in the Design Centre of his native Kilkenny. Afterwards he worked in the Bradden Design Centre in Dublin, returning to the Kilkenny Design Centre in 1980. He moved to Limerick in 1992, where he had his workshop on Mathew Bridge. He returned to Kilkenny in 1998 and now works there at 48 Maudlin Street.

Martin O'Driscoll *Robert O'Shaughnessy*

ROBERT O'SHAUGHNESSY, of Charlotte Quay, Limerick, registered in Dublin 1802 in compliance with the 1783 Act and entered his maker's mark on a pewter plate in the Assay Office. The *LC* of 10 March 1804 carried his advertisement from 18 Charlotte Quay as a 'Watch and Clockmaker, Goldsmith and Jeweller' offering watches, clocks and jewellery, and seeking an apprentice. A few months later he advertised from 6 Charlotte Quay, 'double cased silver or hunting do. finished under his own inspection for 8 guineas' adding that 'A young man of genteel connections will be immediately taken Apprentice'.

In March 1810 a legal assignment between O'Shaughnessy and Messrs. Steward and Mosely, jewellers of Dublin, stated that Frank Arthur of Manchester Square in England leased on 13 March 1805 to Robert O'Shaughnessy the new dwelling house, no. 3 in George's Street, Newtownperry, for lives of said Robert, his wife Mary and Edmund Robert O'Shaughnessy, his son. At the time O'Shaughnessy was indebted to Stewart and Mosely and others for the sum of £602 18s.[49] His will was proved at Limerick in 1842. An advertisement in the *LC*, 8 March 1848, stated that the firm, then at 18 George's Street, had been established in 1795.

JOHN O'SHEA, known in religion as Father Henry, is a Benedictine monk attached to Glenstal Abbey, Co. Limerick. He studied to be a silversmith at Munsterschwarzach, Germany, in the 1970s. He registered his maker's mark, JOS in an oblong, at the Dublin Assay Office on 11 June 1984.

John O'Shea

EDWARD PARKER, described as a goldsmith when named in deeds dated 26 July 1718, 8 November 1722 and 21 September 1725 to which his father John and older brother William (see below) and another brother David were parties.[50] He is possibly the same Edward Parker, described as an aleseller in a deed which he witnessed on 6 February 1723, and as an innkeeper in a lease dated 24 November 1740 to which he was a party.[51] Possibly when younger he may have assisted in his brother William's workshop, learning something of the goldsmith's craft there. His will was probated at Limerick in 1782.[52]

WILLIAM PARKER, goldsmith, Limerick, eldest son of John Parker, gunsmith, Limerick, was apprenticed in 1710 to the Dublin goldsmith Christian Kindt. In September 1719 he married Mary, daughter of Edward Meating of Clunny Connery, Co. Clare.[53] He was a sheriff of Limerick Corporation in 1723 and two years later noted as a burgess. In May 1725 he was a party to a conveyance to Samuel Monsell, Esq., of Tiervoe, Co. Limerick, of a house in High Street, Limerick, which Parker's father had purchased in 1718 from Viscountess Blessington.[54] The business connection with the influential Monsell family may, perhaps, explain the maker's mark, W.P in a rounded oblong, stamped on an octagonal sugar bowl and cover, Dublin 1716-19, which were offered for sale by Sotheby's, New York, in October 2002. These pieces bore contemporary Monsell armorials. Other contemporary pieces of Monsell family plate bearing the same maker's mark were sold at Christie's, London, 11 July 1934. It is suggested that the maker in question was William Parker.

JOHN PENNYFATHER, a goldsmith working in Dublin in the early years of the eighteenth century. He had obtained his freedom from the Company of Goldsmiths of Dublin in September 1704 on the grounds that he had served seven years apprenticeship to a goldsmith in Limerick. Before moving to Dublin he had worked for some years in Kilkenny of which city he appears to have been a native. It is not known when or to whom he served his apprenticeship in Limerick. The possibility that he may have remained on

in Limerick for a period after serving his time there has to be borne in mind when trying to identify late seventeenth-century plate of Limerick provenance bearing a currently unattributed maker's mark I.P.

FRANCIS PHIPPS, jeweller; his daughter Ann by his wife Elizabeth, whom he married in 1788, was baptised in St. Mary's on 18 October 1789.

CHARLES PURCELL, son and successor to John Purcell (below), advertised in the *LC*, 4 December 1813, as Charles Purcell & Co., 31 Patrick Street, offering gold and silver, clocks, watches, gold and gilt chains, seals and keyes of the newest fashion, etc., adding that 'it shall be his study to merit that share of Public favor the Establishment has experienced these 26 years past'.

JOHN PURCELL, watch and clock maker and silversmith, working 1787. He served as a bailsman in the Tholsel Court in 1791. His *LJ* advertisement in May 1794 for his variety of clocks and watches gave his shop address as under the King's Head Tavern nearly opposite the Exchange. He died in Patrick Street, 19 May 1813.

John Purcell

SAMUEL PURDON, manufacturing jeweller and silversmith, of 3 Charlotte Quay, 1800. He is probably the Samuel Purdon, son of John and Mary (Quinn), who was baptised in St. Mary's, 10 April 1780, and who married, 13 February 1811, Joanna Lannen in St. Mary's. He was listed as a jeweller at 12 Rutland Street, in 1824. Their children, baptised in St. Mary's, were Margaret (1811), Mary (1816), Anne (1818), Henrietta (1820), Johanna (1823) and Avarina (1825). The Registry of Voters in April 1837 listed him as a jeweller and silversmith with a shop and premises in Charlotte Quay. Johanna Purdon was buried in St. John's, 31 October 1839 and Samuel was buried there, 29 March 1849.

Samuel Purdon

EDWARD ROBINSON, silversmith (son of George, see below), baptised 24 July 1742 (St. Mary's). He became a freeman of Limerick 3 September 1759.

GEORGE ROBINSON, an advertisement in the *MJ*, 1 January 1749, stated, 'to be sold by public cant on the 10th January by George Robinson of the City of Limerick, silversmith, several household goods and furniture in the house on the quay in Limerick, wherein Jacob White, gent, deceased, lately lived, which goods were taken at the suit of said George Robinson'. By his wife Catherine he had issue Margaret (1740), Edward (1742) (as above), George (see below), and two children buried 1743 and 1749.

George Robinson

GEORGE ROBINSON, silversmith (son of George above), became a freeman 3 September 1759; he was active until at least 1775. A son, John Robinson, advertised as a painter and glazier in the *LC* of 13 October 1768.

JAMES ROBINSON, goldsmith, a sheriff of Limerick, 1686 and 1691, a burgess of Limerick and a member of its Common Council in 1687, and Mayor, 1698. He was party to a lease dated 26 April 1719.[55] He was buried in St. Mary's, 3 June 1736, and his will was probated in 1738.

James Robinson

JAMES ROBINSON, a son of George Robinson, Limerick, gentleman, was apprenticed to John Paturle, silversmith, Dublin, in 1718. His precise connection, if any, with the Robinson family of goldsmiths has not been elucidated.

JOHN ROBINSON may have been the person of that name (address not recorded) who was apprenticed to the prominent Dublin goldsmith, Matthew Walker, in 1717. Significantly, perhaps, the minutes of the Dublin Goldsmiths' Company for 20 August 1725 note that a 'John Robison (sic) was fined for bringing a substandard ladle to the Hall and procuring Mr Walker's stamp to be put on it.' Some years later, 17 January 1738, the minutes record that 'A silver waiter being brought to the Hall to be touched and 6 silver teaspoons sent with it by John Robinson of the city of Limerick, goldsmith, and upon tryal the waiter was found 6 dwt worse and the two spoons 5 dwt worse by which it appeared to the Hall that a fraud was intended not only on the publick but on the Hall. It was therefore ordered that the said waiter be broke. And on it being proposed that the said Robinson should be fined the question was whether it should be 20/- or 10/. For 20/- three votes; for 10/- twelve votes. Mr Matthew Walker promised to pay the said 10/- to the Master.'

John Robinson *John Robinson*

John Robinson married, first, Mary Crips in May 1733[56] and by her had Joseph, baptised 11 November 1735, George, baptised 30 November 1736 and John, baptised 17 December 1739, all in St. Mary's. In August 1743 he married, secondly, Elizabeth, eldest daughter of the Reverend John Brown, Chancellor of Limerick Diocese. While not listed by Lenihan as a sheriff in 1731, he was described as such in a deed dated 17 February 1731, when he may have held the office temporarily.[57] He was mayor in 1742. Alderman John Robinson was buried in St. Mary's on 24 April 1753.

JOSEPH ROBINSON, silversmith, (son of John above), was baptised, 11 November 1735 (St. Mary's). He married, 2 January 1763, Ann Barrington, (St. Mary's) and had issue Joseph Barrington, baptised 6 November 1764 (St. Mary's). His death in Limerick, was noted by *FLJ*, 11 February 1767.

JAMES ROCHE, was a member of the Benedictine community at Glenstal Abbey, Co. Limerick. He studied metalwork at the Benedictine Abbey of Maredsous, Belgium, for three years commencing January 1946. He used the initials OSB in an oblong as his maker's mark. He died on 14 August 1998.

Joseph Robinson *James Roche*

MALACHY RYAN, a watch and clockmaker, worked for a period in Dublin before setting up, in 1766, his shop near the Exchange, next door to George Halloran's, where his sign showed a clock with hands pointing to 12.20 (compare with Charles Harrison and Robert Latch).[58] He married a Miss Verlin of Tulla, in Limerick in October 1768 (*FLJ* 1-5 October 1768).

THOMAS RYAN, artist, designer and medallist, was born in Limerick in 1929. He commenced his art studies at the Limerick School of Art, continuing his training at the National College of Art in Dublin. His standing as an artist is reflected in his being elected President of the Royal Hibernian Academy in 1982. His artistic talents are not confined to painting. As well as the medal and university mace exhibited here, he has designed numerous other medals and some of the Irish coins.

HENRY W. SMITH, registered in the Dublin Assay Office in 1830 as of 34 Patrick Street, Limerick, in partnership with R. Wallace; listed as a silversmith and jeweller of 108 George's Street, in 1846.

RICHARD W. SMITH of the house of Smith & Gamble, working jewellers, gold and silversmiths, Exchequer Street, Dublin, advertised a branch at 34 Patrick Street, Limerick, in the *LC* on 4 August 1827.

ROBERT SMITH, goldsmith, elected a sheriff of Limerick City in June 1674 for the ensuing year and was admitted a member of the Common Council in the following year. He became mayor in 1685 and was one of the four goldsmiths to be elected to that high office in Limerick, the others being James Robinson (1698), John Robinson (1742) and Joseph Johns (1773). In April 1678 the then mayor was formally authorised by Council to pay Robinson for the three silver freedom boxes presented in the previous month to the Earl of Strafford, Thomas Ratcliffe, Esq., and George Matthews, Esq.[59] He was listed on the Earl of Orrery's roll of tenants in 1679. In connection with his mayoralty in 1685, Ferrar wrote in his *History of Limerick* 'It is imagined the mayor understood engraving for he placed a pillar in the Exchange with a brass table, commonly called the Nail and engraved on it the following inscription: Ex dono Roberti Smith, Majoris / Limericensis Civibus.' This object is now on exhibition in the Civic Museum. Robert Smith, goldsmith, is named in various municipal records as leasing property from Limerick Corporation on dates between 1670 and 1700.[60] Probate of his will was taken out in 1703.

Robert Smith

WILLIAM SMITH, goldsmith, was a tenant of the Earl of Orrery in High Street, Limerick, in the 1660s.[61]

HENRY SMYTH, silversmith, free by marriage, 28 June 1830.

ABRAHAM SOLOMON, advertised in the *MJ*, 29 May 1749, that he was an 'Engraver from Germany, now at Mr Paul Moynahan's in Limerick, performs all manner of engraving on steel, silver, copper, cornelian and chrystal. His stay in the city will be but short.'

HENRY STERLING, described as a watchmaker, jeweller and silversmith of 115 George's Street, Limerick, in the *LC* of 3 January 1867.[62]

HENRY L. STEWART of 104 George's Street, Limerick, described in 1892 as a 'high class Art Goldsmith, Jeweller, Silversmith, and Watchmaker...Business established by father of present proprietor about a quarter of a century ago...Branch in Ennis.'[63] Registered at the Dublin Assay Office in 1889.

JOHN STRIT (or STRITCH), advertising in the *LC*, 1 April 1771, 'working jeweller near the Main Guard, Englishtown' stated that 'he has worked some years under the instructions of the late ingenious Mr Brunton, so much distinguished for his great abilities in the various branches of jewelling and staining kerry stones'. Next year in the *LC*, 19 November 1772, describing himself as a working jeweller, goldsmith and gilder he announced that 'he is lately returned from Dublin where he has been for improvement and procuring every necessary material to carry on said business, etc. … He will execute any piece of jewellery work and gilding. NB, he wants an apprentice.' Seven years later his advertisement in the *LC*, 16 August 1779, stated 'John Strit jeweller and silversmith has just opened shop near the Main Guard, where he sells every article in his way and will make it his special study to dispatch every order as all his work in done under his own inspection he can vouch for its neatness and strength. An apprentice is wanted'. He registered in Dublin in 1784 as of Quay Lane, Limerick.

MATTHEW STRITCH of 20 Broad Street, Limerick, when registering in 1788; described as a hardware man in 1809.

RICHARD WALLACE, silversmith, admitted free by marriage, 11 October 1830; listed as a jeweller, silversmith, watch and clockmaker and optician, 125 George's Street, in 1856. The firm survived into the 1930s.

EDMOND WALSH, described in the *LC* of 3 April 1850 as a silversmith.[64]

EDWARD WALSH, born 1939, holds doctoral degrees in nuclear and electrical engineering. He was President of NIHE, Limerick, 1970-89, and President of the University of Limerick, 1989-98. Amongst his many distinctions is the Freedom of Limerick, conferred in 1995. He is a self-taught silversmith, commencing in 1967 with a borrowed book on the craft, and has been learning ever since. While President of UL he made over 100 silver presentation spoons bearing the arms of the university, and amongst the distinguished recipients are the King of Spain and the Prince of Wales.

JOHN WALSH, manufacturing jeweller and silversmith, watch and clockmaker, 122 George's Street in 1856; 125 George's Street in 1867; 54 Catherine Street in 1877.

MATTHEW WALSH, of Quay Lane when registered in 1784.

PHILIP WALSH, silversmith, admitted a freeman of Limerick, 29 Jan. 1781, he registered under the 1783 Act in 1784 as of Main Street, Limerick. His advertisements in the *LC* in February 1779 stated (most likely exaggerating

Henry L. Stewart *Henry L. Stewart*

John Strit

Richard Wallace *Edward Walsh*

Matthew Walsh *Philip Walsh*

his range of goods) that he had 'newly imported from London a fashionable assortment of silver and jewellery work, viz. Tea Kitchens, Coffee Pots, Candlesticks, Bread baskets, Dish rings, Cups & goblets, Butter boats, Sugar basons, Baskets and dishes, Cream basons, Waiters, Coasters, Cruet stands, Salts, Snuff stands, Shoe, knee & stocks buckles, Rings, Lockets and Hair Pins, Seals, etc., with many other articles in the silver & jewellery branches. Those who are pleased to favour him with their commands will find it their interest as his Silver Work is all touched and sold on reasonable terms' (see plate 19). A few months later, 21 June 1779, he described himself in the *LC* as 'Philip Walsh silversmith and jeweller near the Jail in the Englishtown', reporting that 'his wife Mary Walsh is just returned from Dublin with an assortment of millinery and haberdashery' adding that 'NB. Said Walsh is as usual well supplied with a variety of touched plate.' On 29 July in the *LC* Mary Walsh, 'near the Main Guard' returned thanks to her customers and announced the arrival of 'a second new assortment of millinery goods'.

THOMAS WALSH (WELSH), of 6 Charlotte Quay in 1790, from which he registered under the 1783 Act in 1806. His advertisement in *The General Advertiser or The Limerick Gazette*, 12 December 1809 announced that 'Thomas Welsh (Jeweller, Hardware, Toy Warehouse) acquaints his friends … that he has removed his shop on Charlotte Quay to that held by Mr Poe, saddler, No. 10 Patrick Street, where he has received from London a large and elegant assortment.' Advertising from 38 Patrick Street in the *Limerick Evening Post* on 8 February 1812 he announced that 'intending to change his present system of Business will sell off at First Cost his Present Stock of Goods', adding his request that 'those indebted to him will discharge their accounts', and offered 'Highest Price for old Gold, Silver, Silver Lace, and Diamonds; Plain Shillings and Sixpences taken at full value, 5s 8d for dollars'. He was listed as Thomas Welsh, jeweller, 23 Patrick Street in 1824, and in the Registry of Voters in April 1837, he was named as Thomas Welshe *(sic)*, silversmith with a shop and premises in Patrick Street. In 1846 the firm was listed as Welsh & Co., watchmaker, jeweller and silversmith, of 1 Patrick Street.

Thomas Walsh

WILLIAM WARD, silversmith, acted as a bailsman in the Tholsel Court in 1795. He registered under the 1783 Act, as of Baal's Bridge, in 1798. Listed as a working jeweller and silversmith, 7 Charlotte Quay, in 1824. He was buried in St. Munchin's, 27 August 1832; his widow on 1 August 1836.

JOHN WARE, silversmith, recorded as a bailsman in the Tholsel Court in 1777, but is otherwise obscure.

William Ward

JAMES WATSON, his advertisement in the *LC*, 8 December 1774, stated 'Stopped by James Watson, silversmith opposite the Parade, a lady's sponge box with MB in a cipher on the cover …'

CORNELIUS WOOD, listed as a watch and clockmaker in Catherine Street in 1840 and as a manufacturing jeweller and silversmith at 3 Shannon Street in 1846.

NOTES

Except where indicated by superscript notation and not otherwise evident from the text, the information has been drawn from the following sources:

D. Bennett & R. ffolliott, 'The Silvermakers of Limerick' *The Irish Ancestor*, vol. X, no. 2 (1978), pp99-107.

J. Ferrar, *The Limerick Directory* (Limerick, 1769).

J. Ferrar, *The History of Limerick* (Limerick, 1787).

R. Herbert, 'The Freemen of Limerick', Appendix I to *NMAJ*, vol. 4, no. 3 (1945), pp103-126.

L. Walsh, 'A Directory of Limerick Gold and Silversmiths' in D. Lee & D. Jacobs (eds), *Made in Limerick*, vol. II (Limerick, 2006).

M.S.D. Westropp, 'The Goldsmiths of Limerick' *NMAJ* (1945), pp159-162.

The records of the Company of Goldsmiths preserved in the Assay Office, Dublin Castle.

The registers of St. John's, St. Mary's and St. Munchin's preserved in St. Mary's Cathedral, Limerick.

The Tholsel Court records 1773-1795, preserved in the Limerick Archives.

ABBREVIATIONS:

FLJ: Finn's Leinster Journal (1766-1802)
JRSAI: Journal of the Royal Society of Antiquaries of Ireland
L.: Limerick Chronicle (1768+)
LH: Limerick Herald (1788-95)
LJ: Limerick Journal (1739-44)
MJ: Munster Journal (1749-84)
NLI: National Library of Ireland
NMAJ: North Munster Antiquarian Journal
PRIA: Proceedings of the Royal Irish Academy
RD: Memorials filed in the Registry of Deeds, Dublin.

ENDNOTES TO DIRECTORY

1 RD 204.127.134699; RD 215.212.141609.

2 RD 299.594.199442.

3 RD 273.685.181206; RD 273.686.181207.

4 Limerick City Assembly Book, 30 September 1672 – 4 October 1680 (NLI, Ms. 89)

5 E. MacLysaght (ed.), *Calendar of The Orrery Papers*, IMC (1941), p219.

6 W. Phillimore & G. Thrift (eds), *Index to Irish Wills* (London, 1909), p111.

7 Bennett and ffolliott, p102

8 R. ffolliott, 'The swift rise … of Frederick Buck' *The Irish Ancestor* (1975), 2nd suppl., pp15-24.

9 E.M. Johnston-Liik, *History of the Irish Parliament 1692-1800* (Belfast, 2002), vol. III, p551; see also *Faulkner's Dublin Journal*, 19-22 June 1731.

10 Duke of Ormond, Petitions and Answers, vol 2, 1664 (NLI, Ms. 2512).

11 M. Lenihan, *Limerick: its History and Antiquities* (Dublin, 1866), p703. The name is spelt 'Backner' in this work.

12 C. O'Brien, 'Some misidentified Munster goldsmiths' *The Silver Society Journal*, no. 13 (2001), pp31-39.

13 *Burke's Irish Family Records* (London, 1976), p295.

14 *LC*, 13 March 1769.

15 C. O'Brien, 'The goldsmiths of Waterford' *JRSAI*, vol. 133 (2003), pp111-129.

16 *Dublin Hibernian Journal*, 11 October 1780.

17 RD 155.409.105231.

18 RD 68.446.48906; RD 68.447.48907; RD 63.250.43418.

19 British Library, Ms. 31888. We are grateful to Jennifer Moore for this information.

20 RD 320.468.219704 & RD 490.510.316421.

21 RD 336.108.224029.

22 National Archives, D.10850.

23 RD 155.409.105231; RD156.220.105230.

24 RD 156.220.105230.

25 Our thanks to Jennifer Moore for this information.

26 Advertisement in *LC*, 16 August 1779, 26 August 1779 and 2 September 1779.

27 *LC*, 5 July 1770; our thanks to Jennifer Moore for this information.

28 S. Marrinan, 'An Additional List of Limerick Shop-Signs' *NMAJ*, vol. XXV (1983), p58.

29 M.S.D. Westropp, 'Notes on Irish Money Weights' *PRIA*, sect. C, XXXIII (1916), p66.

30 C. O'Brien, as note 12 above, p35.

31 Phillimore & Thrift, as note 6, p120.

32 Our thanks to Jennifer Moore for this suggestion.

33 RD 93.425.66163; RD 106.154.73163.

34 *Finn's Leinster Journal,* 20-24 February 1768.

35 RD 376.446.251837.

36 RD 307.595.206242.

37 RD 293.608.19810.

38 RD 336.108. 224029.

39 *The Irish Fiants of Tudor Sovereigns,* vol. II (Dublin, 1994): no. 1470.

40 Marrinan, as note 28 above, p60.

41 *Calendar of the justiciary rolls, or proceedings in the Court of the Justiciar of Ireland,* 1305-7, pp405, 448.

42 L. Walsh, 'Two new Limerick silversmiths' *NMAJ,* XXXIII (1991), p101.

43 R. Caulfield, *The Council Book of the Corporation of Cork* (Guildford, 1876), p54.

44 J.R. Bowen and C. O'Brien, *Cork Silver and Gold* (Cork, 2005), pp183, 187.

45 *The Irish Fiants of Tudor Sovereigns,* vol. II (Dublin, 1994): Fiants of Elizabeth No. 177 of 1559.

46 We are grateful to Jennifer Moore for this reference.

47 See *JRSAI,* vol. 28 (1898), p41.

48 See note 33 above.

49 RD 624.145.427425.

50 RD 22.132.11605; 45.348.29540 & 47.202.30197.

51 RD 40.302.25901 & 137.85.92484.

52 Phillimore & Thrift, as in note 6, p128.

53 RD 31.452.19921.

54 RD 45.216.29106.

55 RD 37.236.22536.

56 RD 81.254.57261.

57 RD 71.9.48337; 168.314.113382.

58 See Marrinan, as note 28 above, p60.

59 See note 5 above.

60 B. Hodkinson, 'The Limerick Corporation Index of 1843' *NMAJ,* vol. 39 (1998-9).

61 See note 11 above.

62 Our thanks to Jennifer Moore for this reference.

63 Stratten's *Dublin, Cork and South of Ireland* (London, 1892).

64 Our thanks to Jennifer Moore for this.

Glossary of Terms

Alloy: The material formed by combining (fusing) two or more substances, at least one a metal. Silver is normally alloyed with copper, sometimes with small additions of other metals for specific purposes.

Armorials: A collective term for the coats of arms, decorative shields, banners and such like, displayed as marks of dignity and distinction, and emblematic of a family's history or of a corporate authority; originally employed by medieval knights who painted their shields with distinctive devices to enable them to be identified in battle when clad in armour.

Assay: Testing wares to ascertain that the alloy contains the legally-required proportion of precious metal.

Baroque: A highly ornate art style that evolved in Europe in the later sixteenth century, remaining popular until the mid-eighteenth century; characterized by extravagant curved forms and pompous grandeur in general.

Base metal: Any metal other than a precious metal. In Ireland the precious metals recognised under the Hallmarking Act of 1981 are gold, silver and platinum.

Bombé: Rounded, curved outward; literally 'blown out'.

Bright-cutting: A form of engraving in which the lines are cut with sides of varying steepness, conferring distinctive brightness to the pattern; done by applying the graver's cutting point sideways to the metal, producing faceted grooves that sparkle in the light.

Calyx: The leaf-like ornament supporting and partly enclosing the bowl of a chalice or cup.

Carat: A measure of fineness of gold, pure gold being 24 carats. Thus 18ct gold is 75% fine, denoted by contemporary hallmarks as 750 in a rectangular shield with chamfered corners at one side. A carat is also a unit of weight for precious stones, one carat being equivalent to 200mg.

Cartouche: An ornamental panel framing features such as armorials and inscriptions.

Casting: Fashioning objects or component parts by pouring molten metal into moulds of the desired form.

Chasing: Decorating the surface of an object from the front using punches or chasing tools of variable shapes. In contrast to engraving, it does not entail removal of metal.

Crest: In heraldry, the device surmounting the helmet and shield of a coat of arms. The same crest can frequently pertain to a number of unrelated families, rendering specific identification uncertain.

Cut-card work: Decorative shapes, usually foliate, cut from flat sheet silver and soldered on to the surface of a vessel.

Embossing/Repoussé: Decorating silver in relief by hammering from the reverse or inside without removing any of the metal. The raised patterns are then finished by chasing from the front.

Engraving: Decorating the surface of metal from the front by cutting the desired pattern into it with a graver or burin.

Flatware: A term denoting table utensils such as spoons, forks and knives.

Fleur-de-lis (or lys): A stylised representation of an iris flower; in heraldry it is especially associated with France and the French monarchy.

Fluting: Ornament consisting of half-round parallel channels embossed on plate; derived from classical architectural columns.

Fineness: The proportion of pure gold, silver or platinum in an alloy.

Fineness mark: The particular hallmark denoting the degree of fineness. In Ireland since 1638 the mark of a 'Harp Crowned' on an article of silver denoted fineness of 92.5%. Since 2001 the Harp Crowned has been superseded by a millesimal mark consisting of the figures 925 in an oval, denoting a fineness of 925 parts of fine silver in every 1,000 parts by weight of the article. Corresponding millesimal marks have been prescribed for precious metal articles of other permitted degrees of fineness.

Gadrooning: A series of rounded, convex ribs; the reverse of fluting.

Hallmark: A mark or series of marks struck on an article in an Assay Office to denote compliance with regulations. Originally a mark struck at Goldsmiths' Hall, London.

Hanoverian pattern: A style of spoon and fork which evolved c. 1710, characterised by an upward turn given to the handle terminal.

High relief: Embossed or sculptured decoration which projects prominently above its background.

Hollow ware: A term denoting vessels such as bowls, tea and coffee pots, cups, goblets, sauce boats and such like, as opposed to flatware.

Huguenot: French, Dutch and Swiss Protestants who emigrated after the revocation of the Edict of Nantes in 1685. Huguenot goldsmiths brought Continental decorative techniques and styles to their adoptive countries, characterized by bold and elegant shapes.

Knop: A protuberance, sometimes decorated, on staffs, the stems of chalices, cups and such like to facilitate handling.

Old English pattern: A style of flatware where the handle curves slightly backwards at its end. (See Hanoverian pattern.)

Onslow pattern: A flatware style which appeared around 1760, characterised by ribbed and scrolled terminals on handles.

Passant: A heraldic term describing an animal walking and looking forward. When the animal is shown looking out of the shield it is described as 'passant guardant'.

Plate: A traditional term for articles of gold or silver; not to be confused with Sheffield plate or electroplated wares.

Rampant: A heraldic term for an animal, usually a lion, shown with one hind leg on the ground, the other three paws elevated, the head looking forward. See further under 'passant'.

Rat-tail: A tapering rib running down the back of a spoon's bowl from where it joins the handle.

Rocaille: An element of rococo decoration suggestive of sea-worn rocks and shells; literally 'rockwork'.

Rococo: A style of late-baroque, florid decoration characterized by asymmetric patterns incorporating scrolls, shells and naturalistic motifs; first appeared on Irish silverware in the late 1730s.

Scratch weight: Its weight in troy ounces and pennyweights frequently found inscribed on the underside of a silver object; intended to indicate the object's intrinsic value.

Sejant: A heraldic term describing an animal (usually a lion) in a sitting posture with its forelegs stretched on the ground, the head and tail elevated. The term 'sejant rampant' describes the animal seated like a cat with its forelegs erect.

Silver-gilt: Silver covered with a thin layer of gold. Objects gilded in selected areas are referred to as parcel gilt. The ancient way of gilding silver involved applying an amalgam of gold and mercury to the desired areas with a brush, then heating the article to remove the mercury by vaporisation, leaving a thin layer of gold. This highly toxic procedure was superseded by an electrolytic process developed in the 1840s.

Sterling: The fineness standard adopted from early times for both silver coinage and silverware, namely 925 parts pure silver per one thousand of alloy.

Touchstone: A fine-grained stone used to test the fineness of a precious metal by the colour of the streak produced on the stone when rubbed with the metal.

Tressure: In heraldry, a narrow band or border near the edge of a shield; generally set round with fleurs-de-lys.

Trippant: A heraldic term describing an animal, typically a stag, having the right forefoot lifted.

Troy weight: A system of weights used for precious metals. A troy ounce contains twenty pennyweights (dwt) and is equivalent to 31.104 grams.

Zoomorphic: Decorative representation of animal forms.

A Select Bibliography

BOOKS, CATALOGUES, etc.

Bennett, D., *Irish Georgian Silver* (London, 1972).

Bennett, D., *Collecting Irish Silver* (London, 1984).

Bowen, J.R. & O'Brien C., *Cork Silver and Gold: Four Centuries of Craftsmanship* (Cork, 2005).

Buckley, J.J., *Some Irish Altar Plate* (Dublin, 1943).

Ferrar, J., *Limerick Directory, 1769* (Reprinted in *The Irish Genealogist* (Oct 1964).

Ferrar, J., *History of Limerick* (Limerick, 1787).

The Hunt Museum, *North Thomond Church Silver 1425-1820* (Limerick, 2000).

Jackson, C.J., *English Goldsmiths and their Marks*, 2nd ed. (London, 1921); 3rd (revised) ed. by I. Pickford, Woodbridge, 1989.

Lee, D. & Jacobs, D. (eds.), *Made in Limerick Vol. II* (Limerick, 2006).

Lenihan, M., *Limerick: its History and Antiquities* (Dublin, 1866).

Lucas, R., *A General Directory of the Kingdom of Ireland* (Dublin, 1788).

Sweeney, T., *Irish Stuart Silver* (Dublin, 1995).

Wallace, J.N.A., *Silver Plate in St. Mary's Cathedral, Limerick* (Limerick, 1939).

Walsh, L., *Historic Limerick: The City and Its Treasures* (Dublin, 1984).

Webster, C.A., *The Church Plate of Cork, Cloyne and Ross* (Cork, 1909).

Wyse Jackson, R., 'Irish-made Communion Plate 1559-1870' in *Church Disestablishment 1870-1970* (Dublin, 1970).

Limerick Holy Year Exhibition 1950 (Souvenir Catalogue).

Treasures of Thomond (Catalogue of an Exhibition in Limerick Museum, 1980).

ARTICLES IN PERIODICALS

Bennett, D. & ffolliott, R., 'The Silvermakers of Limerick' *The Irish Ancestor*, (1978), pp99-107.

ffolliott, R., 'The swift rise and slow decline of Frederick Buck' *The Irish Ancestor*, (1975), pp15-24.

Gleeson, D., 'Ancient Chalices of Killaloe Diocese' *Molua*, (1939), pp22-31.

Herbert, R., 'Limerick 18th century Shop Signs' *NMAJ*, vol. II (1940-41), pp162, 166.

Herbert, R., 'The Antiquities of the Corporation of Limerick' *NMAJ*, vol. IV (1945), pp84-129.

Hunt, J., 'The Arthur Cross' *JRSAI*, vol. 85 (1955), pp84-7.

Lynch, M., '17th Century Church Plate from Co. Clare' *The Other Clare*, vol. 28 (2004), pp61-2.

Marrinan, S., 'An Additional List of Limerick Shop-Signs' *NMAJ*, vol. XXV (1983) p60.

O'Brien, C., 'Some misidentified Munster goldsmiths' *The Silver Society Journal*, no. 13 (2001), pp31-39.

O'Brien, C., 'The Goldsmiths of Waterford' *JRSAI*, vol. 133 (2003), pp111-129 [re Jonas Bull].

Ó Dálaigh, B., 'An Ennis Freedom Box, 1760' *The Other Clare*, vol. 29 (2005), pp99-100.

O'Halloran, P., 'Antique Chalices in Killaloe Diocese' *Molua*, (1936), pp17-19.

Sinsteden, T., 'A Freedom Box for *A Hot Whiffling Puppy*' *Irish Arts Review*, vol. 16, (2000), pp139-141.

Ticher, K., 'The Lion Rampant on Mid-18th Century Limerick Silver' *Collector's Guide*, October 1969.

Ticher, K., 'Limerick Oddities' *Collector's Guide*, April 1975, pp80-2.

Wallace, J.N.A., 'Notes on Limerick Silver Marks' *NMAJ*, vol. II (1940-41), pp135-6.

Wallace, J.N.A., 'Origin of the Early Marks on Limerick Silver' *NMAJ*, vol. III (1944), pp75-6.

Wallace, J.N.A., 'Limerick Silver Freedom Boxes' *NMAJ*, vol. IV (1945), pp131-3.

Wallace, J.N.A., 'A Limerick Silver Tankard' *NMAJ*, vol. VI (1949), p26.

Wallace, J.N.A., 'Limerick Freedom Box' *NMAJ*, vol. V (1947), p80.

Wallace, J.N.A., 'Eighteenth-century Silver Buttons' *NMAJ*, vol. V (1947), p80.

Walsh, L., 'Two New Limerick Silversmiths' *NMAJ*, vol. XXXIII (1991), p101.

Walsh, L., 'A Limerick Silver Freedom Box, 1693' *NMAJ*, vol. XXXIII (1991), pp101-3.

Westropp, M.S.D., 'The Goldsmiths of Limerick' *NMAJ*, (1939), pp159-164.

Wyse Jackson, R., 'Old Church Silver of East Killaloe' *NMAJ*, vol. II (1940-41), pp63-70.

Wyse Jackson, R., 'Some Church Silver in Limerick' *NMAJ*, vol. IV (1949-52), p21-3.

Wyse Jackson, R., 'Some Irish Provincial Silver' *NMAJ*, vol. VIII (1959), pp1-4.

Wyse Jackson, R. 'Limerick Made Silver' *NMAJ*, vol. VIII (1961), p204.

Wyse Jackson, R., 'An Introduction to Irish Silver' *NMAJ*, vol. IX (1962 & 1963), pp1-24.

NMAJ = North Munster Antiquarian Journal;
JRSAI = Journal of the Royal Society of Antiquaries of Ireland

Index

All exhibits are indexed, both under object type and maker name. All references are to page numbers; plates are indicated by italics, bold denotes the catalogue entry. (n) = note no. The term goldsmith includes silversmith.

A

Angell, George
 hunting trophy, *107*, **108**
Angling, 100, *102*, **110**, **111**
Ardagh Chalice, 12, 42, 43
Assay Office, Dublin, 11, 16, 19, 23, 31, 116, 141
Assaying, 10

B

Barrington, Croker, 35, 190, *190*
Beere, Hercules,
 bread plate, *52*, **69**
Blundell, J.C., 117, 190
Boland, Eavan, poem about Hester Bateman, silversmith, 5
Bowls
 Joseph Johns, *143*, *147*, **153**, **154**
 Edward Walsh, *120*, *121*, **124**
Bowl (punch)
 John or James Robinson, *104*, **112**
Bowls (sugar)
 Jonathan Buck, *172*, **186**
 Cosmacs Ltd., *117*, **123**
 William Fitzgerald, *144*, **154**
 Joseph Johns, *152*, **153**
Box
 Joseph Johns, *156*, **168**
Bracelets
 Edward Walsh, *122*, **125**
Bradford, Robert, 25, 190
Bread plates
 Hercules Beere, *52*, **69**
 Maurice Fitzgerald, *46*, *51*, **68**
 John O'Shea, *56*, **75**
Brehon, Collins, 14, 190, *190*
 candlesticks, *150*, **155**
 tablespoon, *130*, **139**
 paten, *49*, **67**
 pill box, *165*, **169**
 salvers, *165*, **169**
 sauceboats, *141*, **153**
Brooches
 Cosmacs Ltd., *120*, **124**
 Martin O'Driscoll, *119*, **123**, **124**
 Edward Walsh, *122*, **125**
Brush, George, 25, 190
Buck, Adam, 27, 190-1, *190*
 chalice, *64*, **70**
Buck, George, 27
Buck, Jonathan, 14, 27, 28, 29, 30, 140, 190, *190*
 brandy saucepan, *145*, **155**
 chalice, *55*, **71**
 communion cup, 44, *50*, **68**
 finger ring, *159*, **169**
 freedom boxes, *79*, *81*, *88*, **92**, **97**
 marrow scoop, *134*, **139**
 monstrance, 45, *56*, **70**
 paten, *55*, **71**
 saffron pot, *181*, **188**
 salt shovels, *132*, **138**
 salvers, *150*, **155**
 sauceboat, *145*, **154**
 seal matrix, **92**
 snuffboxes, *157*, *158*, *162*, **167**, **168**
 sugar bowl, *172*, **186**
 tablespoons, *130*, **137**
Bucknor, John, 13, *14*, 26, 43, 191-2, *191*
 communion cups, 43, *48*, *49*, *52*, *53*, **67**, **69**, **70**
 flagon, 45, *52*, **69**
 patens, *44*, 45, *49*, *53*, **66**, **68**, **70**
Bull, Jonas, 35, 192, *192*
 freedom box, *81*, **94**
Bumbury, Thomas, 192
Burbridge, John, 192
Burbridge, Philip, 192
Burke, Thomas, *17*, 25, 192-3, *192*
 basting spoon, *127*, **135**
 dessertspoons, *133*, **138**
 dividing spoon, *127*, **135**
 sauce ladles, *129*, **135**
 sugar tongs, *133*, **138**
 touchstone, *10*, *161*, **167**
Buttons
 Samuel Johns, *164*, **167**

C

Calbeck, John, 17, 35, 193
Calbeck, Samuel, 25, 30, 193, *193*
 chalice, 45, *63*, **74**
 communion cup, *64*, **69**
Camogie, 99, *100*, **112**
Candlesticks
 Collins Brehon, *150*, **155**
Carroll, William, 25, 193
Chalices, 42-3, 44
 Adam Buck, *64*, **70**
 Jonathan Buck, *55*, **71**
 Samuel Calbeck, 45, *63*, **74**
 Cosmacs Ltd., *57*, **71**
 Richard Fennell, 44, *59*, *62*, **72**, **74**
 James Roche, *56*, **71**
 Unidentified maker, *57*, *58*, *60*, *61*, *62*, **71**, **72**, **73**, **74**
Chaplain, Jules-Clément
 medal, *102*, **111**
Cherry, John, 17, 25, 35, 193
Cherry, William, 28, 30, 193
Coasters
 George Moore, 170, *175*, **186**
Coffee pots
 Samuel Johns, *178*, **187**
 John Smith, *185*, **189**
Coins, 78
 groat, Edward IV, *85*, **96**
 halfpenny, James II, *86*, **96**
 halfpenny, King John, *89*, **97**
 penny, King John, *89*, **97**
Colbeck, Caleb, 30, 194
Collopy, James, 17, 194
Communion cups, 43-44
 Jonathan Buck, 44, *50*, **68**
 John Bucknor, *48*, *52*, *53*, **67**, **69**, **70**
 John Bucknor (attrib.), *49*, **67**
 Samuel Calbeck, *64*, **69**
 Maurice Fitzgerald, *46*, *51*, **68**
 Joseph Johns, 44, *65*, **67**,
 Joseph Johns (prob.), *47*, **66**
 John Purcell, *48*, **67**
 James Robinson, *50*, *51*, **68**
 Robert Smith, 44, *47*, **66**

Unidentified maker, 44, *54*, **69**
Connell, Patrick, 25, 194, *194*
 basting spoons, *128*, **138**
 dessertspoon, *133*, **139**
 skewer, *133*, **135**
 soup ladle, *129*, **136**
Conway, James, 194
Corkscrews, *see* Seals
Cosmacs Limited, 15, 117, 194, *194*
 brooches, *120*, **124**
 chalice, *57*, **71**
 cream jug, *117*, **123**
 decanter labels, *116*, **123**
 sugar bowl, *117*, **123**
Cowell, Simon, 30
Croan, John Herbert, 25, 34, 194
Cromer, Conrad, 117, 194, *194*
 watch movement, *159*, **168**
Cross
 Philip Lyles, *63*, **74**
Cullum, John, 17, 25, 194-5
Cups
 Joseph Johns, *173*, **189**
 Samuel Johns, *148*, **153**
 John Robinson, *140*, **153**
Cutlery, *see* Forks, Ladles, Marrow scoops, Shovels, Skewers, Spoons, Tongs

D

Decanter labels, *116*, **123**
De Lond, William Turner,
 'A view of Limerick, c. 1837', *8*
 'The Chairing of Thomas Spring Rice in 1820', *36*
Dish rings, 171
 George Halloran, *175*, **187**
 Joseph Johns, *177*, **188**
Donegan, Edward, 195
Donovan, Peter
 University of Limerick mace, *83*, **94**
Downes, Henry, 25, 195, *195*
 sauceboat, *180*, **188**
 soup ladle, *129*, **137**
Drinking vessels, 170
Duffner, A.
 medal, *99*, **108**
Dupon, Josué
 medal, *102*, **110**

F

Fennell, Richard, 44, 195, *195*
 chalices, 44, *59*, *62*, **72**, **74**
 autograph, *13*
Finger rings
 Jonathan Buck, *159*, **169**
 Joseph Johns, *159*, **168**
 Edward Walsh, *122*, **125**
Fitzgerald, Garrett, 14, 195, *195*
 sauce ladles, *128*, **135**
Fitzgerald, Maurice, 14, 25, 195, *195*
 communion cup, *46, 51*, **68**
 bread plate, *46, 51*, **68**
 marrow scoop, *134*, **136**
 paten, 45, *46, 51*, **68**
 salt spoon, *132*, **138**
 soup ladle, *129*, **136**
 strawberry dish, *172*, **186**
 sugar tongs, *171*, **189**
Fitzgerald, William, 14, 25, 195-6, *195*
 pickle fork, *184*, **189**
 poultry skewers, *134*, **135**
 sugar bowl, *144*, **154**
 sugar tongs, *133*, **136**
 table forks, *126*, **137**
Flagons, 45
 John Bucknor, 45, *52*, **69**
 James Robinson, *42, 43*, **66**
Forks (table)
 William Fitzgerald, *126*, **137**
 Joseph Johns, *126*, **135**
Fork (pickle)
 William Fitzgerald, *184*, **189**
Franciscan plate, 44
Freedom boxes, 76-77
 Cork,
 Jonathan Buck, *88*, **97**
 Ennis,
 Joseph Johns, *80*, **92**
 Limerick,
 Jonathan Buck, *79, 81*, **92**, **94**
 Jonas Bull, *81*, **94**
 George Halloran, *82*, **94**
 Joseph Johns, *82*, **94**
 Unidentified maker, *76*, **93**
Freemasons, membership of *see* Goldsmiths

G

Gaelic Athletic Association (GAA) medals, *see* Medals
Gaelic football, 99, *99*, **108**
Gaelic games, *see* Camogie, Gaelic football, Hurling
Gladman & Norman Limited
 Masonic square, *90*, **97**
Gloster, John, 25, 35, 196
Goggin, James, 25
Gold, purity, 9
 'touch of Paris', 9
Goldsmiths
 Company of, Dublin, 11
 guild in Limerick, 21-22
 Freemasons, 35, 140
 location, *24*, 25
 history, 18-39
 fifteenth century, 12
 sixteenth century, 13
 seventeenth century, 13-14
 eighteenth century, 14-15
 nineteenth century, 15, 116-17
 twentieth century, 15, 117
 twenty-first century, 118
 marks, 16, 190-208
 'town mark', 16-17, 23
 sterling stamp, 16, 28
 trefoil, 35-6
 Worshipful Company of, London, 11
Gorgets, gold, found at Gleninsheen, Co. Clare, 12
Guild of Hammermen, 21, 38 (15n)
Guild of Masons, 20, 38 (15n), 39 (55n)
Guild of Smiths, *see* Goldsmiths
Gunmoney, *see* Coins
Guppy, Alexander, 25, 196
Guppy, William, 196

H

Hackett, John, 196
Hallmarking and hallmarks, 9
 statute of 1300, 9
 introduction to Ireland, 11
 Dublin Assay Office marks, 11
 Dublin hallmarks, *11*
Halloran, George, 25, 34, 196-7, *197*
 cream jug, *173*, **188**
 dish ring, *175*, **187**

INDEX

freedom box, *82*, **94**
shoe-buckles, *158*, **167**
soup ladle, *129*, **137**
Harrison, Charles, 25, 197-8
Hartmann, Joseph, 198
Hautsch, Georg
 medal, *87*, **96**
Hawley, John, 25, 198
Hicks, Randal, 25, 26, 198
Hill, Samuel, 30, 198
Horse-racing, *104*, *106*, **112**
Hunting, **108**
Hurling, *98*, 99, *99*, *100*, **108**, **109**, **110**, **113**

J

Jewellery, *see* Bracelets, Brooches, Finger rings, Necklaces, Stick pin
Johns, Joseph, 14, *16*, 25, 30, 32-3, 35, 37, 198-9, *198*
 bowls, *143*, *147*, **153**, **154**
 box, *156*, **168**
 communion cups, 44, *47*, *65*, **66**, **67**
 cream jug, *147*, *152*, **154**
 dessertspoons, *130*, **136**
 dish ring, *177*, **188**
 finger ring, *159*, **168**
 fork, *126*, **135**
 freedom boxes, *80*, *82*, **92**
 Masonic jewel, *91*, **96**
 nutmeg grater, *181*, **187**
 pap boat, *182*, **187**
 patens, 45, *47*, *65*, **67**
 punch strainer, *182*, **189**
 salvers, *144*, *146*, *151*, **154**, **155**
 sauceboat, *148*, **155**
 saucepan, *171*, *174*, **186**
 seal and corkscrew, *166*, **169**
 soup ladle, *128*, **136**, **137**
 spouted pot, *183*, **187**
 sugar bowl, *152*, **153**
 tablespoon, *130*, **138**
 tumbler cup, *173*, **189**
 wine funnel, *179*, **188**
Johns, Joseph (2), 199
Johns, Samuel, 25, 34, *34*, 199-200, *199*
 buttons, *164*, **167**
 coffee pot, *178*, **187**
 cups, *148*, **153**
 lemon strainer, *180*, **188**
 sifter spoon, *132*, **137**
 tablespoon, *130*
 trencher salts, *171*, *179*, **186**
 sugar nips, *183*, **187**

Johnston & Co., H.
 Montana Silver spoon, *163*, **167**
Jugs (cream)
 Cosmacs Ltd., *117*, **123**
 George Halloran, *173*, **188**
 Joseph Johns, *147*, *152*, **154**

K

Kelso, Joseph, 200
Kinraghte, Thomas, 200
Kinsela, Joseph, 30
Kinselagh, Edmund Roche, 200
Knight, Nicholas, 25, 200

L

Ladle (brandy)
 Unidentified maker, *184*, **189**
Ladles (sauce)
 Thomas Burke, *129*, **135**
 Garrett Fitzgerald, *128*, **135**
Ladles (soup)
 Patrick Connell, *129*, **136**
 Henry Downes, *129*, **137**
 Maurice Fitzgerald, *129*, **136**
 George Halloran, *129*, **137**
 Joseph Johns, *128*, **136**, **137**
Ladle (toddy)
 John Purcell, *132*, **136**
Laighléis family of goldsmiths, 13
Laing, John, 25, 200
Latch, Robert the elder, 25, 34-5, 200
Latch, Robert the younger, 25, 34-5, 200
le Orfeure, Thomas, 201
Limerick,
 Anglo-Norman mint, 18
 arms, *21*
 Englishtown, *24*, 28, 36
 guilds, 20-22
 Irishtown, *24*, 36
 maps, *12*, *24*
 Newtown Pery, *24*, 33-34, 36
 plan of, 1769, *33*
 'The Custom House,' print of, *22*
Lyles, John, 201
Lyles, Philip, 201, *201*
 cross, 42, *63*, **74**
 autograph, *13*
Lynch, Arthur, 25, 201
Lynch, James, 201
Lynch, Robert, 25, 201
Lysaght, Daniel, 25, 201, *201*
 tablespoons, *130*, **138**
 teaspoons, *132*, **136**

M

Maces, 77
 Limerick city, *32*, *79*, **92**
 University of Limerick, *83*, **94**
 Peter Donovan, *83*, **94**
 John Robinson, *32*, *79*, **92**
Marrow scoops
 Jonathan Buck, *134*, **139**
 Maurice Fitzgerald, *134*, **136**
 Philip Walsh, *134*, **135**
Martin, George, 25, 201
Masonic regalia
 Gladman & Norman Ltd., *90*, **97**
 jewel, *91*, **96**
 Joseph Johns, *91*, **96**
 square, *90*, **97**
McCarthy, Susan, 118, 201, *201*
 snuffbox, *118*, **123**
Mecgyllysaghta, Donald, 202
Medal Manufacturing Ireland
 medal, *83*, **95**
Medals, 78
 Jules-Clément Chaplain, *102*, **111**
 A. Duffner, *99*, **108**
 Josué Dupon, *102*, **110**
 European Heineken Cup Winners, *105*, **114**
 Exposition Universelle Internationale, *102*, **111**
 GAA All-Ireland Intermediate Camogie, *100*, **112**
 GAA All-Ireland Senior Gaelic Football, *99*, **108**
 GAA All-Ireland Senior Hurling, *98*, *99*, *100*, *103*, *104*, **108**, **109**, **113**
 GAA Munster Junior Camogie, *100*, **112**
 GAA Munster Senior Hurling, *100*, **109**, **110**
 GAA National League Hurling, *100*, **109**
 Georg Hautsch, *87*, **96**
 Jim Kemmy Commemorative Medal, *84*, **95**
 Limerick Civic Carnival, *105*, **114**
 Limerick Union, *157*, **167**
 Medal Manufacturing Ireland, *83*, *100*, **95, 112**
 John Miller, *98*, *99*, *100*, *104*, **108**, **109**, **113**
 Moore & Co., *103*, **113**
 Munster Challenge Cup Rugby, *104*, **113**
 Munster Junior Cup Rugby, *104*, **113**
 O'Connor, *104*, **113**
 Martin O'Driscoll, *84*, **95**
 Olympic, *101*, *102*, **110**

William Pitts, *101*, **115**
Presentation, *119*, **124**
Rathkeale Volunteers, *101*, **115**
Student European Rugby Championship, *105*, **113**
University of Limerick Silver Jubilee, *83*, **95**
Vaughton Ltd., *102*, 110, **111**
Williamite, *87*, **96**
Wimbledon Tournament, *102*, **111**
World Fly-fishing, *102*, **110**
Miller, John
 medals, *98*, *99*, *100*, *104*, **108**, **109**, **113**
Mills, John, 202
Monstrances
 Jonathan Buck, 45, *56*, **70**
 Unidentified maker, *60*, **73**
Moore & Company
 medal, *103*, **113**
Moore, George, 14, *16*, 25, 202, *202*
 coasters, 170, *175*, **186**
 paten, *53*, **70**
 sauceboat, *174*, *176*, **187**, **188**
Moore, William D., 202
Mug
 John Robinson, *176*, **186**

N

Necklaces
 Martin O'Driscoll, *119*, **124**
 Edward Walsh, *122*, **124**, **125**
Nutmeg grater
 Joseph Johns, *181*, **187**

O

Oar, silver, 35
O'Carryd, Thomas, 202
 crosier, 12, 42
 mitre, 12, *18*, 42
O'Connor
 medal, *104*, **113**
O'Cowltayn, Gilladuffe, 202
O'Dea, Conor (bishop of Limerick, 1400-26), 12, 18, *18*, 42
O'Driscoll, Martin, 118, 202, *202*
 brooches, *119*, **123**, **124**
 medals, *84*, **95**, *119*, **124**
 necklace, *119*, **124**
O'Halloran, George, *see* Halloran, George
Olympic games, 100, *101*, *102*, **110**
Olympic medals, *see* Medals
O'Shaughnessy, Robert, 15, 25, 116, 202-3, *202*
 teaspoon, *134*, **139**

O'Shea, John, 203, *203*
 bread plate, *56*, **75**

P

Pap boat
 Joseph Johns, *182*, **187**
Parker, Edward, 29, 30, 203
Parker, Philip, 25
Parker, William, 25, 29, 30, 203
Patens, 44-5
 Collins Brehon, *49*, **67**
 Jonathan Buck, *55*, **71**
 John Bucknor, 44, 45, *53*, **66**, **70**
 John Bucknor (attrib.), 45, *49*, **68**
 Maurice Fitzgerald, 45, *46*, *51*, **68**
 Joseph Johns, 45, *47*, *65*, **67**
 George Moore, *53*, **70**
 Matthew Walsh, 44, *55*, **74**
 Unidentified maker, 44, *61*, *64*, *54*, **69**, **70**, **73**
Pennyfather, John, 203-4
Pery, Edmund Sexten, 30, 31, 32
Phipps, Francis, 204
Pill box
 Collins Brehon, *165*, **169**
Pitts, William
 medal, *101*, **115**
Presentation trowels, 78
 Richard Sawyer, *81*, *84*, **93**, **95**
Purcell, Charles, 25, 204
Purcell, Elizabeth, 25
Purcell, John, 25, 204, *204*
 communion cup, *48*, **67**
 teaspoons, *131*, **136**
 toddy ladles, *132*, **136**
Purdon, Samuel, 15, 25, 116, 204, *204*
 caddy spoon, *132*, **135**

R

Robinson, Edward, 38 (36n), 204
Robinson, George, 30
Robinson, George (fl. 1740s), 38 (36n), 204, *204*
Robinson, George (c. 1742-59), 38 (36n), 204
Robinson, James, *16*, 26, 30, 38 (36n), 141, 204, *204*
 communion cups, *50*, *51*, **68**
 flagon, *42*, *43*, **66**
 punch bowl, *104*, **112**
Robinson, James (fl. 1718), 205
Robinson, John, 33, 38 (36n), 141, 205, *205*
 cup, *140*, **153**
 mace, *32*, *79*, **92**

mug, *176*, **186**
punch bowl, *104*, **112**
Robinson, Joseph, 205, *205*
 soup tureen, 170, *170*, **186**
Roche, James, 205, *205*
 chalice, *56*, **71**
Rowing, 99-100, *103*, **111**
Rugby, 99, *104*, *105*, **113**, **114**
Ryan, Malachy, 25, 205
Ryan, Thomas, 206

S

Saffron pot
 Jonathan Buck, *181*, **188**
Salvers
 Collins Brehon, *165*, **169**
 Jonathan Buck, *150*, **155**
 Joseph Johns, *144*, *146*, *151*, **154**, **155**
 Unidentified maker, *105*, *106*, **114**, **115**
Sauceboats
 Collins Brehon, *141*, **153**
 Jonathan Buck, *145*, **154**
 Henry Downes, *180*, **188**
 Joseph Johns, *149*, **155**
 George Moore, *174*, *176*, **187**, **188**
 John Strit, *177*, **188**
 Philip Walsh, *148*, **154**
Saucepans (brandy)
 Jonathan Buck, *145*, **155**
 Joseph Johns, 171, *174*, **186**
Sawyer, Richard
 presentation trowels, *81*, *84*, **93**, **95**
Seals, 77
 Jonathan Buck, *77*, **92**
 Joseph Johns, *166*, **169**
 Kilmallock, *77*, **92**
 Limerick city, *80*, **93**
Shoe-buckles
 George Halloran, *158*, **167**
Shovels (salt)
 Jonathan Buck, *132*, **138**
Silver, as investment, 30
 fineness, 9
 sterling standard, 8
 self-sterilising, 170
Silvermines, Co. Tipperary, 19
Skewers
 Patrick Connell, *133*, **135**
 William Fitzgerald, *134*, **135**
 Matthew Walsh, *133*, 171, **186**
Smith, Henry W., 25, 206
Smith, John
 coffee pot, *185*, **189**
 trophies, *103*, **111**

219

INDEX

Smith, Richard W., 25, 206
Smith, Robert, 26, *26*, 140, 141, 206, *206*
 communion cups, 43, 44, *44, 47*, **66**
 tankard, *151*, **153**
Smith, William, 25, 26, 206
Smyth, Henry, 206
Snuffboxes
 Jonathan Buck, *157, 158, 162*, **167, 168**
 Susan McCarthy, *118*, **123**
Solomon, Abraham, 206
Spectacles case
 Henry L. Stewart, *160*, **167**
Spoons, 30, 126-7
 H. Johnston & Co., *163*, **167**
 Edward Walsh, *121*, **125**
Spoons (basting)
 Thomas Burke, *127*, **135**
 Patrick Connell, *128*, **138**
 William Ward, *128*, **137**
Spoon (caddy)
 Samuel Purdon, *132*, **135**
Spoons (dessert)
 Thomas Burke, *133*, **138**
 Patrick Connell, *133*, **139**
 Joseph Johns, *130*, **136**
Spoon (dividing)
 Thomas Burke, *127*, **135**
Spoon (salt)
 Maurice Fitzgerald, *132*, **138**
Spoon (sifter)
 Samuel Johns, *132*, **137**
Spoons (table)
 Jonathan Buck, *130*, **137**
 Collins Brehon, *130*, **139**
 Joseph Johns, *130*, **138**
 Samuel Johns, *130*
 Daniel Lysaght, *130*, **138**
 Matthew Walsh, *128*, **138**
 Thomas Walsh, *130*, **137**
Spoons (tea)
 Daniel Lysaght, *132*, **136**
 Robert O'Shaughnessy, *134*, **139**
 John Purcell, *131*, **136**
Sports, 98-100
Spouted pot
 Joseph Johns, *183*, **187**
Sterling, Henry, 206
Stewart, Henry L., 117, 207, *207*
 Spectacles case, *160*, **167**
 Watch movement, *159*, **168**
Stick pin
 Unidentified maker, **167**
Strainer (lemon)
 Samuel Johns, *180*, **188**

Strainer (punch)
 Joseph Johns, *182*, **189**
Strawberry dish
 Maurice Fitzgerald, *172*, **186**
Strit, John, 25, 207, *207*
 sauceboat, *177*, **188**
Stritch, Matthew, 25, 207
Sugar nips
 Samuel Johns, *183*, **187**
Sugar tongs
 Thomas Burke, *133*, **138**
 Maurice Fitzgerald, *170*, **189**
 William Fitzgerald, *133*, **136**

T

Tankards
 Robert Smith, *151*, **153**
 Unidentified maker, *142, 143*, **153**
Toast rack
 Edward Walsh, *121*, **125**
Touchstone, 10
 Thomas Burke, *10, 161*, **167**
Trencher salts
 Samuel Johns, 171, *179*, **186**
Trophies
 rowing, *103*, **111**
 horse-racing, *104, 106*, **112, 114**
 hunting, *107*, **108**
 long jump, *106*, **114**
 yachting, *105*, **115**
Tureen (soup)
 Joseph Robinson, 170, *170*, **186**

V

Vaughton Limited
 medals, *102*, 110, **111**

W

Wallace, Richard, 25, 117, 207, *207*
 watch movement, *159*, **168**
Walsh, Edmond, 207
Walsh, Edward, 118, 207, *207*
 bowls, *120, 121*, **124**
 bracelet, *122*, **125**
 brooch, *122*, **125**
 finger rings, *122*, **125**
 necklaces, *122*, **124, 125**
 spoon, *121*, **125**
 toast rack, *121*, **125**
Walsh, John, 207
Walsh, Matthew, 15, 25, 207, *207*
 paten, 44, *55*, **74**
 skewer, *133*, 171, **186**
 tablespoons, *128*, **138**

Walsh, Philip, 25, 141, 207-8, *207*
 marrow scoop, *134*, **135**
 sauceboat, *41, 148*, **154**
Walsh, Thomas, 25, 208, *208*
 tablespoon, *130*, **137**
Ward, William, 25, 208, *208*
 basting spoon, *128*, **137**
Ware, John, 208
Watch movements
 Conrad Cromer, *159*, **168**
 Henry L. Stewart, *159*, **168**
 Richard Wallace, *159*, **168**
Watson, James, 25, 208
Weight-throwing medals, *101, 102*, **110**
Willem (moneyer)
 coins, *89*, **97**
Wine funnel
 Joseph Johns, *179*, **188**
Wood, Cornelius, 25, 208